THE OPEN UNIVERSITY

Arts: A Third Level Course

Modern Art 1848 to the Present:
Styles and Social Implications

Unit 7

CUBISM: THE DISRUPTED AND THE CONSTRUCTED IMAGE

Unit 8

LANGUAGE OF THE FEELINGS: FIGURATION AND ABSTRACTION IN EXPRESSIONIST ART

Unit 9

FUTURIST ART AND THE DYNAMISM OF MODERN LIFE

Prepared by Norbert Lynton for the Course Team

The Open University Press

The Open University Press
Walton Hall Milton Keynes MK7 6AA

First published 1976

Designed by the Media Development Group of the Open University.

Printed in Great Britain by
COES THE PRINTERS
RUSTINGTON, SUSSEX

ISBN 0 335 05153 7

This text forms part of an Open University course. The complete list of units in the course appears at the end of this text.

For general availability of supporting material referred to in this text, please write to the Director of Marketing, The Open University, P.O. Box 81, Walton Hall, Milton Keynes, MK7 6AT.

Further information on Open University courses may be obtained from the Admissions Office, The Open University, P.O. Box 48, Walton Hall, Milton Keynes, MK7 6AB.

1.1

Unit 7 Cubism: The Disrupted and the Constructed Image

Introduction 4

The Heroic Age 6

Tradition and Change 7

An Outline of Cubism 9

Les Demoiselles d'Avignon 10

Towards Cubism 20

Analytical Cubism 29

Synthetic Cubism 35

Juan Gris 46

Fernand Léger 49

The Other Cubist Painters 53

The Problem of Cubist Sculpture 54

Cubist Sculpture: Picasso 55

Other Cubist Sculptors 58

Intentions, Practice and Theory of Cubism 63

Cubist Painting and Cubist Sculpture 68

Introduction

Though it refers to Hamilton for specific points (as well as to Hamilton and Haftmann for illustrations) and to Chipp's texts, this unit is more independent than some. I have chosen, in writing it, to examine—and to invite you to examine with me—a sequence of works of art. Its subject is Cubism; more particularly the gradual discovery and development, first and foremost by Picasso and Braque, of a new pictorial idiom (its application to sculpture was second in time and secondary in importance). Almost the whole of the unit is devoted to that. The more I see of Cubism the more I am impressed and also entertained by the great adventure which those two great professionals undertook—by the probing and testing, the recognizing of what was useful and effective and the abandoning of methods which, whatever their attractions, would counteract their disruptive and constructive ambitions. Those two adjectives appear in the title of this unit. They are there because they signalize something of Cubism's magisterial role on the level of art history as well as its thoroughly ambiguous (and thus richly human) functioning on the psychological level. Cubism changed the nature of western image-making for keeps, more widely and more radically than any other artistic adventure since Masaccio, Donatello and Brunelleschi launched the early Renaissance in fifteenth-century Florence. I often think that systematic perspective (credited to Brunelleschi but first made full use of by Masaccio in the 1420s) must have been as disconcerting a device to encounter as it was an exciting one—it gave dictatorial rights to mathematical calculation, at the expense often of psychological truth (as when the important person in the background appears tiny next to an unimportant bystander in the foreground), and tended to negate a picture's first means of communicating with us, i.e. its arrangement of colour and form as a two-dimensional composition. It is noticeable that the first fully fledged Renaissance paintings, such as the marvellous fresco cycle Masaccio painted in the Brancacci Chapel of the Carmelite Church in Florence (and left incomplete when he died in 1428 at the age of 27) are gruff and ungracious and suggest aggressiveness as well as a peculiarly stubborn sense of pictorial dramatics. Any development in art involves some jettisoning of what is known to work, and the big developments demand a painful wrench. In the case of Cubism the story starts with Picasso's terrible and magnificent painting (also unfinished) *Les Demoiselles d'Avignon*, where the wrenching is blatant, but it is extraordinary how very quickly Picasso and Braque can be seen to be rebuilding even more than disrupting. What is exceptional about Cubism, even among the greatest developments in art, is that disruption and construction both remain as active elements. At any rate, when the disrupting ceases, when Cubism exists as a ready-made language with which to speak, the excitement and the quality drop instantly and we are confronted with the first substantial form of modern academicism.

There will be scarcely any space in which to touch on the other Cubists and on Cubism as an international diffusion. I shall assume, however, that you will have read—or are reading in parallel—the relevant pages in Hamilton (pp. 235–76 approximately; you don't need to know at this point about the later work of Lipchitz, and Unit 9 will deal with Futurism and Vorticism). One might wish to argue with a sentence here or there in Hamilton, but his account is both sound and marked by real insights. What I am doing here is, in effect, to put a magnifying glass to parts of his story and to leave the rest of it to him. In a radiovision programme (RV 8) I shall juxtapose different examples of Cubist art by several artists, partly to point to their particular contribution and partly just to drive home the important fact that to call a work of art 'Cubist' is merely to designate it a member of a far-flung family, whose name tells you as little about it as most people's names, and which includes illegitimates and second cousins twice removed as well as central, key, members.

At the end of the unit you will find a list of recommended reading. A great deal has been written about Cubism but, you may be pleased to know, there is not a lot that is really of great value. Where I refer to books included in the list, I use a short form consisting of author and year with a page reference when appropriate.

The Heroic Age

The decade preceding the 1914–18 war is sometimes called the heroic age in modern art. Important movements brought lasting changes; great individual artists became known; issues were raised that matter to this day. Edward Fry considers those years 'one of the golden ages of Western civilization' and offers in evidence this list of illustrious individuals, non-artists as well as artists:

> It was a period which saw the emergence of Mann, Proust, Apollinaire, Gertrude Stein; of Gropius and Frank Lloyd Wright; of Stravinsky and Schoenberg; of Planck, Rutherford, Einstein, Bohr; and of Croce, Poincaré, Freud, Bergson, and Husserl. In painting and sculpture these same years produced Matisse, Picasso, Braque, Gris, Léger, Delaunay, Duchamp, Mondrian, Malevich, Kandinsky, Brancusi, Archipenko, Boccioni, and Lipchitz, to name only the most prominent of a brilliant galaxy of artists.
> (Fry, 1966, p. 9.)

I would want to add Joyce and Klee (and Frank Lloyd Wright emerged sooner, even if his international fame dates from those years). More important, I often think that, from the point of view of art at least, the 'heroic' label should be stretched to embrace the first quarter century and thus include Russian Constructivism and Dutch *De Stijl* and their fusion in 1920s Germany, as well as Dada and Surrealism. This would also enable us to include the first really substantial incursions of the new art's methods and images into the socially effective media: photography, film, advertising, typography, etc. All these together can be said to make up the platform that has served art to this day.

Fry's list reflects a Paris-centred view of art which is common and hard to avoid. Paris easily dominated nineteenth-century art and became the almost undisputed Mecca for ambitious artists, replacing Rome. It offered a concentrated support system of public and commercial galleries, societies and exhibitions, official and private schools and studios in which to learn, critics and journals, and so forth. It functioned as a Mecca for modern art, for contributors as well as bystanders, even if the best patrons of the avant garde were to be found in Russia, Germany and America; and thus Paris continued to dominate until the Second World War, helped by the repression of modern art in Russia after 1922, in Germany after 1933 and to some extent in Italy.

Tradition and Change

The nineteenth century had readily associated change with progress. But art does not progress; it egresses rather, it tends peripatetically. While antiquity and the great masters of sixteenth-century Italy retained their authority there was a core of images and ideals by which an artist could orientate himself even if he did not want to emulate them closely. This authority was firmly questioned in the eighteenth century and we have seen it rejected or ignored from Baudelaire's time on. The image of the modern artist is that of one straining at the leash of tradition and on occasion snapping it. At times a lot of barking at tradition goes with that but usually it is the idolization of tradition that is at issue and the lip service that seemed to be all the academies had to offer to it.

There was a hunger for change and an impatience with the burden of the past. Hoarding the past had spread from the aristocracy to the middle classes; monuments embodied it everywhere; museums and libraries enshrined it. The move from one millennium into the next seemed to bring with it a consciousness of how far the western world, at least, had travelled from the past it gave so much attention to. Urban industrial life; rapid, often dramatically public, developments in technology; political and social unrest and a monstrous war. There were also new explanations of man's inner and outer world. A swelling chorus had for some time been announcing the death of God with varying degrees of satisfaction. Some, like Nietzsche, spelled out the implications of that news in thrilling terms; others, like Sir James Frazer (*The Golden Bough* in two volumes 1890, in twelve volumes 1911–15) were presenting early religions and societies as eloquent artefacts and thus supporting a relativist attitude to religions that led many into sampling exotic spiritual systems. Meanwhile scientists were offering radically new explanations of the material world, and the psychologists offered man a view of himself that could not fail to leave him questioning the imperatives on which the Victorian views had been based.

Artists are probably of their nature attuned to change. Since the Renaissance, at least, ambition has meant the desire to make a personal contribution to art and to have it recognized. Institutions, on the other hand, are proverbially resistant to change ('Institutions are like snow drifts', said Thoreau; 'They occur where there is a lull in the wind'), and the art academies were institutions dedicated to upholding standards embodied in past achievements. The story of the young artist going through an academic training only to find that he has to jettison most of what he was taught, recurring in the nineteenth century, becomes a platitude in the twentieth – so much so that it is necessary to warn against seeing it as a predictable and painless process. What can it feel like to abandon, say, commended skills in drawing the figure (such as Picasso and Klee had) in order to engage in pioneering activities that almost everyone will condemn?

We tend to study the history of modern art in terms of movements, and what I have said suggests some of the reasons why artists tended to group in various ways. The labels that these groups invented or acquired, misleading as they often were, became banners by which other artists could orientate themselves. I must warn, though, against seeing the history of modern art as a succession of such movements: they often overlap in time; their ideals and their membership change; some artists manage to belong to two or more, even apparently contradictory ones; some movements, like Futurism, were fairly firm groups with a more or less definable aim; others, like Expressionism, were at best a broad tendency embodying only the vaguest common ideals; most of them, with Cubism as a good example, will reveal quite a gap between what its originator did, what the wider membership did in consequence, and what the wider world thought they were doing. Also, to concentrate on movements means

disregarding the artist who stayed out of them and also the often magnificent work done by leading artists after the movements that centred on them have broken up.

The theories and slogans associated with a movement rarely fit it exactly or for long. Manifestoes and other public statements of that kind are made at a particular moment and are rarely even intended as the objective explanations they are taken for. They tend to express an ambition and an intended direction rather than define what has been achieved, and their immediate purpose is often that of distinguishing a group's position from that of predecessors or rivals. My impression, from observation of contemporaries as well as from studying the past, is that programmatic clarity is a fiction, and that artists proceed tentatively, rarely looking beyond the present work and the next, and that when asked to explain themselves they are likely to nominate goals that they had not needed to determine for their own purposes. When what an artist says is clear and helpful we seize on it—especially when it supports or extends our understanding—and thus we are in danger of stressing statements that may not be as central to the artist himself as we should like them to be. It is his work that we must give our chief attention to and against which we must always check any theories or interpretations.

Our greatest burden is hindsight. As historians it is our task to make something significant out of the clutter of evidence we call the past. That means selecting, emphasizing, interpreting. It is a creative process and one we need not be ashamed of but it becomes dangerous (and dull) the moment we consider it finished. The moment history sounds pat the time has come to unravel the stuff it is knitted and spun from and see whether it couldn't produce a better outfit. At the same time, we have to formulate our ideas at the risk of making them sound more final than they are. Most of all, however we phrase things, we are going to make the artist sound more of a programmed operator than he is likely to be. Bear this in mind. The most obvious instance is when we speak of an artist's development. *He* did not set out to go from A to B. He may have stopped at many places on and off the route; on the other hand, he may not and yet have meandered and backtracked repeatedly. I cannot think of a work of art that was the necessary, logical consequence of what preceded it. Yet we are likely to make it sound so because what continuity we can find and demonstrate will reflect his underlying concerns.

When Picasso showed his friends a large, unfinished painting later to be known as *Les Demoiselles d'Avignon*, he did not announce: 'Look, I've invented Cubism'. But I am certain he knew that he was doing something new and dangerous and possibly all wrong, something to himself as yet uncertain and elusive and to them, it appears, thoroughly odd and nasty.

An Outline of Cubism

You should have read by now, or now read, pp. 235–64 in Hamilton. I should like here to pick out very briefly a few cardinal points. The name 'Cubism' arose accidentally and tells us next to nothing about the artists' intentions, but of course it influenced people's interpretation of what this art was about; it created expectations and was likely to attract or repel to or from the work itself. The terms 'Analytical Cubism' and 'Synthetic Cubism' were Juan Gris's invention; I shall use them to set into contrast two processes in the work of Picasso and Braque that they would not have wanted to see as separate or opposed. Picasso and Braque slowly created Cubism; when Cubism became a movement, i.e. appeared before the public complete with label in 1911, it was not their work that was manifested but that of five others (see Hamilton, p. 258). When thirty Cubists exhibited together in 1912, Picasso and Braque were not among them (see Hamilton, p. 261). Two of those thirty, Gleizes and Metzinger, in the same year published the first manifesto of the movement, *Du Cubisme*. Chipp provides a translation of most of it (pp. 207–16), and you'll notice from his footnote (p. 207) that the 25 illustrations in that book include one Picasso but no Braque. To see *their* work at this time, one would have had to go to their studios or to the gallery that a young German, D. H. Kahnweiler, had opened in Paris in 1907. Relatively few people did either, and so the public image of Cubism in those years, in Paris and elsewhere even more, was that offered by the others. 1911–12 saw Cubist works exhibited in Germany (Munich, Cologne, Berlin), Zurich, Moscow, London and Barcelona. 1912 saw also the European debut of Italian Futurism: the exhibition that started in Paris in February went on to tour (sometimes in modified form) twelve European cities plus Chicago. Since the Futurists adopted some of the main pictorial methods of Cubism their campaign helped to propagate these even if the context was different. By 1914 Cubism represented a bewildering diversity of work and ascribed aims, studied and reacted to all over the western world. The war interrupted and even terminated many an artist's career, and brought a partial hiatus to art activities at large. The post-1918 years saw something of a retreat from avant-garde positions, especially in Paris. But Cubism continued in various forms and for various purposes, some characteristics of it finding application in 1920s decoration (Art Deco) and others providing the idiom for a chastened and disciplined version of the style, Purism (Hamilton, pp. 267–69).

Hamilton provides a good account of Picasso's origins and early work on pp. 140–46 (very properly under the heading 'Symbolist art in Spain'); see also plates 155–59 in Haftmann. The words (Hamilton, p. 141) 'emotionally rewarding' can serve to highlight Picasso's inclinations in those years. There was much he shared with his Barcelona friends, and Paris offered him a host of experiences, but it must be stressed that Picasso's work of those early years was intensely original even if it warrants the label 'Symbolist' and also remains within relatively easily accessible areas of descriptive and narrative representation. Had he died in 1906 at the age of 25 (instead of in 1973 at the age of 92) he would be remembered as a poetic painter of bitter and of bitter-sweet pictures portraying the life of the poor and the rootless. We might have been left wondering about what would have been his last paintings, works like *La Coiffure* and the *Self Portrait* (Haftmann 158 and 159), and also the *Two Nudes* (Fig. 1; all 1906). A change of direction, clearly, but towards what? A clumsy classicism? The emotional content seems to have gone almost entirely and the figures have taken on a statuesque solidity they rarely had before. Picasso's biographers tell us of his visit, that summer, to the Spanish Pyrenees and the calming effect that had on him, and also of his interest in Iberian (i.e. pre-Roman Spanish) stone carvings put on show at the Louvre earlier in the year. These may have suggested the firm, curving planes of his heads and the large, clearly rimmed eyes. At the same time painters in Paris were becoming intensely conscious of the work of Cézanne, which could also be described as aiming at a clumsy sort of classicism (see below).

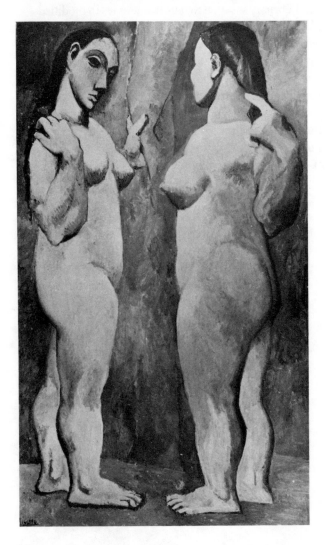

Figure 1 Pablo Picasso, *Two Nudes*, autumn 1906, oil, 24¾ × 18½ ins (Collection G. David Thompson, Pittsburgh; photo: James H. Flude © SPADEM 1975).

In any case, Picasso's career did not end in 1906. Late that year he bought an exceptionally large canvas, had it specially lined for extra permanence, made a series of preparatory studies and then, with (as a friend recorded) a lack of his normal youthful enthusiasm, started to work on the painting itself. He was to abandon it, unfinished, some time around the middle of the following year. He has himself said that one of the studies (Fig. 2) shows a sailor seated amid naked women and a man entering left, bearing a skull. At that stage, then, he was envisaging a painting in which the traditional *memento mori* (reminder of death) intruded on a scene of carnality. Picasso's friends nicknamed the picture 'The philosophical brothel'; *Les Demoiselles d'Avignon* was invented later, probably by Louis Aragon, the poet, in reference to Avignon Street in Barcelona, the heart of the port's red-light district.

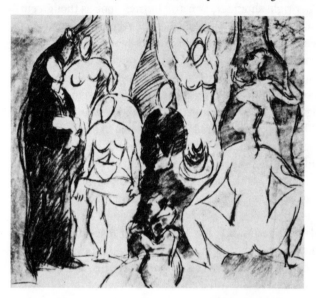

Figure 2 Pablo Picasso, Study for *Les Demoiselles d'Avignon*, 1906/7, pencil and pastel on paper, 19 × 25½ ins (Artist's collection © SPADEM 1975).

Exercise

Now study Plate 1 very carefully, and ask yourself the following questions. (You may find some sort of adaptable questionnaire-in-the-head useful on other occasions, as a means of focusing on a picture and distinguishing its particularities. I also find that these stand out when one makes an apt comparison. In this case, it may help you to use Picasso's *La Vie* (1903; Hamilton Fig. 69) in this way. Try to observe what is actually there in the picture you are studying, in so far as reproductions allow. The painter has arranged paint on canvas; he has chosen not to arrange it otherwise. That arrangement is the factual basis of your study. It will produce subjective reactions in you, and you may be suspicious of those, but those that are produced by the picture and not by assumptions and prejudices unrelated to it, are part of what the painter is offering and are of significance.)

1 What is the general character or 'feel' of the painting?
2 What is the subject of the picture?
3 How are the figures presented?
4 What sort of space are they in?
5 How is the whole organized in terms of colour?

Discussion

My answers would be as follows:
1 Very uncomfortable, both in terms of the images put before me and the manner in which they are shown.
2 Female nudes, displayed as though for my pleasure (and thus suggesting the ancient tradition of images that combine bodily dignity and sexuality) but made repellent. The food still life likewise. What other information there is suggests an indoor setting but I am more aware of a general restlessness: the figures are ungrasp-

able and the space is unusable. Although nothing particular seems to be happening, the scene appears to be one of emotional crisis.

3 Their outlines are established mostly by straight or tautly curved lines, sometimes silhouetted by tonal contrast, sometimes not. This gives them a certain flatness. Within the outlines changes of form are indicated mostly by line rather than modelling, though the sharp hatching on the breast of the standing woman on the right and the more gently indicated plane across the chest of the woman entering on the left suggest another way of modelling form without actually suggesting solidity. The three standing figures on the left are, all in all, reasonably proportioned (except for that foot and the dislocated hand holding back the curtain). The two women on the right are more obviously distorted, especially the seated woman who seems to have been opened out like a kipper: her right shoulder, arm and buttock look as though cut from one plane; her other arm and hand are so distorted as to be recognizable only from their context. The five faces belong to two or three distinct types. The two central faces, linear and caricaturish, are exaggerated variations on the Iberian type Picasso had used, for instance, in his *Self Portrait* (Haftmann 159). The head on the left is related to these but has a sculptural feel that recalls one of the heads in *Two Nudes* (Fig. 1). The head top right, in some ways similar to the last, appears as an emphatically sculptural mask while that of the seated woman seems to be a drawn (rather than sculpted) and dislocated version of it. The two sculptural heads stress, by contrast, the lack of mass and weight in the rest of the painting.

4 Only the entering woman's foot has usable pictorial space. (It looks as though Picasso was thinking of enlarging it; that would have meant reducing the sense of space.) The placing of the figures, clear enough in the two-dimensional sense of composition, is not understandable in terms of space. What hint of space there is is both given and denied by the flickering draperies that at times seem to press out towards us. We cannot guess the distance between the different curtains, nor the space between, say, the precariously hovering still life and the emphatic foot. There is no directional lighting to provide shadows and thus to tell us about masses and intervals.

5 The colour is concentrated, so to speak, into two elements: warm (brown, pink and yellowish flesh tones) and cold (the blue, grey and white of the draperies). This makes for a kind of clarity which is then denied by the use or abuse of form and space.

I must go on to summarize, very briefly, the most important factors that seem to have affected this painting. (In my first draft for this unit, they threatened to use up all the space available, so please allow for compression and omissions. It is the diversity of considerations that make this, in many ways terrible, picture so fascinating, and because the influences it records are in many cases those that were beginning to, or about to, affect other painters too it is the key work we are treating it as. At the same time, any intelligent, enquiring artist's mind gathers material ceaselessly and from all sorts of sources; he is also affected, consciously as well as unconsciously, by his professional and personal environment.)

1 Tradition A large painting of nudes points to the classical tradition recreated in the Renaissance on the basis of ancient sculpture and much admired as well as debased in the nineteenth century. Picasso's fearsome manner contradicts its pleasurable connotations. In the last decades of the nineteenth century the Symbolist poets and painters had made much of woman as a delicious and loathsome trap.

2 Cézanne Cézanne's reputation had been rising among young artists since 1895 when the dealer Vollard put on a one-man show of 150 works. Cézannes were shown in the Salon d'Automne in 1904 (33 works), 1905 (10) and 1907 (56: a memorial exhibition following Cézanne's death); 1907 also saw a show of 79 watercolours at the Galerie Bernheim-jeune. In October 1907 successive issues of the *Mercure de France* published the letters Émile Bernard had received from Cézanne (see Chipp, pp. 18–22 for excerpts). In effect, Cézanne's influence was becoming dominant with the avant

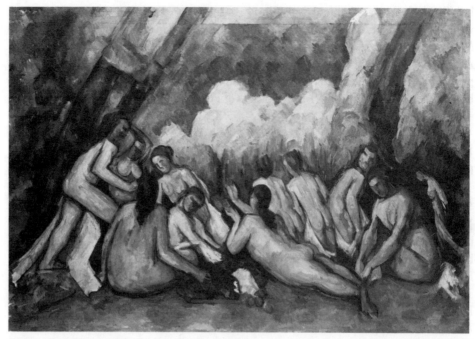

Figure 3 Paul Cézanne, *The Bathers (Les Grandes Baigneuses)*, ? pre-1905, oil, $50\frac{1}{8} \times 77\frac{1}{8}$ ins (National Gallery, London).

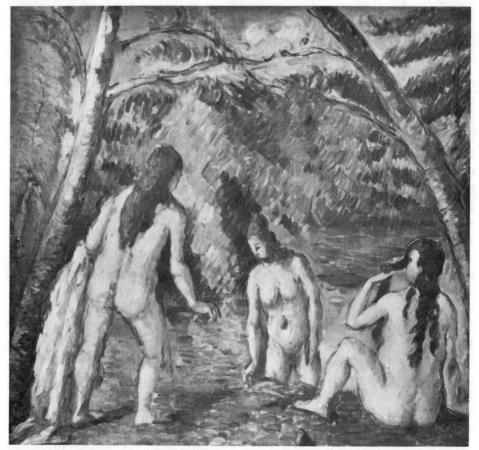

Figure 4 Paul Cézanne, *Three Bathers*, *c.* 1880, oil, 21×20 ins (Petit Palais, Paris; photo: Bulloz).

garde, overshadowing Gauguin's and Van Gogh's.

(a) Cézanne's figure paintings: Throughout his career Cézanne had given much time to drawing and painting figure subjects, but especially so during the years around 1900. The three large paintings of *Bathers* (National Gallery, London, Fig. 3; Philadelphia Museum of Art, Hamilton Fig. 14; and Barnes Foundation, Merion, Pennsylvania) attracted especial attention as independent ventures into an area

heavily worked by academic artists. The years 1905 to 1910 witnessed something of a wave of monumental figure painting by ambitious young and youngish men (notably Matisse, Derain, Léger, Duchamp and Picabia as well as Picasso and Braque). The *Demoiselles* is in good part a response to Cézanne. The seated woman on the right is probably related to the seated woman in the small Cézanne *Three Bathers* Matisse had bought from Vollard in 1899 (Fig. 4); others of Picasso's figures recall Cézanne also.

Exercise

I suggest that you compare the Picasso with the Cézannes both for specific echoes and for their more general similarities and also differences.

Discussion

My feeling is that the Picasso is in almost every respect contradictory to the Cézannes, in spite of specific debts. I presume intentionally so. The old man had been reaching back to the roots of classicism and trying to ignore the conventions of traditional figure drawing in order to achieve the deepest and warmest union between figures and landscape (and also between his pictorial forms and his personal experience). Picasso was intent, increasingly as the work proceeded, on disharmony. The *Demoiselles* are ungraspable, unlovable. There is no conviviality, only separateness. Instead of benign nature naturally inhabited, an unknowable, unpossessable interior peopled with stripped townswomen. At the same time, Picasso's homage to Cézanne is implied in his open borrowing of important methods, such as the use of a strong, statuesque figure on the left, the omitting or eliding of hands and feet with rare and very effective exceptions, and the contracting of the colour range into a warm and a cool group.

(b) Cézanne's words: Two of Chipp's excerpts are especially relevant here. In his letter of 15 April 1904 Cézanne made his most often repeated statement: 'May I repeat what I told you here: *treat nature by the cylinder, the sphere, the cone*, everything in proper perspective so that each side of an object or a plane is directed towards a central point.'[1] The words here italicized reappear frequently in modern art and design writing, often with the word 'cube' slipped in or implied. Cézanne did not use the word 'cube' here, nor did he use it in a similar statement recorded by Bernard and published in Cézanne's lifetime with his explicit approval: 'Everything in nature is modelled on the sphere, the cone and the cylinder. One must learn to paint from these simple forms; it will then be possible to do whatever one wishes.' (*L'Occident*, July 1904. See the Northern Arts & Arts Council, 1973, for a translation of almost the entire article.) The somewhat cubic forms that Provençal houses assume in his land-scapes (and indeed actually have) and those brushstrokes in Cézanne's pictures, most evidently in his late watercolours, that make rectangular patches of colour, appear to have encouraged the world to assume that Cézanne omitted 'cube' by an oversight. But that omission may be the most significant thing about his words. At any rate the invitation to see nature in terms of the main regular solids is familiar from the fifteenth century onwards and was repeated by many a nineteenth-century instructor. (Such as Lord Clark's teacher at prep. school: ' "It's all based on the cube, sonny", he used to say, "the cube, the cone and the cylinder." ' See Clark, 1974, p. 54.) In his letter of 12 May 1904 Cézanne warned the artist to 'beware of the literary spirit which so often causes painting to deviate from its true path—the concrete study of nature—to lose itself all too long in intangible speculations'. We have seen that Picasso already seemed to be reducing the symbolic and anecdotal burden of his painting and in the *Demoiselles* excised the symbolism indicated in the preparatory sketch. (Cubism, we shall see, is markedly lacking in literary content—at any rate until it goes on to a characteristic extreme in introducing actual writing into the picture.)

3 *Matisse* By the time he embarked on the *Demoiselles* Picasso was beginning to be seen in Paris as chief claimant to Matisse's position of leader of the avant garde. In the

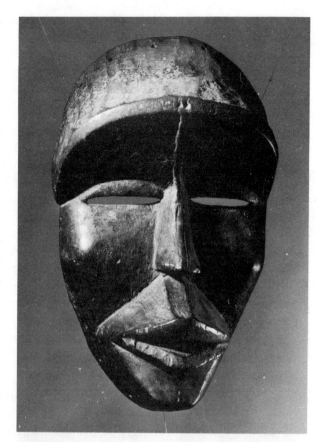

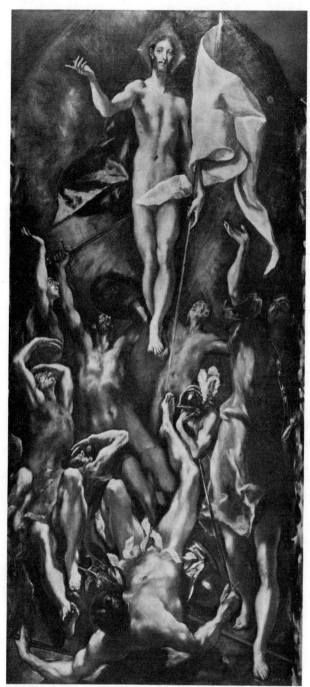

Figure 5 El Greco, *Resurrection of Christ*, *c.* 1600–5, oil, 108¼ × 53 ins (Prado Museum, Madrid).

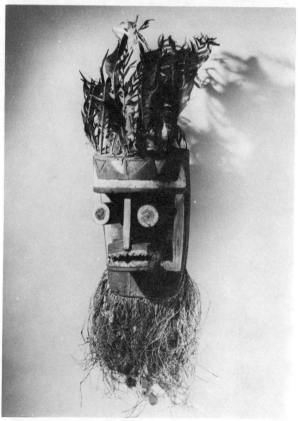

Figure 6 Upper: Wooden mask, Dan, Ivory Coast, 10 × 7 ins; lower: Wobe ceremonial dance mask, Sassandra, Ivory Coast, painted wood with feathers and grasses (Collection Musée de l'Homme, Paris).

spring of 1906 Matisse exhibited a large painting at the Salon des Indépendants. *Joie de vivre* (Haftmann 51) is a lyrical picture, suggesting the joys of a Golden Age through images of relaxation and delight. The Picasso is an even more aggressive counterstatement to this than it is to the Cézanne; it is also striking that the two central women in the *Demoiselles* are drawn in a manner close to Matisse's while the

woman with her arms raised behind her head could be taken to be a caricature of the blithely seductive girl to the left in the Matisse. Had all the *demoiselles* been portrayed in this manner, the whole painting might have looked like an intended affront to Matisse. As it is, we are told that Matisse was angered by the *Demoiselles* and saw it as 'an attempt to ridicule the modern movement' (Penrose, 1958, p. 125).

4 El Greco The Cretan-Venetian-Spanish painter El Greco (1541–1614) stands apart from tradition both for the idiosyncratic character of his art and because, until the end of the nineteenth century, he was almost entirely forgotten. The first solid monograph on his work appeared in 1908, preceded by two smaller studies. In the 1890s a monument to the painter was erected in Sitges; Picasso and his Barcelona friends sought out his work during the same years and in 1901 Picasso went to Toledo to see the El Grecos there. By 1908 El Greco was being seen as a forerunner of of modernism: at the Salon d'Automne that year 21 El Greco paintings were shown in a modern-art context. The verticality of Picasso's composition and the general zig-zagging of its main lines, as well as the flickering of his curtains, suggest aspects of El Greco (Fig. 5). But the most patent quality in El Greco's art is his readiness to distort appearances and also to give anti-naturalistic tension to entire compositions in order to produce an intensely emotional effect. Picasso's earlier work reflects this in several paintings; here, in the *Demoiselles*, it takes its last bow.

5 African sculpture We can accept as certain that Picasso painted, or repainted, the two heads to the right in the *Demoiselles* (and perhaps altered the head to the left) after seeing African masks in the ethnography section in the Palais du Trocadéro in 1907, in Matisse's studio and possibly elsewhere. (The Trocadéro's ethnography section and its anthropology gallery were subsequently combined into the famous Musée de l'Homme in the Palais de Chaillot. Figure 6 shows two masks that Picasso may have seen then; Chipp's 1908 photograph of Picasso (p. 200) shows two Melanesian sculptures he had acquired by then; his photograph of Braque in about 1911 (p. 261) shows two Gabon masks one of which is illustrated in Fig. 7.)

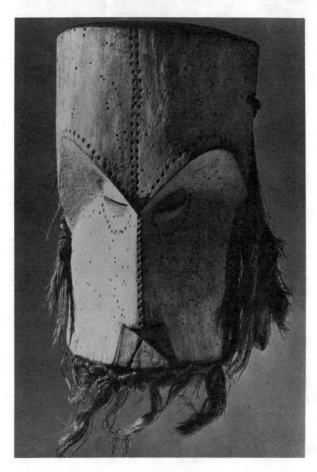

Figure 7 Fang Mask, Gabon (Collection C. Laurens, Paris).

Figure 8 Pablo Picasso, *Nude with Drapery*, 1907, oil, 61½ × 41 ins (Hermitage, Leningrad; photo: Giraudon © SPADEM 1975).

We are not certain in what spirit Picasso introduced these jarring elements into his large painting. It is reasonable to assume that he set out to repaint all the heads, and perhaps the whole picture in an idiom congruous with the heads. Did his friends' negative reaction to the unfinished painting make him drop the idea? The result would have been shocking but not perhaps as shocking, or as lastingly shocking, as the incongruity of having conflicting idioms in the same picture. A *Nude with Drapery* of 1907 hints at how the *Demoiselles* might have turned out and was possibly done as a study towards the large painting (Fig. 8): flat, sharp but rhythmical forms, delineated by means of long curves and hatched with bold brushstrokes to suggest distance and projection rather than to indicate volume.

Picasso was not, of course, the first to introduce primitive images and forms into

17

European art. What is remarkable is that, unlike Gauguin, he was doing so without adopting (however superficially) any aspect of the cultures that produced these forms. Today this may seem like exploitation. Artists such as Derain, Matisse and Vlaminck were collecting African sculpture and showed some consciousness of its context. Picasso, who here seized on its forms for his own purposes, did not. Gertrude Stein says something in her little book on Picasso that may have more sense in it than at first appears (she may be echoing something Picasso said to her):

> After all one must never forget that African sculpture is not naive, not at all, it is an art that is very very conventional, based upon tradition and its tradition is a tradition derived from Arab culture. The Arabs created both civilisation and culture for the negroes and therefore African art, which was naive and exotic for Matisse, was for Picasso, a Spaniard, a thing that was natural, direct and civilized.
> (Stein, 1959, p. 22.)

In any case, is it all right for him to make free use of ancient Iberian sculpture but not of relatively recent African sculpture? Picasso's later career proves that it was an essential part of his creative fluency that all artefacts, and equally any material, could serve his art. In any case, his generation's recognition of the artistic potency of many forms of so called primitive art has radically and permanently altered our understanding of objects which until then were studied only for anthropological purposes.

Among the people to whom Picasso showed the unfinished *Demoiselles*, late in 1907, was the painter Georges Braque. See Hamilton, p. 237, on Braque at this time; I think it is reasonable to say that when Apollinaire brought Braque to Picasso's studio, Braque was already experiencing some doubts about Fauvism. He had seen the Cézannes at the Salon d'Automne and, in June, at Bernheim-jeune and was modifying his Fauve manner towards something more solidly constructed in the Cézanne manner. Braque is reported to have reacted to the Picasso with horror; he commented that 'it is as though we are supposed to exchange our usual diet for one of tow and paraffin'. In fact, all recorded reactions were totally negative. The painting stayed in Picasso's studio until it was bought by a Paris collector in 1920. It was reproduced, almost by chance, on a very small scale and with the caption 'Study by Picasso' in a flippant article on avant-garde painting in Paris written by an American, Gelett Burgess, and published in *The Architectural Record* in May 1910, but then not again until Gertrude Stein's little book on Picasso came out. The painting was exhibited in the Petit Palais in 1937 and acquired by the Museum of Modern Art in New York in 1939.

How Cubist a painting the *Demoiselles d'Avignon* is must depend on what we consider Cubism essentially is. Three relevant quotations:

1 Cubism was an art of realism and, in so far as it was concerned with re-interpreting the external world in a detached, objective way, a classical art. The first impression made by the *Demoiselles*, on the other hand, is one of violence and unrest . . . But it is incontestable that the painting marks a turning point in the career of Picasso and, moreover, the beginning of a new phase in the history of art.
 (Golding, 1968, p. 47)

2 The radical quality of *Les Demoiselles* lies, above all, in its threat to the integrity of mass as distinct from space.
 (Rosenblum, n.d., p. 25)

3 *Les Demoiselles d'Avignon* may be called the first cubist picture, for the breaking up of natural forms, whether figures, still life or drapery into a semi-abstract all-over design of tilting shifting planes compressed into a shallow space, is already

cubism; cubism in a rudimentary stage, it is true, but closer to the developed
cubism of 1909 than are most of the intervening "Negro" works.
(Rubin, 1972, p. 42)

My preference is for the first view. However much in the painting resembles aspects of
what Picasso and Braque were to do in works which are central to Cubism, as a whole
it is quite unlike those in character and intention. The 'integrity of mass' is already
negated when representation is as two-dimensional as this; in the *Demoiselles*
mass is denied rather than broken into. And when this two-dimensionality is dis-
turbed by 'tilting shifting planes' this seems to be an isolated event rather than a way
of interpreting reality and finding a new pictorial structure.

Towards Cubism

There follows a short but busy transitional period during which painting might have gone in many different directions, but at the end of which we find Picasso and Braque ('rather like two mountaineers roped together', Braque said later) working mentally and, for a time, physically in close proximity and producing fully Cubist works in such accord that it can still be difficult to tell the Picassos from the Braques.

Braque had been shocked by the *Demoiselles*, but in December 1907 began to work on a figure painting that amounts to a positive response to it. Together with an associated drawing his *Nude* (Fig. 9) proves his abandoning of the colouristic and temperamental concerns of Fauvism in favour of constructive issues focusing on the handling of form and space. The drawing (Fig. 10; Braque gave it to Burgess who mocked and re-

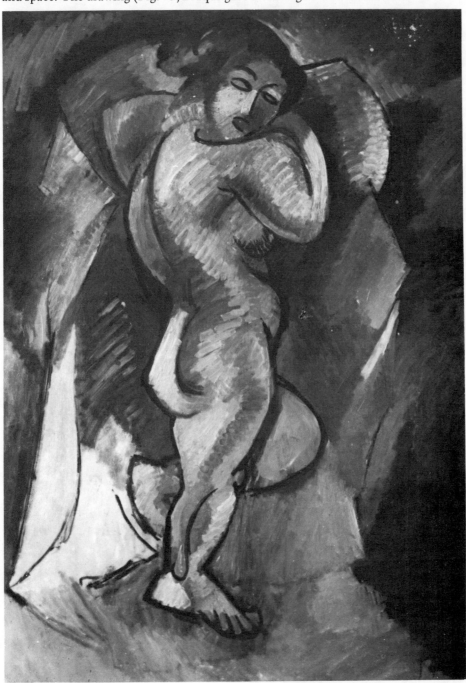

Figure 9 Georges Braque, *Nude (La Baigneuse)*, 1907/8, oil, 56 × 40 ins (Cuttoli Collection; photo: Galerie Louise Leiris, Paris © ADAGP 1975).

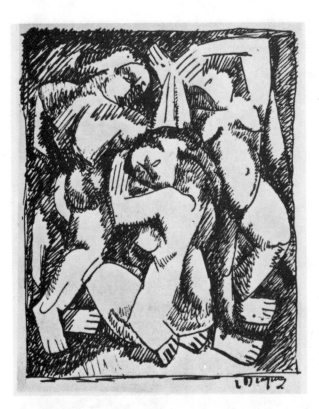

Figure 10 Georges Braque, *Three Nudes, c.* 1907, pen and ink (Present whereabouts unknown, *Architectural Record*, May 1910 © ADAGP 1975).

produced it in the 1910 article referred to above—its subsequent fate is unknown) shows three nudes in complementary poses, arranged to fill an area and thus giving the design a relief-sculpture effect and mitigating the primitiveness of the bodies by means of the neatness of the design. The painted figure is a development of one of these, and less harmonious. She is delineated with firm lines and partly modelled with hatching strokes that give some solidity and weight. The body is painted in ochre and is posed against blue drapery that hangs vaguely before some uneven brown ground. There is little sense of space. The broken background and the drapery seem to bear the figure towards us and she seems to hover above the green brushstrokes that imply grass.

In the summers of 1908 and 1909 Braque painted landscapes at two sites associated with Cézanne, L'Estaque near Marseilles and La Roche Guyon in the Seine valley. These are now unambiguously related to Cézanne. The colour concentration, the formal emphasis on cubes and cylinders, the diminution of this emphasis by means of breaks in the forms and linking passages to adjacent areas and also by the ambiguous use of tone—so that in the end the effect is painterly rather than sculptural—all these things speak of Cézanne. What Braque does not attempt is Cézanne's high-wire compromise between the demands of the motif and those of the pictorial construction. Braque does not seem concerned with finding a pictorial vehicle for a complex and passionate apprehension of a subject; he is content to make a pictorial image that conveys a pictorial satisfaction. Like Picasso, he is willing to subdue the motif, apparently valuing it principally as a pretext for building a picture; unlike Picasso at this time (though he will influence him in this respect) he likes a well carpentered, well rounded composition.

Haftmann illustrates three such landscapes (154, 174 and 176). Hamilton illustrates a *Harbour in Normandy* that was painted in the studio early in 1909 (Fig. 132). This painting and *La Roche-Guyon, the Chateau* (Fig. 11) show less emphatic forms and a gentler faceting. Slanting patches of contrasting tone break up the surface of the picture and almost cancel out what spatial effect is left by the main elements in the subject. It was in 1908 that Braque found his work rejected by the jury of the Salon d'Automne and described as consisting of little cubes (see Hamilton, p. 238). This, as

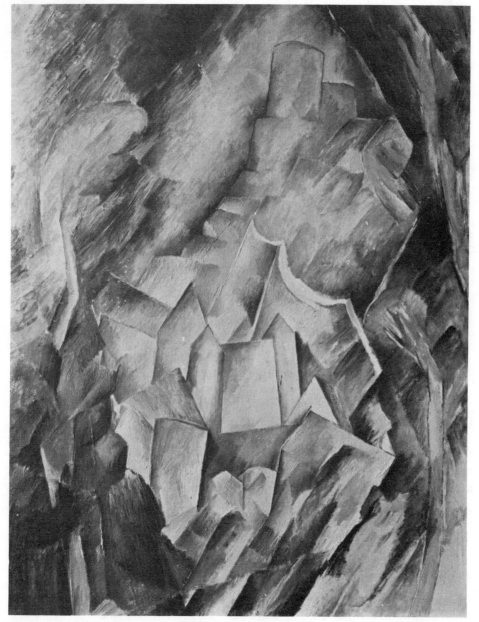

Figure 11 Georges Braque, *La Roche-Guyon, the Chateau*, 1909, oil, 32 × 24 ins (Stedelijk 'Van Abbe' Museum, Eindhoven; photo: Martien Coppens © ADAGP 1975).

is always stated, was the origin of the name Cubism. Was it also the reason for Braque's pronounced move away from stereometric effects?

The years 1908–9 also see Braque turning to still life painting. Landscape had been his preferred subject, as figure painting had been Picasso's, but now still life becomes dominant (and remains so for the remainder of Braque's life). Still life is the genre that permits the greatest possible control of the motifs; it also, I suspect, permits a much greater degree of freedom in that representation can depart further from direct transcription than it can with figure painting before the effect becomes emotional and possibly distressing. Three Braque still lifes of this period will demonstrate his development. *Still Life with Fruit Dish and Plate* (Fig. 12) is close to Cézanne but looser and less physical (thus closer to Cézanne's watercolours than to his paintings). *Guitar and Accordion* (Fig. 13), his first group of musical instruments, was painted out of his head cund has an almost heraldic clarity and flatness. *Piano and Mandola* (Fig. 14) shows an emphatic faceting and dislocating of forms and announces the arrival of fully fledged 'Analytical Cubism' (this term will be discussed below). Haftmann illustrates a companion piece to this picture, *Violin and Palette* (178; also Hamilton Fig. 132).

Figure 12 Georges Braque, *Still Life with Fruit Dish and Plate (Compotier, Serviette et Couteau)*, 1908, oil, 18⅛ × 21¼ ins (Private collection USA; photo: Galerie Louise Leiris, Paris © ADAGP 1975).

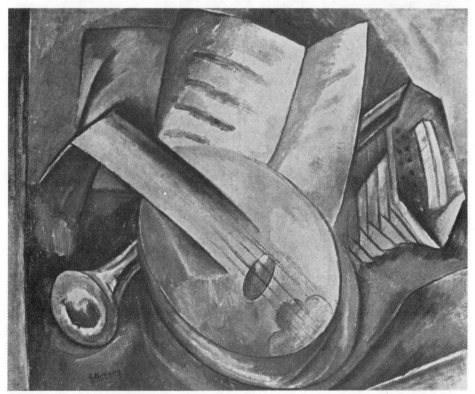

Figure 13 Georges Braque, *Guitar and Accordion*, 1908, oil, 20 × 24 ins (Private collection, Paris; photo: Louis Laniepce, © ADAGP 1975).

Even if this development—away from Cézanne and the seen motif—is made more obvious by hindsight, Braque's progress does seem to have been much more direct than Picasso's during the same period. He, to summarize it crudely, could not decide

between sculptural and painterly painting. His *Three Women* (Fig. 15) feels like a stone relief: the figures are much more solid in themselves, more tightly knit together, than in the *Demoiselles*; their planes, and those of the small areas of background and drapery, tilt this way and that with convincing sequentiality. The *Still Life with*

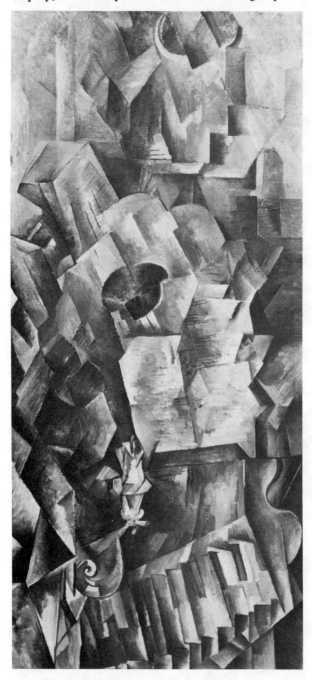

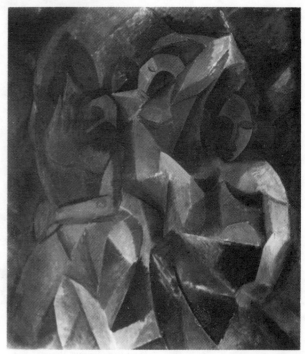

Figure 15 Pablo Picasso, *Three Women*, 1908, oil, 78¾ × 70½ ins (Hermitage, Leningrad; photo: Galerie Louise Leiris, Paris © SPADEM 1975).

Figure 14 Georges Braque, *Piano and Lute (Mandola)*, 1910, oil, 36⅛ × 16⅝ ins (Solomon R. Guggenheim Museum, New York © ADAGP 1975).

Carafe and Candlestick (Hamilton Fig. 133) is close to Cézanne's watercolours. Some of the forms seem sculptural at first, but most of them contain elements that contradict one's attempt to read them as solids; the carafe is itself a transparent object, and Picasso picks on the contradictions presented by that fact in a way that is typical both of him and of mature Cubism. At the same time one feels, with him as with Braque, that his emotional attachment to the motif is much less than Cézanne's.

With Braque's example before him, and equally under Cézanne's influence, Picasso too painted landscapes (something he did very rarely during his long career). His manner in painting them is crisper than Braque's, so that the push-pull effect of his emphasis on geometrical solids and his concurrent denying of them by the use of inconsequential shadows and anti-perspective construction, is even more marked.

This is particularly clear in the landscapes he painted at Horta de San Juan (then also known as Horta de Ebro) in northern Spain (Fig. 16).

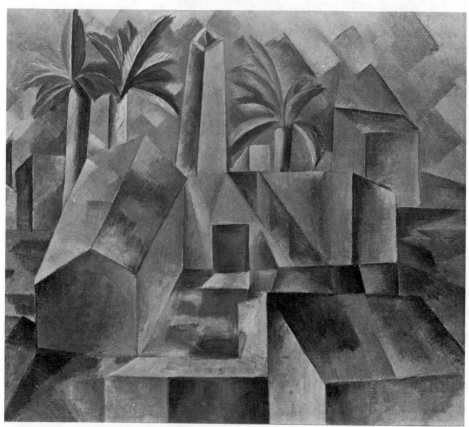

Figure 16 Pablo Picasso, *Horta de San Juan, Ebro : Factory*, 1909, oil, 21½ × 24 ins (Hermitage, Leningrad; photo: Giraudon © SPADEM 1975).

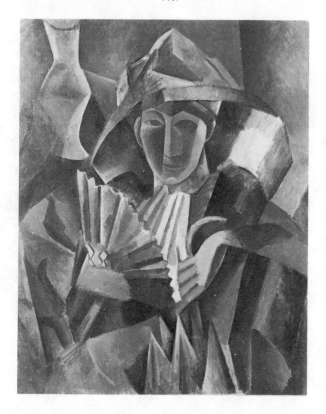

Figure 17 Pablo Picasso, *Woman with a Fan*, spring 1909, oil, 39½ × 32½ ins (Pushkin Museum, Moscow; photo: Giraudon © SPADEM 1975).

Picasso's most typical, and perhaps most revealing, works during this uncertain phase are found among his figure paintings. *Woman with a Fan* (Fig. 17), in colour not unlike Braque's *Landscape at L'Estaque* (Haftmann 154 as *Landscape*), has something

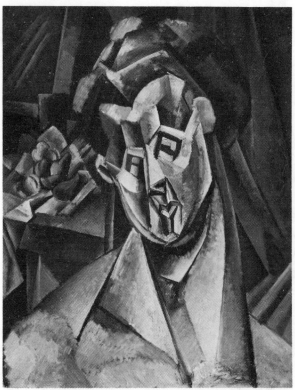

Figure 18 Pablo Picasso, *Woman with Pears*, summer 1909, oil, $36\frac{1}{2} \times 24\frac{1}{4}$ ins (Collection Museum of Modern Art, New York © SPADEM 1975).

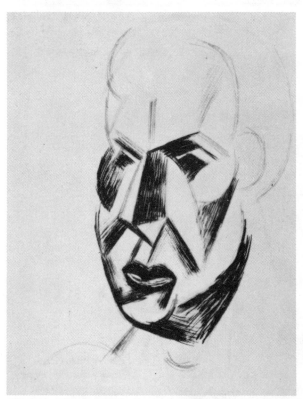

Figure 19 Pablo Picasso, *Woman's Head,* 1909, ink on paper, $25 \times 19\frac{3}{8}$ ins (Metropolitan Museum of Art, New York © SPADEM 1975).

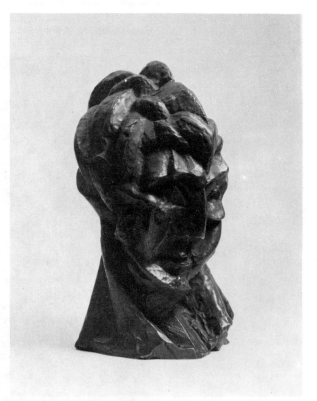

Figure 20 Pablo Picasso, *Woman's Head*, autumn 1909, bronze, $16\frac{1}{4}$ ins high (Collection Museum of Modern Art, New York © SPADEM 1975).

of the broken surface we have seen in Braque, but the face remains close to Picasso's Iberian/African mask synthesis and has a carved look that contrasts with the thinner and more brittle forms of the rest. (Notice also the zigzag form of the fan, echoed

closely in the stock at the woman's neck and more vaguely in other parts of the painting. Fan, accordion, steps: a formal motif to watch out for in Cubism.) The urge to dramatize the head through sculptural emphasis dominates a series for which Picasso's mistress Fernande was the model. Haftmann illustrates a portrait (164) in which the facial forms are tweaked and prodded into a rich and satisfying landscape of peaks and slopes. A more rigorously stereometric head is in *Woman with Pears* (Fig. 18), supported by a massive substructure. A drawing in the series (Fig. 19) further demonstrates his desire for a strong sculptural effect to be achieved without the traditional means, i.e. one-directional lighting and logical shadows. Picasso's shadows are contradictory and the lit portions tend to connect with each other (a device Cézanne used frequently) so that the three-dimensionality of the thing is hinted at rather than proven and one's reading of it is left in tension. Compare this drawing with the bronze head Picasso modelled at this time, closely related to *Woman with Pears* (Fig. 20, and see Hamilton Fig. 134 for another view). Here forms used am-

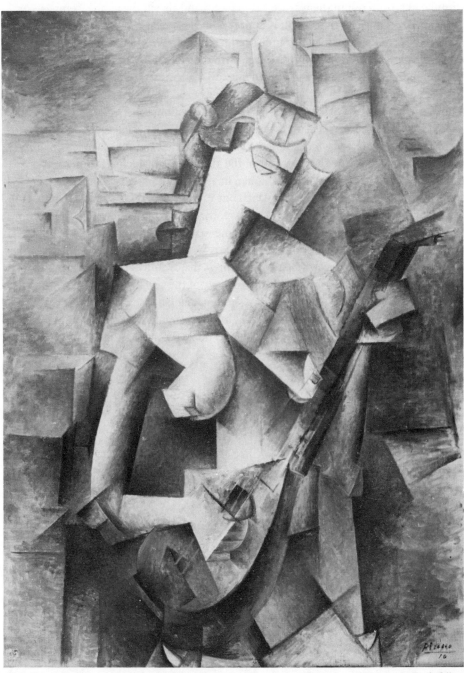

Figure 21 Pablo Picasso, *Girl with Mandolin*, 1910, oil, 39½ × 29 ins (Collection of Nelson A. Rockefeller; photo: Charles Uht © SPADEM 1975).

biguously in two dimensions are made three-dimensional fact. What do you think of the result? I'll return to the question of Cubism and sculpture later.

This urge towards relief effects created by tonal contrast appears in a significantly different form in *Girl with Mandolin* (early 1910; Fig. 21). Painted from a professional model, and probably posed in recollection of some of the Corot paintings of women exhibited at the Salon d'Automne in 1909, this is a gentle and reticent image in spite of all the sharp edges made by her body and the flattened-block look of her face. These relate easily to the background so that the total effect is one of rippling flatness rather than pronounced projection and recession; also the colours are fairly light and tonal contrast is moderate. Hair, breasts, elbow and guitar permit localized formal adventures that have a decorative and playful effect such as Braque too delighted in (see Fig. 14) and are very much part of both painters' fully developed Cubist idiom.

We have already seen musical instruments in Braque's paintings. Picasso too had used them before, most significantly in his Blue Period pictures, but I imagine that Braque stimulated his interest in them as well as in Corot and also in the gentle, semi-transparent relief effect that certainly appeared in Braque's paintings before Picasso's and fits one's understanding of Braque's temperament. The guitar was to become especially closely connected with Cubism, with the violin and the mandolin not far behind. Picasso and Braque both owned musical instruments of the kind; their frequent appearance in their paintings from now on suggests that they become a formal theme in the way that, as Lord Clark pointed out in *The Nude* (1970, p. 3), the naked body has been a *form* of art rather than a *subject* in the usual sense. We begin to recognize the fragmentary forms and the flat symbols that Braque and Picasso use to represent these objects with something of the alacrity with which attachment and experience teach us to recognize the human image in fragmented and abstracted signs. And there is a special sense in which one can know an object such as a guitar: it is inert and passive and we can memorize its forms and explore them without needing the object itself in front of us. At the same time we value it as potentially an expressive extension of man, a source of potent sounds and rhythms. Braque emphasized his consciousness that these instruments were things that would come alive through human touch. For Picasso, always the more likely of the two to be moved by personal and emotional association, the guitar was also the Spanish instrument *par excellence*. The Symbolist world of Barcelona had taught him to honour the guitar and its music as the voice of humanity in suffering and love, and its form as an image of woman.

Analytical Cubism

Exercise

The *Mandolin* of early 1910 and *The Portuguese* of a year later (Plates 2 and 3) are exceptionally fine Braques of the Analytical Cubist phase. Spend a few minutes comparing the two. What do they present?

Discussion

For the brief comments that follow I'll use (a) to designate *The Mandolin*, (b) for *The Portuguese*.

1 General effect Both tend to be 'all-over' paintings, meaning that (as in a lot of Impressionism and Post-Impressionism) the whole picture surface is activated to much the same extent by much the same sort of marks. In both cases you may note a tendency to fade the activity out a little towards the edges and particularly towards the top corners. In (a) this activity can be described as the apparent (but not too con-vincing) tilting of little planes; a sort of rippling of the surface by means of dark and light tones. In (b) the activity is two-fold, being determined by firm lines that usually, but not always, mark the edge of a plane, and also by the texture of pronounced brushstrokes, laid horizontally like soft brickwork. The composition of (a) is vertical/central: the emphasis is firmly on the centre of the canvas but there are subsidiary elements that attract our attention above and below, though not left and right. In (b) there are two major areas of attention: near the top, centre, where we may guess at a head, and near the bottom, half right where a whole cluster of emphatic planes support a guitar: there are also minor events, such as the bottle and glass shown in line to the left of the head and the rope to the right of the head, as well as the stencilled lettering, but the structure that shows through all this is roughly that of a tall triangle whose base is parallel to the bottom edge of the canvas and whose apex would come a few inches above the top.

2 Legibility How clear is the subject matter, even today and given the titles? (a) presents a shattered image of the musical instrument (the same as in *Piano and Lute*; the titles are not always accurate, tend to change, and frequently did not originate with the artist), seen as though through reeded glass but fairly legible. The motifs of (b) are more remote but could be guessed at by anyone at all familiar with Cubism: there are curves and straight lines to suggest the sides, sounding hole, neck and strings of the guitar; the face is less certain, and that he was a Portuguese is inside informa-tion. The bottle and glass suggest a drinking situation; the lettering, that could be part of notices on a wall, might imply a bar or café. There can be no certainty about the objects other than the mandolin in (a); one presumes it is part of a still-life group.

3 Colour The tones in (a) are gentle, in (b) are more emphatic through contrast. In both cases there is two-colour emphasis: yellow+grey-green in (a), browns+cool and warm greys in (b). In (b) one is tempted to add black as a third colour but I feel it is read more as structure than as colour. Braque and Picasso had both, as we have seen, been concentrating their colour arrangement towards an interaction of two hues. This, as I said, shows the influence of Cézanne; Braque also said that it was done to stress the manipulation of space by reducing the attention drawing effect of bright or rich colours.

4 Space At no point in either painting does one feel quite certain of the location in depth of what one sees, nor of the space apparently available to the objects. The tilting planes in (a) suggest a low relief, a few inches deep; in (b) the planes suggest 'in front' and 'behind' by their tonalities, but the general effect is of flatness or near flatness, so that a busy area, like that bottom right, half suggests that it protrudes in front of the

canvas. The letters in (b) ('D BAL', 'D CO', '&' and '10,40'; the first is probably part of 'GRAND BAL') hover ambiguously; when the painting is seen behind glass they are likely to appear to attach themselves to the underside of the glass, but they can just as well be taken to mark the background.

5 *Signs and devices* In so far as we can read the mandolin in (a) we do so in spite of dislocations that we have to counteract in our minds. We reassemble the broken object and allow it a three-dimensionality that is only vaguely hinted at by the shifting grey areas at its right side. In (b) we are given our information through signs that need to be interpreted like a foreign language rather than through fragmentation of the appearance of things. The lines that say 'guitar' could, in other circumstances, be held to say something else. Experience (which is how we learn language) tells us that the lines to the left of the head (let's assume that that is a head) are to deliver, not represent in the normal sense, a glass and a bottle: we get parts of the profile of each, plus parts of circles that indicate a view from above—plan, section and elevation as it were. The stencilled letters are signs that have to be interpreted too, but they also appear as themselves, not transformed into something else, and so they introduce an element of unmitigated reality (not even transcription from reality) that is surprising and contradicts the metamorphic process that produced the rest of the painting. (An earlier, and comparable, intrusion of a form of 'reality' into the 'other-reality' world of a painting occurs in Braque's *Violin and Palette*; see Hamilton Fig. 178.)

I said above that the signs Braque gives us have to be interpreted, but need they? To be more specific, need we concern ourselves with the motifs?

Much heat has been generated during the last fifty years by the distinction drawn and the conflict generated between abstract and figurative art. Each has had its champions and each, following the emergence of abstract art shortly before the First World War, has had its periods of dominance. On the whole, abstract art, the more visibly modern of these alternatives, has had the harder fight and has shown more aggression in order to survive. The Cubists held fast to nameable and on the whole visible subject matter, with rare exceptions, but Cubism was certainly the road that led pioneers such as Mondrian and Malevich into total abstraction and they represented Cubism to their own followers as a step on the way to abstract art.

Today the opposition is far less absolute but aggressive attitudes on one side and defensive ones on the other are still met with. Most historians of art emphasize Cubism's continuing hold on visible reality—in spite, they imply, of all temptations to slip into abstraction. Now it is true that the Cubists rarely attempted poetical or visionary subjects but concentrated on simple studio subjects. It is also true that they opposed structured compositions to the fluid pictures of the Impressionists and the often loose, not to say rampant, arrangements of the Fauves. And, Delaunay excepted, Cubist paintings were not in any normal sense 'about colour', beautiful though we may find their suave tonal harmonies. In addition, and this certainly felt important at the time, they were not after pictorial illusionism in the sense of treating the picture frame as a window opening and presenting a more or less real piece of the visible world beyond it.

Please read, now, the first pages of the Gleizes and Metzinger text, Chipp, pp. 207–13. It is not always clear what they are trying to convey, but a paragraph at the top of p. 212 says, fairly unambiguously, that the 'reminiscence of natural forms' may shortly be banished from art and that we should be fools to miss it when it goes. Its absence would mean that art had been 'raised to the level of a pure effusion'. Chipp also provides substantial passages from Apollinaire's *The Cubist Painters*, 1913 (pp. 221 *et seq.*). Apollinaire was close to Picasso and Braque but in the period during which much of this text was written he had also associated with the *Section d'Or* group of Cubists (Delaunay, Villon, etc.). Among the sentences on p. 222 are these: 'Real resemblance no longer has any importance, since everything is sacrificed by the artist

to truth, to the necessities of a higher nature whose existence he assumes, but does not lay bare. The subject has little or no importance any more.' Further down on the same page Apollinaire refers to the *Section d'Or*'s move towards 'pure' painting, based on mathematics: 'It is still in its beginnings, and is not yet as abstract as it would like to be.'

So some Cubists tended towards complete abstraction. Picasso and Braque come close to it in their Analytical Cubist paintings, and we shall see that the later, Synthetic, phase of their Cubism brings in a very curious relationship with the visible world— the opposite of 'reminiscence of natural forms', one could say. Both Analytical and Synthetic Cubism involve some forms of illusionism: the marks on the canvas or on paper make us believe in that which is not actually there, such as when one plane appears to be in front of another. That there are nameable motifs in a painting can surely not be taken as an assertion of reality. What is being asserted, I should say, is the artist's total right to manipulate things in the visible world for the sake of another thing altogether, a picture, and secondly, the sheer magic of the game of image-making whereby dabs of pigment deposited on a surface become a strange, a beautiful and sometimes also a puzzling reality of another sort.

It is often said that Analytical Cubism involved principally a process of taking successive views of figures and other objects and juxtaposing parts of these successive views on the canvas in order to present these as coexisting in one moment of time. This 'simultaneous vision' process implies that the artist moves around his objects, taking views of them from several angles, in imagination if not in physical fact. Distinguishing Picasso's Cubism from that of the *Section d'Or*, Apollinaire says, somewhat suddenly, 'A man like Picasso studies an object as a surgeon dissects a cadaver' (Chipp, p. 222), and some commentators prefer to speak of a process of dissection (or analysis) and reassembly instead of successive views. Cooper quotes Picasso to the effect that one should be able to cut up his canvases and, having reassembled them 'according to the colour indications . . . find oneself confronted with a sculpture'.[2] But will the sculpture resemble the motif to any marked degree? I doubt it, but note the painter's acceptance that his process is one of dismemberment. We may wonder whether the urge is playful or seriously aggressive. The paintings must have looked extraordinarily aggressive to a public used to seeing the wholeness of things insured by all the best means of art—directional light and modelling, perspective and a logical sufficiency and complementary of legible information. That the aggression was partial or even negligible is suggested by the fact that most of Picasso's and Braque's paintings were done without a model, out of their heads. So that the successive views, or the dissected fragments—which actually appear in their pictures very rarely— would also seem to be arbitrary forms of notation intended to invite a 'reminiscence of natural forms' rather than the product of actual study of particular objects.

In this respect Cubism is the opposite of Cézanne (and equally of Courbet, invoked by Gleizes and Metzinger as a forerunner (Chipp, p. 207) and thence adduced by commentators in evidence of Cubism's attachment to visible reality). For Cézanne continual contact with the motif was prerequisite to his discovering within himself those 'sensations' which he repeatedly said were his subject matter as well as his impulse. He often stressed in his paintings, and never negated, the physicality of the objects in front of him; it was his need to weld them into intimate pictorial union without compromising their individual there-ness that was his chief problem.

What do Picasso and Braque expect of the spectator standing before their Analytical Cubist works? Picasso and Braque present their compositions like conjurors: the picture is a total 'act'; within or during it they produce bits signalizing the real world like rabbits out of a hat. We can either focus our attention on them and take the rest as mere 'business' or concern ourselves with the 'act' as a whole. If the former, we are likely to start with the title (usually Kahnweiler's creation, done as much to help

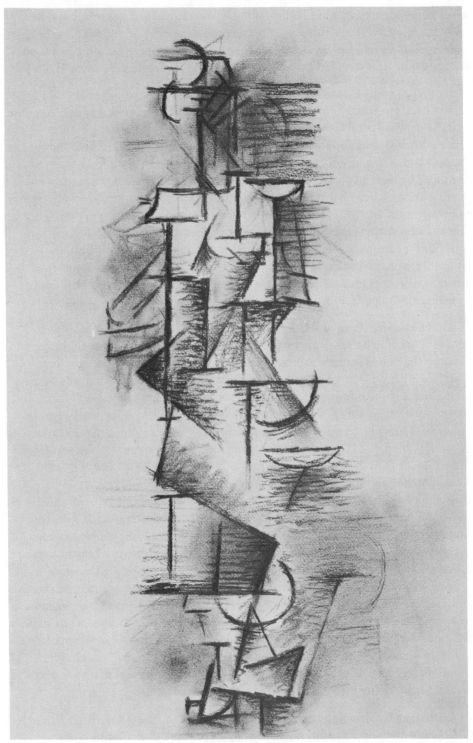

Figure 22 Pablo Picasso, *Nude*, 1910, charcoal on paper, 19 × 12½ ins (Metropolitan Museum of Art, Alfred Stieglitz Collection, 1949 © SPADEM 1975).

himself distinguish between the paintings as to help us to look at them) and scan the picture for signals to interpret and, whenever possible, to fit together in order to get closer to the presumed starting point of the picture, the object or objects said to be in it. If the latter, we find ourselves confronted by an often very satisfying galaxy of dabs and strokes of paint, usually with a distinct structure visible within it. The first reading leads to the pleasure of recognizing and naming; the second is more of a sensory experience. There is validity in both and we should practise both; the tension between conscious reading and interpreting and the more instinctive apprehending of the physical character of the picture-object before us gives Cubism its peculiar and lasting charm.

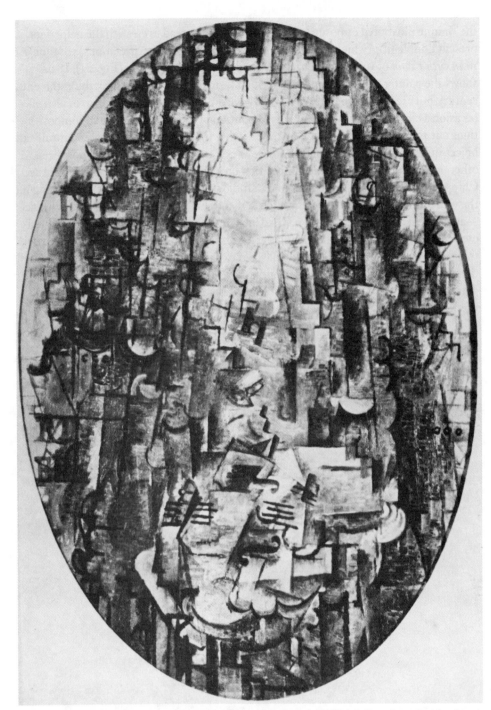

Figure 23 Georges Braque, *Man with Violin*, 1911/12, oil, 39¼ × 28 ins (Buhrle Sammlung, Zurich; photo: Galerie Louise Leiris, Paris © ADAGP 1975).

Neither Picasso nor Braque is a theorist. Chipp quotes statements by both (Braque: pp. 259–62; Picasso: pp. 263–74). If you look at them I think you will agree that they avoid saying anything that could be taken for a considered programme. Their general message is an assertion of freedom.

Picasso's *Female Nude* of 1910 (probably summer or autumn; Hamilton Fig. 135) shows how far he could move from anything like verisimilitude. Painted in greeny greys and browns, the picture suggests a flimsy tower of leaning pieces of cardboard. Notice, by the way, that the effect is sculptural but that now the sculpture implied is massless, a construction of thin planes open to space. Only the verticality of the image and the cluster of signals where the face would come imply a figure. A Picasso drawing of a nude (Fig. 22) suggests no bodily presence but is unambiguously a construction of lines, most of them straight and either vertical or horizontal. See also Hamilton Fig. 138, *The Accordionist (Pierrot)*, for a 1911 Picasso rich in signals of many sorts (like

the Braque illustrated opposite to it) but impossible to read even with the help of its present double title (which may in fact indicate conflicting interpretations). Braque's *Man with Violin* of 1911–12 is a particularly dense cloud of signals (Fig. 23). It also shows the painter using an oval format. Such formats were favoured by the eighteenth century but are otherwise fairly rare. Braque had begun to use them in 1910; also on occasion a circular format, possibly in recognition of the tendency to fade compositions out towards their corners. The result is that the painting is more emphatically an object in itself, not a view through a window. See also Haftmann 179–181 for three other ovals, one of them an oval composition on a visible rectangle of canvas. And see Chipp, p. 261: the photo of Braque in his studio includes a little oval painting hung on the wall in the company of pipes, a watch, a mandolin, a violin and two African masks —all of them looking like things, not like images of other things. Picasso also painted oval compositions, presumably taking the idea from Braque. The years 1910–11 mark their closest collaboration. They do not seem to have minded that others could not tell their work apart (which, by the way, implies another kind of abstraction: the artist detaches himself from his creation and thus asserts its independence in yet another way).

Synthetic Cubism

The year 1912 saw a profound change in Picasso's and Braque's methods. If we can say, as a rough simplification of something very complex, that Analytical Cubism was brought to maturity through Braque's response to elements in the work of Picasso, then here the reverse happened.

The main step was taken by Picasso in May 1912 with *Still Life with Chair Caning* (Plate 4). In this little picture domestic objects (pipe, glass etc.) and the letters 'JOU' (signifying the newspaper *Le Journal*) are shown related to a comparatively large area of chair caning that turns out to be a piece of printed oilcloth pasted (*collagé*) on to the canvas. The objects are hinted at through signals of the sort we have observed before; the newspaper is indicated rather more directly since the painted letters resemble those of its current masthead; but the chair caning looks shockingly real in this company and is actually a real piece of industrially produced material which is designed to be a lie. The oval canvas is surrounded by a frame that could be carved wood but actually is rope.

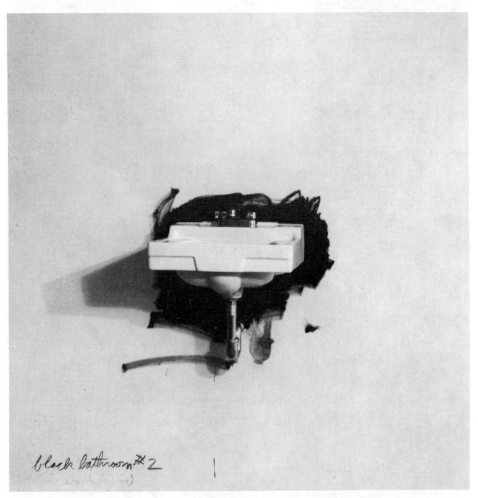

Figure 24 Jim Dine, *Black Bathroom II*, 1962, mixed media, $73\frac{1}{2} \times 31\frac{1}{2}$ ins (Art Gallery of Ontario; photo: Eric Pollitzer).

The act of introducing that piece of oilcloth threatened a host of conventions. Compared to this act, the bright colours and undrawing brushstrokes of the Impressionists, the rough patches of exaggerated or unnatural colour of the Fauves, even the terrible masks of the *Demoiselles*, were crises that could be contained within the Fine-Art context; at least they were caused by and with art materials, the same materials by means of which many a masterpiece had been produced as well as many a disaster.

Now Picasso had broken into another world in order to bring into the art compound a few square inches of mass produced banality. With it he added another generous twist to the confusion which Cubism had already brought to the reality versus pictorial reality game. Other examples of collage followed at once; perhaps Picasso and Braque recognized that this too was a sort of primitivism, both in their turning to lower cultural products and because folk art and decoration had long been glad to incorporate existing images and decorative motifs. In any case it was not a momentary aberration but a move that had extensive consequences of many sorts. It took half a century for such a logical extension of the method as is represented by Jim Dine's *Black Bathroom* to appear, but the road from one to the other is a very direct one (Fig. 24).

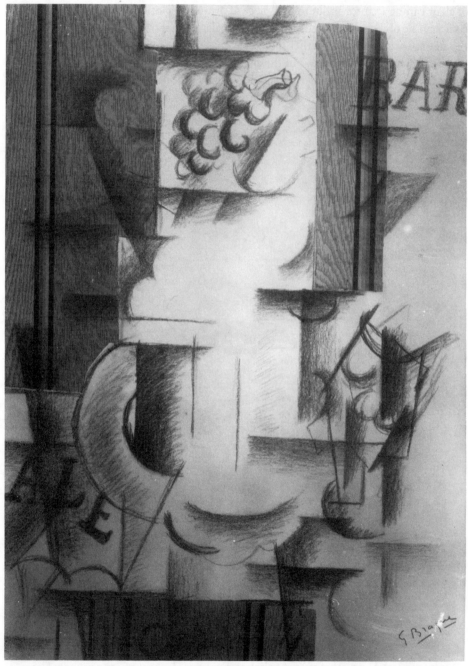

Figure 25 Georges Braque, *Fruit Dish and Glass*, 1912, pasted paper and charcoal on paper, 25 × 19½ ins (Private collection, France; photo: Galerie Louise Leiris, Paris © ADAGP 1975).

The use of painted lettering can now be seen as a halfway stage between making a painted version of reality and pasting a fragment of reality on to a surface and calling it art. Here too Picasso seems to have followed Braque's lead. Braque, son and

apprentice of a house painter, now had recourse to the house painter's graining comb in order to get a wood effect: a little patch of it appears in a painting of early 1912 (probably before May). That was still *painting*, even if of a rather low sort. Early in September 1912 Braque made a painting out of charcoal lines and shading and stuck-on pieces of decorators' paper printed to resemble wood panelling (Fig. 25). The printed paper is the only colour note in the picture (apart from the off-white of the canvas itself), and the episodic charcoal shading is the only space-making element. The main effect is one of flatness, because of the slightness and the transparency of the charcoal drawing, the prominence given to the canvas itself, and the verticality and horizontality of the applied bits of paper. Braque's use of charcoal would not have been surprising on paper, nor on canvas as a means of marking out the main lines of a composition yet to be painted (which may have been what he intended when he began); yet it still looks surprising. This may be because the fake panelling and the fake table, made to support the still life, have greater visual force than the charcoal marks and thus invert the logical priorities. Notice too that while the fruit dish and the glass are drawn in the successive viewpoints manner, the grapes are drawn in a more or less representational manner that permitted Braque a nice display of deftness but looks like a quotation from another art or artist. Thus there are at least three idioms at work in this picture, as well as the signature which asserts the canvas plane as the ground on which the art work is performed. (It is noticeable that Braque's preceding paintings are signed, when at all, on the back; the few that are signed on the front are signed very reticently lest the writing should stress the existence of the canvas plane and thus interfere with the in-and-out flickering of the Cubist planes.)

Now look at the following illustrations in Haftmann, relating to the first months of Synthetic Cubism:

169—Picasso, *Violin*, 1912: close to Braque in the use of the graining comb and the emphatically centred and stacked composition.

172—Picasso, *Violin*, 1913: elaborately grained panelling and table areas; heavily textured paint (admixture of sand) right and left, ambiguously for part of the violin and for the background; even more pronounced vertical-horizontal axes, strong sense of projection forward from the canvas (also physical projection of texture) and impression of clear and measurable space which does not survive close reading.

182—Braque, *Still Life with Playing Cards*, 1913: at first sight a mere variant of *The Fruit Dish* (1912; Fig. 25), but rather a teasing counter to it: charcoal again presents most of the objects, and areas of 'wood' as part of the table and as background panelling again outweigh them visually, but here the collage element is an illusion: the areas of 'wood' are painted to resemble the printed paper he used before.

Picasso's *Bottle, Glass and Violin* of 1912–13, illustrated overleaf (Fig. 26), consists of charcoal and pasted paper but in no way recalls Braque's use of this combination. Compositionally it is a curiously dispersed picture, the objects being displayed with little evident connection between them and particular importance being given to the paper on which they are arranged. From the point of view of reading, it adds two or three further twists to the game with reality. The major solid object named in the title, the violin, is shown transparent and bodyless (it starts with a relatively clear account in line at the top but soon dissolves into hints plus one firmer allusion in the shape of the collage patch on the right); the glass is a Cubist hieroglyph drawn on a piece of newspaper whose shape serves not the glass but the violin; the bottle is a shaped piece of newspaper; the newspaper, i.e. the 'Journal' centrally announced by means of collage, is otherwise shown merely by an outline. Two patches of pasted coloured paper sit firmly and opaquely on the paper ground, one of them part of the violin, the other quite unexplained. The patches of stuck-on newspaper have a kind of transparency: the print advances visually, the newsprint paper recedes; the charcoal lines, sometimes running over the bits of newspaper, sometimes not, are difficult

to place in space—but everything is, and feels as though it is, in front of the paper ground. (Poster design in the 1920s derived several of its most effective ideas from Cubism, especially from this playful way of transmitting information and at the same time surprising us with visual double meanings etc. In this sense avant-garde art inventions, despised or even feared by many, became part of the familiar and accepted world. Watch out for other instances of this kind of socialization of art ideas (for instance, the influence of succinctly structured geometrical art, of Surrealism). They give at least a partial answer to the charge that highbrow avant-garde activities are of no use to the wider world.)

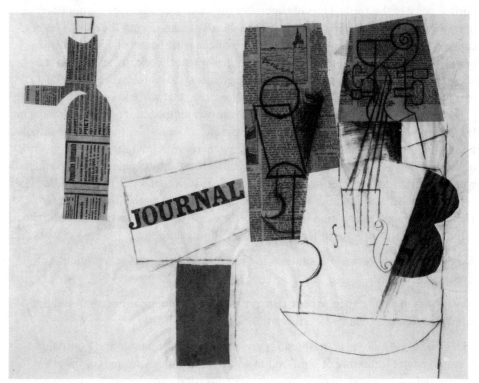

Figure 26 Pablo Picasso, *Bottle, Glass and Violin*, 1912–13, charcoal and pasted papers on paper, $19\frac{1}{2} \times 25$ ins (Moderna Museet, Stockholm © SPADEM 1975).

Examine also two illustrations in Hamilton:

Fig. 139—Picasso, *Guitar and Wineglass*, 1913: a smallish picture made entirely of gummed on paper or *papier collé* (a more specific term than collage which can refer to anything stuck on): the background is a piece of wallpaper (white pattern on terracotta ground); a rectangle of newspaper bottom left; above it a black segment to suggest the bottom of a guitar; a wood-imitation shape left for the side of the guitar; a piece of pale blue paper for its upper part and a white(!) disc for its hole; above right a bit of printed music and, below it, a piece of white paper with a charcoal drawing of a glass on it. Note that this picture has been assembled rather than painted or drawn, and assembled of clear and discrete elements which one reads almost as objects in themselves. Some of the games: the white disc/hole is echoed to the right by the top of the glass; the glass itself looks more like a musical instrument than what purports to be a guitar; part of the guitar is background, i.e. is totally transparent while the glass, a transparent object, shows no background; the words on the piece of newsprint imply a sort of joking innuendo: 'la bataille s'est engagé'='battle has been joined', but 'LE JOU' (obviously part of 'Le Journal'), being truncated, suggests other words: *jouer*, to play, amuse oneself, *le jouet*, plaything, *jouir*, to enjoy, to be in possession of something.

Fig. 140—Braque, '*Le Courrier*', 1913: *papier collé* and charcoal, including part of a cigarette packet; an exceptionally emphatic and tightly centred stack of collage elements that seem to conflict with, rather than support, the information we are being

given about the still life objects; the table itself is reduced to a framing line on the canvas.

Exercise

It is clear by now that not only the methods but also the implications of Synthetic Cubism are different from those of Analytical Cubism. Allowing for the human truth that Picasso and Braque neither adopted new personalities in 1912 nor gave any sign of intending to exchange one art form for another, Analytical and Synthetic Cubism do reveal themselves as profoundly different and, in some respects, opposed styles. Since there is no such thing as a typical Analytical and a typical Synthetic Cubist work, we cannot expect to be able to define these differences in absolute terms. Nevertheless, try to pinpoint a few of them—not local, occasional differences but those shared by most of the works you have studied in each category.

Discussion

Here are a few of them (AC=Analytical Cubism: SC=Synthetic Cubism):

1 AC unity of means: paint on canvas.
SC multiplicity of means: paint, charcoal, plain and printed *papiers collés*, sand in paint—later instances include string, pins, dishcloth, razor-blade packet—and, of course, the frequent bits of newspaper which introduce printed words and images. AC fine-art materials; SC fine-art materials plus decorators' materials plus rubbish plus other bits and pieces for special occasions.

2 AC diversity of signals: drawn hieroglyphs that we learn to read plus bits of near naturalism that we can recognize though disguised through fragmentation and incompleteness.

SC much increased diversity of signals: the main object is often easily located and recognized but soon disintegrates into its contradictory constituent elements; these, the elements, we easily recognize for what they are (bit of newspaper, bit of mock wood panelling) except when the painters set out to trip us up by imitating non-art elements in paint.

3 AC tendency to compositions structured by means of a rising triangle, based on an invisible horizontal line about a quarter of the way up from the bottom edge; tendency to fade to corners (occasional use of oval format).

SC tendency to central compositions, often with vertical and horizontal ties to picture edge; more frequent use of oval format, or grouping that ignores the corners; somewhat more frequent horizontal, as against vertical, picture format.

4 AC space ambiguous, suggested by tonally tilted planes that themselves tend to be incomplete and thus uncertain; ripple relief effect, on the whole suggesting a shallow space just behind the picture surface.

SC space is the space in front of the supporting canvas or paper, thus (apparently and actually) our physical space even though actual physical projection may be minimal; occasional use of shadows to lift or tilt a plane (e.g. Haftmann 172: shadow at top of light plane, top left), but planes normally left to exist parallel to picture plane; stratified space made by superimposed planes sometimes negated by drawing or painting forms across them, ignoring the steps.

5 AC's attitude to the visible world ambiguous: spectator invited to use the clues in order to find the supposed subject.

SC's attitude more direct and more negative: subject usually not difficult to read, but it turns out to have been constructed out of elements that have little to do with the subject, have no traditional role in representing objects and retain their own character.

AC done from model or, more frequently, from knowledge of the appearance of things.

SC little suggestion of study of appearance, whether by means of model or of memory; very free and generalized representation of objects combined with introduction of actual and pretence-actual pieces of reality.

I emphasized earlier Picasso's and Braque's detachment from the objects that they were to some degree representing in their paintings, and I indicated that I could not see their interest in these objects as in any sense central to their activity. But then, in my experience, subject matter as such functions as an artist's primary concern relatively rarely.

Chipp reprints a translation of D. H. Kahnweiler's 1915 essay on Cubism (pp. 248–59). Kahnweiler was writing from close personal month by month experience of Picasso's and Braque's development; also by 1915 he was close to Juan Gris and it may be that his essay reflects here and there Gris's understanding of the significance of that development. In any case, this essay, first published in 1920, has always been seen as a document originating very close to the source of the art as well as recording the memories and insights of a well informed specialist. It may be that some of Kahnweiler's references to multiple vision are in turn the source for the emphasis others place on this method in Analytical Cubism—see particularly the third paragraph on p. 255 and the fourth on p. 256; notice in the latter, also, the opposition of analytical and synthetic processes (which Gris voices also and from which no doubt the labels we still use derive). Kahnweiler is right to emphasize the 'great advance made at Cadaques'. He refers here to Picasso's visit to the coast of Catalonia in 1910 and his move, during that visit, from a tendency to paint solids to organizing his painting in terms of massless planes—common, of course, to mature Analytical and Synthetic Cubism. The *Portrait of Kahnweiler* illustrated by Haftmann (168) was painted shortly after Picasso's return to Paris.

Some of Braque's statements of 1917 (Chipp, p. 260) support the impression I have formed through contact with artists, that the subject of a painting is not the object or objects in it but the whole work, 'a new unity'. When Picasso said in 1923 that Cubism was 'an art dealing primarily with forms' he was not, I am certain, speaking of the shapes of guitars and glasses but of the deployment of pictorial elements: 'when a form is realized it is there to live its own life' (Chipp, p. 265, fourth paragraph). This attitude is embodied in Analytical and Synthetic Cubist work equally, but it seems to me that, if in Analytical Cubism this led to a teasing use of fragmented and abstracted portions of reality orchestrated to offer a rich but confusing art/reality experience, in Synthetic Cubism the playfulness is all on the art side whereas the reference to the visible and familiar world, the guitar or the glass or whatever, is introduced and left standing (a bit like the unwelcome but unavoidable guest from the flat above, invited to what otherwise is to be a close and intimate party) while the collage elements and the drawn or painted signals entertain themselves and each other.

This connects with a characteristic of both phases of Picasso's and Braque's Cubism which deserves close study: their desire to yield to these elements an unprecedented integrity and independence. We have already seen that in Analytical Cubism lines could be seen to operate with and without the support of tone. Backed by tone, the lines tend to be read as the edges of tone; without tone, they become difficult to locate in space but become especially valuable as means of imparting information—to signalize objects or indicate a broad structure. If you look again at *The Portuguese* (Plate 3) you will see many lines that intermittently function as edges but that serve principally to indicate the main triangular structure and to support it with vertical and horizontal accents. Changes of tone happen with and without benefit of a demarcating line in many places; similarly, the linear configurations that indicate the bottle and the glass to the left of the head, or the guitar, do so with and also without the support

given by changes of tone. I emphasize tone: the colour range is subtle but very limited and this is typical of Analytical Cubism. Braque said later that they found it necessary to reduce the colour activity of their paintings in order to be able to control form and space in the way they wanted. In *The Portuguese* there is also the new element, the lettering, which also preserves its independence; its separateness is total whereas one might think of the dance of line and tone as a *pas de deux*, and for this reason it seems to announce Synthetic Cubism.

In Synthetic Cubism the elements retain their integrity to such a degree that one is tempted to call the process of assembling them constructive and utterly unpainterly. It is probable that Braque and Picasso came to use patches of paper, etc. because they used them as a way of planning their compositions. The planes that are so noticeable in *The Portuguese* and many another painting of 1910–11 have a transparency that collage does not permit (though newsprint hints at it, as I have suggested) but are likely to have been tested for placing, dimensions, etc. by means of cut paper before being painted in. Fixing and leaving the cut paper—and then finding a particular sort of paper (or oilcloth)—fits our understanding both of the painters' attitude to their work as being adventurous and opportunist in the sense of responding very readily to stimuli, especially those coming from the work itself. The result, in Synthetic Cubism, is the juxtaposing and superimposing of discrete elements. These elements are so pronounced in themselves that one is tempted to see their union as temporary.

This independence of the elements—collaborative in Analytical Cubism, more assertive in Synthetic—can be seen as another aspect of Picasso's and Braque's disruptive inclinations. It is obvious that they disrupted what links art had had with the visible world (complex and contradictory as these had always been). In affording various degrees of independence to the constituents of their pictures, they were disrupting the art process itself, which had always been integrative, had always aimed at unity. The 'new unity' is now relatively familiar and unfrightening but I want to stress that this aspect of Cubism too must have seemed like wanton destructiveness at the time. It has, in fact, been the basis of the long and broad constructive tradition in modern art—Constructivism itself, concerned with assembling discrete elements often already existing in the ordinary world, and also those processes of picture making which, whether the means are paint or pieces of other matter, involve a bringing together rather than a fusion. Mondrian is one extreme example, with his ultra-clarified pictorial structures (see Haftmann 319); another extreme is represented by Klee with his vast appetite for all sorts of marks, materials and methods and his generative process whereby the work grows out of the coming together of these elements as opposed to being conceived and then executed.

Having wrested pictorial domination from the subject—having released form, colour, tone, etc. from their traditionally first duty to the business of representing something —Picasso and Braque were able to establish their means' individual value. Pictorial unity, they imply, must now spring from the relationship between these distinct factors. It is easy to see in this a metaphor for the mature and fair society we all dream of. The feeling I get from a lot of Synthetic Cubist work of the arrangement being temporary even has the effect of diminishing the artist's role of inventor and coordinator.

Picasso and Braque did not, it is right to emphasize, abandon recognizable subject matter altogether. They did, on the other hand, subject it to such undignifying manoeuvres that it is fair to ask what was left. At what point does one lose the sense of a subject? At what point does the issue itself disappear or change fundamentally? I am willing to accept that Picasso's *Head* (Plate 4) is a head because some of the minimal information in the picture confirms the claim of the title. But it is not like a head in appearance or feeling. Most of all, it is not like a head used to look in art. Picasso's composition strikes a fine, tense balance between headiness and abstractness —which is precisely the balance struck and held by many primitive artefacts (Figs 6

and 7). These also (Fig. 6) can have the character of being constructed of discrete elements rather than carved from one piece.

This picture once belonged to André Breton, founder and spokesman of the Surrealist movement of the 1920s. Aptly so: in this and other works of the war years Picasso shows an inclination to sharp and disturbing imagery that one could well consider proto-Surrealist. There is, indeed, something smacking of Surrealism about the reversal of roles we have seen in Synthetic Cubism, as when (Fig. 25) the subject is sketched in but the supporting matter is given physical reality, or when (Haftmann 169; Hamilton Fig. 139) there is a sharp conflict between the denaturalized representation of the object and the conventionally literal, pseudo-naturalistic representation offered by printed wallpaper and frieze.

Figure 27 Pablo Picasso, *Student with a Newspaper*, 1913/14, oil, sand and pasted paper on canvas, $28\frac{5}{16} \times 23\frac{5}{8}$ ins (Private collection, Paris; photo: Galerie Louise Leiris © SPADEM 1975).

It may be that the centrifugal opportunities offered by Synthetic Cubism released the natural vagrant in Picasso. Until then he was a normally concentrated artist, developing his work with reasonable consistency after an initial phase of trying a variety of avenues; about 1914 he starts working in contradictory ways, ceaselessly inventive of new images and processes but always going on to deny special value to any of these by countering it with another. *Woman in a Chemise seated in an Armchair* (Plate 5) and *Student with a Newspaper* (Fig. 27) were done within a few weeks of each other. The

former certainly qualifies as a forerunner of Surrealism with the conflict of idioms (and thus of associations) within it (face *versus* chemise, upholstery *versus* breasts), set against a classical, plain background. The latter is more cheerfully waggish. Apart from the student's grotesque mask there is painted graining, sand in the paint for the texture of his soft beret and, a new element, the visual texture provided by two spotted areas. This playing with visual (as distinct from physical) texture is pronounced in other Picassos of the ensuing years, notably in *Still Life in a Landscape* (Plate 6). At first sight a neat and happy picture, it soon reveals itself as a difficult, almost unreadable cluster of contradictions and disruptions (as when the mottled green we have come to know as representing the meadow turns up in the sound hole of the guitar). One is left, in the end, with an almost unbearable contradiction between the clarity of the composition and its perceptual unintelligibility. In this painting and in *Woman in a Chemise . . .* we also see a new stridency of colour. The pasted papers of Synthetic Cubism had brought colour back into Cubism. Braque used mainly gentle colours or earthy ones that remind one of his 1908 landscapes, but Picasso here introduces a new and shocking note.

Are these Cubist pictures? If you consider the question in the terms in which we have examined paintings in this unit, I think you will agree that they can be called Cubist to only a limited extent.

The same question still remains to be answered for the *Demoiselles d'Avignon* (Plate 1). Neither the subject matter of five nudes nor the implied message of urban anxiety fit Cubism at all well. The size of the painting, its insistence on a monumental statement, is un-Cubist. Looking at it, and then at *Woman in a Chemise . . .*, we begin to see Cubism as an exceptionally umproblematic and even entertaining interlude in Picasso's career—in fact, he goes on to vary his emotional weight and his rhetoric with great freedom, so that we repeatedly have to adjust our image of him. Braque's course is much steadier. In some respects the *Demoiselles* does, however, initiate aspects of

Figure 28 Georges Braque, *The Guitar*, 1917, oil, 24 × 37½ ins (Rijksmuseum Kröller-Muller, Otterlo © ADAGP 1975).

Cubism: I mean its space making and space denying through ambiguously or incompletely described planes.

Picasso's *Harlequin* of 1915 (Haftmann 170) is austere, in spite of its subject, to the point of grimness. Some of the details, the grimacing face, the anti-natural shapes used to indicate arms and hands, reappear in his Surrealist paintings and drawings of the late 1920s.

The war had been going on for some time. Almost all of Picasso's friends had been called up, including Braque, who was badly wounded in 1915 and demobilized in 1916. Braque started painting again in 1917. There is something a little tentative about his first post-recuperation efforts: *The Guitar* (Fig. 28) is almost too disciplined and neat. His friend, the sculptor Henri Laurens, did some low-relief carvings closely related to this painting; one can see why the picture lent itself to this transcription. The 1918 *Guitar and Clarinet* (Haftmann 184) is gayer but it also lacks the feeling of discovery and adventure that is one of the almost constant pleasures of Cubism. It was to be one of Braque's last paper collages. But if the Braques of 1917–20 indicate a weariness and perhaps a desire to consolidate rather than to extend, it has to be emphasized that some of his finest works are to be achieved in the 1920s and after. Much the same inclinations are sensed in most French art after about 1915. Picasso from 1915 on put more and more effort into naturalistic and neoclassical works, encouraged in this by his enrolment into Diaghilev's glittering world of highbrow

Figure 29 Jean Baptiste Chardin, *Still Life with Jar of Apricots (Un Bocal d'abricots, dit un Dessert)*, 1756/8?, oil, 22½ × 20 ins oval (Art Gallery of Ontario).

showbiz. The large painting *The Three Musicians* of 1921 (Hamilton Fig. 141; a variant is in the Museum of Modern Art in New York) is often presented as a culminating masterpiece. Brilliantly designed as it is, it looks to me like a grand finale that has been over rehearsed.

Can we distinguish between Braque and Picasso as Cubists? Obviously we can, even if at particular moments they seem almost in unison. Braque was very much a Frenchman and, by family and inclination, one of those master craftsmen in whose hands the finest traditions in the arts have always rested. It looks as though the Cubist focus on still-life subjects was primarily his, and it was he who turned the infernal restlessness of the *Demoiselles* into the enticing semi-transparent flickering of Analytical Cubism. Picasso, the Spaniard, contributed the original questioning of mass and space and fed into the development repeated acts of boldness and aggression. The main perceptual crises were usually of Picasso's making (though the lettering in *The Portuguese* must be held to represent one of these); the compactness and the decorative elegance of Cubism is certainly Braque's contribution. And France's: Braque had a life-long passion for Chardin's still-life paintings (Fig. 29; Braque went on to work almost exclusively on still life for the rest of his full life). To what extent is Cubism merely a modern development of the traditional still-life painting and also of the kind of decorative trophy that appeared so frequently in polite French interiors in the first decades of the eighteenth century when Chardin was a young man (Fig. 30)? I leave this question to be pondered.

Figure 30 Cartouche with musical instruments beneath figures of Bacchus and Ariadne, corniche in Chambre de Parade de la Princesse, Hôtel de Soubise, Paris, 1730s, probably by Nicolas-Sebastien Adam (Archives Nationales; photo: AGRACI, Paris).

Juan Gris

Hamilton provides a good short account of Gris's emergence as a painter and of the character of his mature work (pp. 250–53). But his two illustrations plus Haftmann's generous display (185–94) leave us short of representatives of his early work. In 1911–12 Gris did paintings and drawings that James Thrall Soby (1958) described as 'diagonally magnetized'. Chipp illustrates one such, the *Hommage à Picasso* (p. 276). This shows the 'magnetizing' produced by the fall of shadows in opposite and therefore contradictory directions—diagonally mostly, but also vertically up and down for the buttons. The colour is almost monochrome: blue-grey for the jacket and the chair, brown-grey for the rest. The same sort of colours combine with elaborate tonal gradations for Gris's portrait of his mother (Fig. 31).

Figure 31 Juan Gris, *Portrait of his Mother*, 1912, oil, 21¾ × 18 ins (Private collection; photo: Galerie Louise Leiris, Paris © ADAGP 1975).

Commentators speak of Gris's use of the simultaneous-vision method in these paintings. It seems to me, though, that what happens here is a lateral displacing that has nothing to do with successive views from different angles fused into one composite image. (If we must try to find a *visual* explanation for this displacement, it might be

Figure 32 Juan Gris, *The Three Cards*, 1913, oil, 26½ × 18½ ins (Hermann and Margrit Rupf Foundation, Museum of Fine Arts, Berne © ADAGP 1975).

found in what happens when we look at an object first with one eye and then with the other; to get the diagonal displacement we have to tilt our heads.) The result, in any case, is to permit a centripetal complex of forms—the face—to become part of an all-over picture pattern (in the case of the Picasso portrait, almost a grid), as well as to tie in well with the background while leaving some suggestion of three-dimensional forms and a limited space.

Chipp adds two statements (pp. 274–77) to the Gris words quoted by Hamilton. These are of historical importance in their polarizing of the Analytical/Synthetic Cubism alternatives in comprehensible terms, while generally representing Cubism as a methodical and reasonable art. (Having perhaps glibly reminded you that Picasso was a Spaniard, a few paragraphs back, I must here do the same for Gris. Gris was born in Madrid; his father was a well-to-do Castillian businessman, his mother an Andalusian. I do not know how much to allow for the differences in Picasso's and Gris's regional origins; perhaps it matters that Gris was the thirteenth child of his

parents. It may be that his Cartesianism as artist has a tenacity that is un-French. *The Three Cards* (Fig. 32) may serve to illustrate this aspect of him. The composition has an architectural rigour that one imagines in French hands only if accompanied by suave or even dulcet tones and tints; here colour and tone are firm and impersonal.)

Exercise

Compare Gris's *Still Life* (Haftmann 191) with Braque's *The Fruit Dish* (Fig. 25).

Discussion

The following comments, produced by this comparison, have general implications. Gris is much more decorative than Braque. Braque's composition is mainly vertical, secondarily horizontal in emphasis. Gris's is central: it uses verticals and horizontals, also oblique lines at roughly 60° and 30° angles, but their effect is to cancel out any strong directional pull and to leave the composition floating. Gris also strives to make every part into an interesting pattern, often with a positive/negative function: the fruit, as neat as dominoes and arranged dark against light; the interaction of pipe and newspaper, light and shade on the fruitbowl, and so forth. The plane of the table tilts one way and, left uncorrected, would have a spatial effect even though there is no perspective, but Gris counters it with a background panel that tilts in the opposite direction. The composition stays within the frame. There is little or no sense of playing with different kinds of reality: the whole picture is a neatly painted surface, as pat as marquetry.

This decorative strength of Gris made him very influential on 1920s and 30s design in a way that Picasso and Braque could not be. Picasso said of him to Kahnweiler, 'Certainly, Gris only wanted to make a Chardin, and since he was honest, he didn't want to imitate him but applied his intelligence to reinvent a way to make Chardins. And, by the way, he would have achieved it if he'd lived' (Ashton, 1972, p. 163).

Fernand Léger

Hamilton gives a fairly full account of Léger's work and ideals on pp. 253–8; Chipp quotes from two of his essays (pp. 277–80); Haftmann offers a generous selection of illustrations (215–21 and 427–44). I should like here to add a few points and to stress others, impelled by a growing conviction that Léger's is one of the most substantial and potentially fruitful ventures in modern art. You will find some fairly accessible reading recommended at the end of this unit.

First, a few biographical details. Léger was the son of a farmer, was apprenticed to an architect, worked for an architect and then also as photographic retoucher. Rejected by the École des Beaux-Arts he studied for some months at the École des Arts Décoratifs, both in Paris, but managed to get himself some instruction in painting at the same time. He was profoundly affected by the 1907 Cézanne retrospective and soon got to know the modern art and poetry circle associated with Cubism. The poet Blaise Cendrars became a particularly close friend. In 1910 Kahnweiler began to take an interest in him and in 1912 he had his first one-man exhibition at Kahnweiler's gallery. In 1913 Kahnweiler became his contracted dealer. Called up 1914; gassed 1916; spent most of 1917 in hospital; discharged towards end of the year. On leave, in 1916, he was taken by Apollinaire to see Charlie Chaplin films. In 1921 he contributed with Cendrars to Abel Gance's film *The Wheel* (he wrote about the film in 1922; see Léger, 1973, p. 20). Subsequently he contributed design work to other films and to ballet and in 1924 he created and produced his film *Ballet Mécanique*, a rhythmic succession of everyday images, often close-ups of familiar objects, without story or patent theme. From 1920 on he was associated with the painter Ozenfant and with Le Corbusier, painter and architect, their *Esprit Nouveau* journal and the Purist movement (see Hamilton, pp. 267–69). In 1925 he contributed mural canvases to the *Esprit Nouveau* pavilion (and also decorated, with Delaunay, the entrance to the French Embassy pavilion, architect Robert Mallet-Stevens) at the international Exposition des Arts Décoratifs in Paris. He was also associated with the Dutch *De Stijl* group (Mondrian was in Paris from 1919 on, and Van Doesburg was there intermittently). Visited Berlin in 1913 and 1928, United States in 1931 and 1940–5, London 1934 to work on Alexander Korda's film of H. G. Wells' *The Shape of Thiugs to Come*. Etc.

Before the 1914–18 war Léger's work was of two sorts: the 'tubism' represented by *Nudes in a Forest* (1910; Haftmann 215), and the nearly abstract, sometimes totally abstract, paintings of 1912–14 (Haftmann 216–19). The difference between the former and the latter is extreme. *Nudes in a Forest* is emphatically a painting of solids placed in a traditional picture space; tone dominates, colour being limited to a grey-green-brown range (thus very unlike Henri Rousseau's vivid pictures). The 1912–14 paintings show some of the same geometric shapes but now they are broken open and left incomplete and also the brushwork itself leaves forms transparent. These paintings (much more than illustrations can show) are emphatically paint on canvas, and energetically so both because of the noticeable action of the brush and because the colours are now lively and optimistic: often the French flag colours, red, white and blue, but see also the colour plate, Haftmann 219. The translating of seen objects into geometrical solids has now become a means of creating strong, rhythmical, optimistic compositions in which many kinds of contrast (form, scale, straight against curved, open against closed, bright against dark, repeated against solo, etc.) produce a remarkably cheerful effect and, in most cases, also transmit enough information to suggest a subject (though I'll agree the *Woman in Blue* takes a little finding: her two hands are at the centre of the painting). I should like to suggest, tentatively, that the experience offered by these paintings, in spite of their lack of immediately legible

subject matter, is celebratory rather than teasing or even argumentative as it often seems in Picasso's and Braque's work.

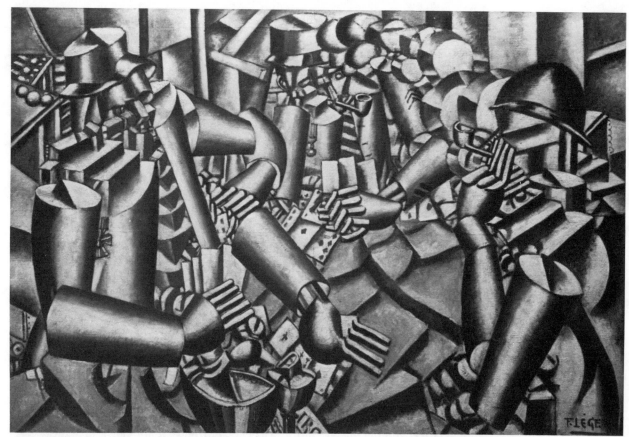

Figure 33 Fernand Léger, *The Card Players (La Partie de Cartes)*, 1917, oil, $51\frac{1}{2} \times 73\frac{1}{4}$ ins (Rijksmuseum Kröller-Muller, Otterlo © SPADEM 1975).

The war experience which, as Léger himself stressed, changed his view of art and its role in the modern world, led him at first to something like a return to his 'tubism'. *The Cardplayers* (inscribed on the back 'Done in Paris, while convalescing, December 1917'; Fig. 33), of which he said that it was the first painting he had done of which the subject was intentionally chosen to reflect the contemporary world, and for which, his largest work to date, he did a lot of preparatory studies, has robot like figures that differ from their 1910 predecessor mainly in their gleaming steel like surfaces. Set in something like traditional picture space, again like the 1910 figures (indicated principally by the diminishing size of the forms and their apparent overlapping), the painting distantly recalls Cézanne's *Cardplayers*. But, of course, the chief characteristic of Léger's vocabulary of forms is their potent suggestiveness—of hard man made things, particularly of machines and here, one fancies, of machines of war. Gun barrels, stepped box forms, grouped tubes, a chain of cones; the rumpled blanket on which the soldiers play looks like part of some fortification. There is a hint of gun fire in the sharp repetition of forms. So the whole picture is a fusion, in a markedly unsentimental fashion, of the subject of soldiers at leisure and the implied ambience of mechanized warfare.

By the spring of 1918 Léger was replacing this idiom with one in which metallic solids make few appearances and in which a great deal of abstraction combined with familiar signals (lettering, architectural and engineering structures, incomplete but entirely legible) make a vivid and tightly organized whole. Some of these paintings are without specific subject matter (*The Discs*, Hamilton Fig. 146, *Composition*, *Abstract Composition*, all 1918–19), and there are later periods when Léger produces more or less completely abstract work (as for instance in the mid-1920s; see Haftmann 432), but

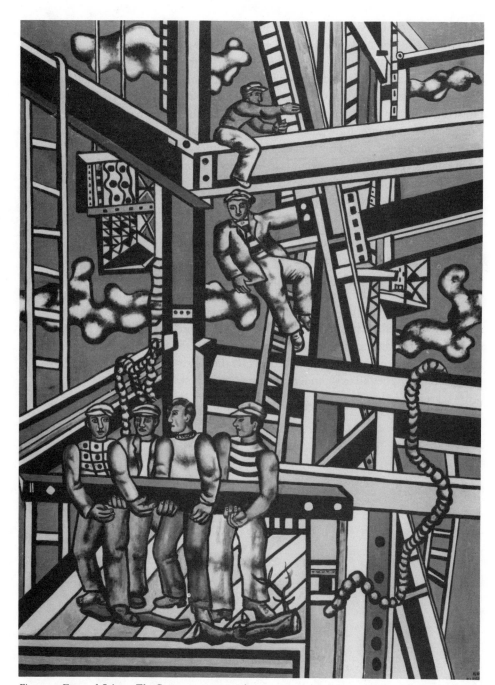

Figure 34 Fernand Léger, *The Constructors*, 1950, oil, 119 × 79½ ins (Musée Nationale Fernand Léger, Biot; photo: Jacques Mer, Antibes © SPADEM 1975).

the characteristic Léger painting from now on is that in which he combines energetic forms, flat and modelled, abstract and figurative, large and small, to create a convincing image of our man made world and of man's place within it. *The City*, which Hamilton illustrates and writes about (Fig. 145), is his first masterpiece in this style. What Hamilton calls 'the renunciation of traditionally humanistic values' (p. 255) and the representation of men as mechanical manikins was an international tendency occasioned by the war and the awareness of mass-man and of the power of technology it brought with it but encouraged also by a desire for classical clarity. In Léger it soon led to a modern equivalent of these humanistic values. The bold figures in *Le Grand Déjeuner* (Haftmann, 429; 'Large breakfast' doesn't sound quite right) are part of the classical tradition that celebrated the splendour of man and woman in impassive but noble representations. The three ladies shown here are not goddesses but ordinary, anonymous women, their shapes adjusted to the technological world in which they live. Later Léger somewhat softened his figures until they looked rubbery rather than metallic but they retain their impersonality, their mentally untroubled wholesomeness

and the monumentality—even when, as in what Hamilton and Haftmann call *Homage to Louis David* (Léger inscribed it *Les Loisirs*), he shows common people at leisure. (This painting always reminds me of the post-1945 films made in France and Italy that gave ordinary people epic status without denaturing them.) In paintings such as this one (Haftmann 442) and the magnificent *The Constructors* (Fig. 34) Léger proves himself the master painter of what Baudelaire called 'the heroism of modern life'. 'The painter, the true painter for whom we are looking, will be he who can snatch its epic quality from life today, and can make us see and understand . . . how great and poetic we are in our cravats and our patent leather boots' (Tate Gallery 1970 catalogue; quoted by John Golding). And, one wants to add for Léger, in our Sunday suits and bathing costumes as well as in our working gear.

Léger stressed, *á propos The Constructors*—men building an electricity pylon—the contrast that struck him between the little men and the great metal architecture they were erecting, and also, behind them, the sky and the clouds. He has modified the anonymity of his figures in order to bring out this contrast, and he said that this contrast should form the painting of all modern painting. Yet I should like to suggest that his true achievement, in this painting and generally, has been to present an optimistic but credible image of man at one with the world he has made. The constructors are building something that represents them; the forces they are struggling against have been calculated and will be met by their strength and the strength of their materials. They all exist under the same rich blue sky.

Do you see anything in common in Léger's art and in Seurat's?

The Other Cubist Painters

Douglas Cooper distinguishes sharply between what he calls 'True Cubism' and the larger Cubist movement. Some such distinction is useful but he limits 'True Cubism' to the Analytical phase of Picasso and Braque. This seems arbitrary. The two phases were complementary: Analytical Cubism must have struck Picasso and Braque as a *cul de sac* and then, as in the boys' story, with one leap they were free. Analytical Cubism was centripetal but it provided them with the means of switching to the centrifugal ways of Synthetic Cubism. The work of both phases had enormous influence.

Hamilton (pp. 258–69) gives an account of Cubism as a movement and of group developments that moved away from Picasso and Braque's example—Orphic Cubism before the first world war and Purism after it. Both involved rejecting a good deal of what Picasso and Braque had achieved, especially in their Analytical phase, because both were harmonizing tendencies, not concerned with teasing propositions about reality and perception. One cannot conceive the possibility of either, however, without the previous example of Picasso and Braque.

Where one is to draw the line between True Cubism and the rest is partly a personal matter. But it is in the nature of any revolutionary development that there will be fellow travellers and also signed-up members whose understanding of what is involved is only skin deep and whose work will therefore show little more than a superficial adherence to aspects of the new style. Cubism offered a variety of means whereby a painter could modernize his work without changing it fundamentally—could, almost literally, give it a facade of modernism. More or less traditional representations could be faceted and geometricized (e.g. Haftmann 225 and Hamilton Fig. 150) to give them a Cubist flavour. And it is very often the half-understood, half-hearted example that is easier to approach and to imitate. The spread of Cubism was much affected by the eruption of Futurism, itself deeply indebted to Cubist methods but using these to substantially different purposes.

The Problem of Cubist Sculpture

In his opening sentence on Cubist sculpture on p. 269, Hamilton poses the essential problem that faced anyone attempting to make sculpture embodying Cubist principles (and, I suppose, anyone attempting to make any sculpture that embodies principles tested and developed in two dimensions). Consider for a moment the Renaissance situation. Painting was concerned with capturing on a flat surface the rays of light converging from the chosen scene on to the painter's and spectator's eye; it could thus share many principles and conventions with a sculpture dedicated to imitating (and of course idealizing) the real world. Of course, the aims of the Renaissance were much more complex than that, and the relationship between painting and sculpture varied according to periods and artists.

In so far as Cubism was an art of disjunction, ambiguity and transparency it was obviously difficult to find a sculptural equivalent—until one gets to kinetic art (and we shall find moves towards it in what follows) sculpture remains stuck with the fact of its material firmness and immobility, but there are of course ways in which this can be mitigated. When Hamilton speaks of a 'pictorial diagram' which could directly lead to sculpture he is, I presume, thinking of the clearer examples of Synthetic Cubism. The facts of the matter are more complex. It appears that both Picasso and Braque made three-dimensional paper and cardboard objects (sculptures if you like) as sketches for their 1912 pictures. Braque's no longer exist; some of Picasso's are said to have survived, and in any case it was Picasso who went on to make Synthetic Cubist sculpture in more permanent materials and on a larger scale.

Cubist Sculpture: Picasso

Picasso was undoubtedly one of the greatest sculptors of our century, both for his inventiveness and because of the lasting power of some of the results. Throughout his career he turned to sculpture from his primary activity as painter, sometimes producing individual pieces, sometimes a whole series of works. During his Cubist years he did both.

He had done occasional sculptures during his Blue and Rose Periods, and we have seen the head of Fernande, done probably in 1909 as a complement to a series of paintings (Fig. 20). In the paintings variations in tone serve to give an illusion of projection and recession; in the sculpture these are replaced by actual mass and hollow. Picasso exaggerates these, with the result that the highlights and hollows made by light shining on the metal impart some illusionistic life. It is possible that this sculpture helped to clarify for him some of the issues he had faced in his paintings: the need he had felt to assert sculptural solidity in painting is almost totally absent from now on—and he does not do another sculpture until 1912.

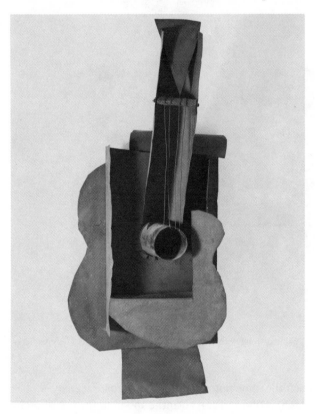

Figure 35 Pablo Picasso, *Guitar*, early 1912, sheet metal and wire, $30\frac{1}{2} \times 13\frac{7}{8} \times 7\frac{3}{8}$ ins (Museum of Modern Art, New York, gift of Pablo Picasso © SPADEM 1975).

The sculpture he then made, *Guitar* (Fig. 35), is of an entirely new type. It consists of several pieces of sheet metal, cut, folded and joined to resemble the guitars of Synthetic Cubism, with wire standing in for the strings in the object and the lines in the paintings. It manages to have some of the ambiguities and contradictions of his pictures: flat yet not really flat, half spatial half solid, like and yet very unlike, decorative yet sharp and austere. This looks like Picasso following 'the temptation to move from pictorial diagram to its spatial realization,' as Hamilton put it.

But Picasso was certain that *Guitar* preceded his first collage, *Still Life with Chair Caning* (Plate 4). Moreover they have little in common. The sculpture looks to a somewhat later stage in Synthetic Cubism when collage and *papier collé* led Picasso to the use of flat elements side by side or stacked and to the paintings that reflect these. *Guitar* has a stern quality coming partly from its single material that contrasts with the

richer decorativeness of those, and it is easier to see it as the starting point of the long history of constructed sculpture in this century, most of it rather solemn, than as the source of the often witty and usually rather charming Picasso pictures that seem to have their origin here. We looked earlier at Picasso's painted *Female Nude* of 1910 (Hamilton Fig. 135) and noted its constructed look; her head makes an interesting comparison with *Guitar*. The painting seems to have been a unique instance of what looks rather like prophecy.

Picasso's sculpture continued in an unprogrammed fashion, like his painting. At the other extreme of his constructed sculpture comes his *Wineglass and Die* (Hamilton Fig. 142) and another impressive work of the same year, 1914, *Still Life* (Fig. 36). Both are made of rough pieces of wood; the Tate Gallery piece has the additional element of a real tasselled fringe. They are simple objects, and the glasses in them are close transcriptions of the glasses in his pictures. At the same time these reliefs are disconcerting and somewhat threatening objects. We have seen something similar in his concurrent paintings.

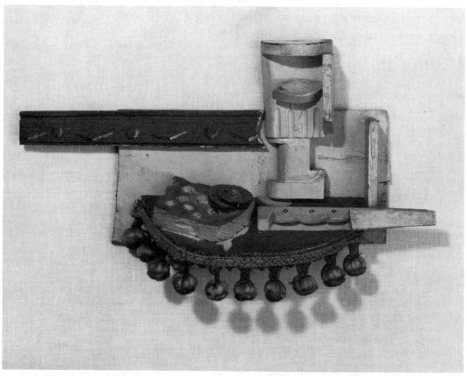

Figure 36 Pablo Picasso, *Still Life*, 1914, painted wood with fringe, 48 × 10 × 18⅞ × 4 ins (Tate Gallery, London © SPADEM 1975).

Another work of 1914 strikes much the same note by different means. Picasso modelled and cast *The Glass of Absinthe*, fixing a real absinthe spoon to the rim of each of the six casts and a bronze sugar lump on to each spoon. Then he painted all the casts differently, with strikingly different results (Plate 7). His formal concern seems to have been with showing the glass's transparency and the level of the liquid in it— and here he seems to have been influenced by the Italian Futurist Boccioni's *Development of a Bottle in Space* (Hamilton Fig. 170), shown in Paris in 1913—but this is countered by the actuality of the spoon, the literalism of the spoon and the all-round interference offered by the coloured and texture surface. In the long history of sculpture more works have been coloured than not. Colouring began to be thought unsuited to high art from the beginning of the fifteenth century onwards until the end of the nineteenth century and beyond. Towards the end of the nineteenth century colour began to creep back in, through tinting and through the use of colourful materials, for the sake of richness or verisimilitude and also, one supposes, to catch the eye in official exhibitions otherwise conventionally full of white marble and dark

bronze. Gauguin had painted his sculptures from 1892 on. Rodin objected to applied colour but was willing to patinate his bronzes carefully by means of chemical treatment. By 1912 colouring was dying out again in art-establishment circles, and so in 1913 it could appear in the avant-garde world of Picasso (his painted constructions of 1913–4) and Archipenko (*Carrousel Pierrot*, 1913), and soon thereafter more widely.

Picasso's application of colour and texture to *The Glass of Absinthe* may originally have been decorative in intention but ended by competing with the already complex information offered by the forms. In effect, this treatment refutes the inertness, the factualness of sculpture. Rubin reports that 'Picasso enjoyed "sitting" stringed instruments in chairs, like personages; it was a favourite position for the sheet metal *Guitar*, which because of its large size took on an especially anthropomorphic appearance' (Rubin, 1972, p. 211). Picasso always tended to personalize the inanimate. This is in itself a tendency to Surrealism but it is a tendency that belongs to humanity at large and that surfaces particularly potently in primitive arts. *The Glass of Absinthe*, too, is in part a personage.

Other Cubist Sculptors

Please read Hamilton's sections on Laurens, Archipenko and Lipchitz, i.e. part of pp. 269–78 (the last paragraphs on Lipchitz deal with his later, non-Cubist work). I shall add here some illustrations and commentary.

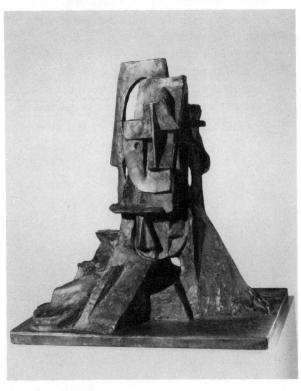

Figure 37 Otto Gutfreund, *Cubist Bust*, 1912/13, bronze, 23⅝ ins high (Tate Gallery, London © SPADEM 1975).

Gutfreund, *Cubist Bust*, 1912–13 (Fig. 37): Otto Gutfreund (1889–1927) was a Czech artist who (like many another young Czech or Pole) came to Paris to round off his artistic education. He was there during 1909–10, working in the studio of Bourdelle (see Hamilton, p. 70). In 1911 he was back in Prague and the work he did there until the war demonstrates a deep and intelligent involvement in Cubism. What did he see in Paris to help him? We don't know precisely but if he left at the end of 1910 he cannot have seen there the climax of Picasso's and Braque's Analytical phase. But he was not dependent on his memories of Paris: in Prague he could and undoubtedly did see exhibitions including the work of Picasso in 1912, Picasso, Braque and Gris in 1913, Picasso, Braque, Archipenko, Duchamp-Villon, Brancusi, etc. in 1914. What is more, the art historian Vincenc Kramar, closely associated with Gutfreund and avant-garde art in Prague, personally formed an outstanding collection of French and Czech contemporary art which is now part of the Prague National Gallery. I illustrate a particularly fine Picasso, very abstract, very subdued in colour, which was in Kramar's collection among several other Analytical and Synthetic Cubist Braques and Picassos (Fig. 38). The similarities and the differences are striking.

Archipenko, *Médrano II*, 1913 (Fig. 39): *Médrano I* is known only from an old and not entirely clear photograph (reproduced in Karshan, 1974). Made in 1912, rejected by the jury for the 1912 Salon d'Automne, but shown in Budapest in 1913 and at the Paris Salon des Indépendants in the spring of 1914, it was made of bent sheet metal, a piece of glass, wire, and shaped and found (i.e. used as found) wood, all of them partly painted. It represented a female juggler, kneeling on one knee; her right arm moved; she is manipulating three balls one of which hovers by being done in paint on the piece of glass (the other two are little wooden balls). Her formal character is close to *Médrano II*, and she presumably represents some sort of circus performer too since

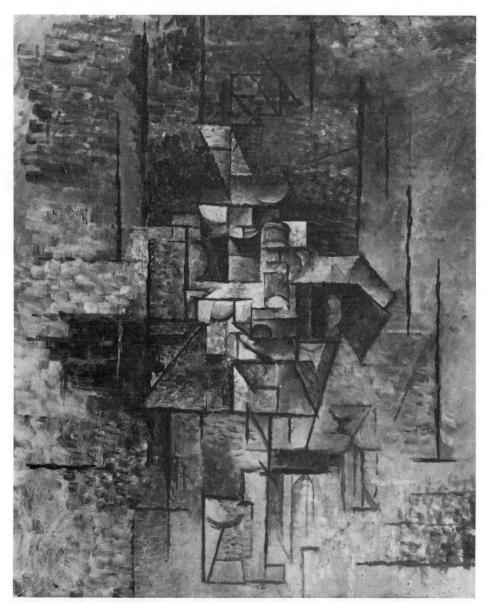

Figure 38 Pablo Picasso, *Toreador playing a Guitar*, February 1911, oil, 26 × 21¾ ins (National Gallery of Prague © SPADEM 1975).

the name of both sculptures refers to the Cirque Médrano, the circus that Picasso, Apollinaire, Satie and other avant-gardists frequented. Her structure is less open and more easily read than that (as far as we can tell) of her predecessor, and Archipenko has given her a back panel as well as a base. She too was exhibited at the Salon des Indépendants in 1914. (Did Picasso make a mental note of Archipenko's painting of her left foot? Compare the hands in Picasso's *Harlequin* painting of the following year; Haftmann 170.)

Both these sculptures are aggressively anti-traditional except in their adherence to the principle that sculpture is first and foremost concerned with the human figure. Archipenko adhered to this almost exclusively, though in style and material his work varied dizzyingly. Among the several other (and different) works he produced in 1913 is his bronze *Head-construction with Crossed Planes* (Fig. 40), a bold and surprisingly effective attempt to make a head out of the sort of planes Picasso and Braque were currently pasting on to their Synthetic Cubist pictures.

Laurens, *The Clown*, 1914? (Fig. 41) and *Small Construction*, 1915 (Fig. 42): Hamilton rightly questions the nature of much of Laurens' Cubist work which often looks more like paintings made three-dimensional than sculpture. But this does not apply to some of his first existing Cubist works. *The Clown*, the dating of which is uncertain, owes a

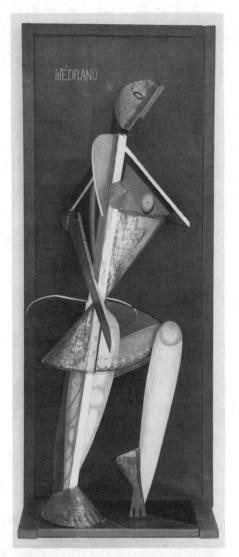

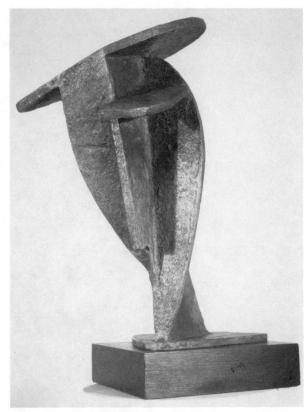

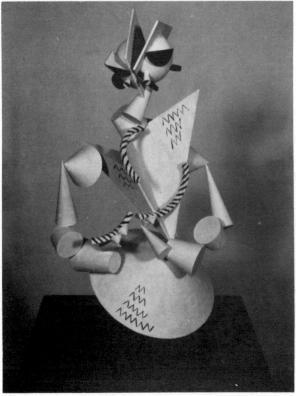

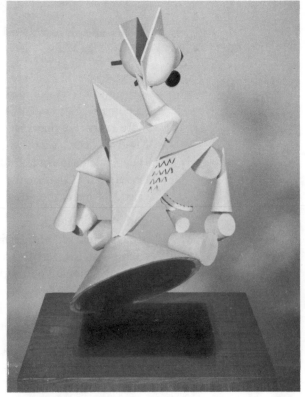

good deal to a painted plaster figure by Archipenko, *Carrousel Pierrot*, but is a lot more sprightly and inventive than even that lively object, as well as more abstracted. It pirouettes in space: compare it with Léger's paintings of around the same time for a similarly mobile play of clear forms (Haftmann 216 and 217). *Small Construction*, which appears to be totally abstract but may be sporting a guitar halfway up (and thus be an abstracted figure), enfolds space with its curving planes of sheet metal. A little known work, given to the French nation by the artist's son in 1967, it could have been the inspiration of much post-1945 sculpture.

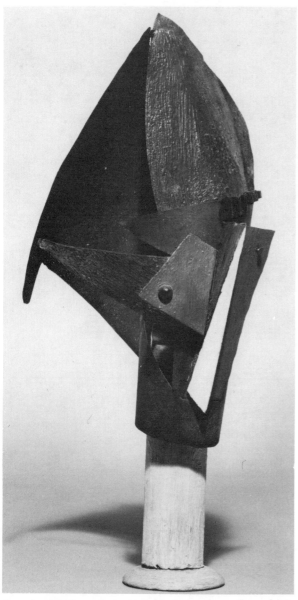

Figure 42 Henri Laurens, *Small Construction*, 1915, polychrome wood and metal, 12 ins high (French National Museums (donated 1967); photo: Réunion des Musées Nationaux © ADAGP 1975).

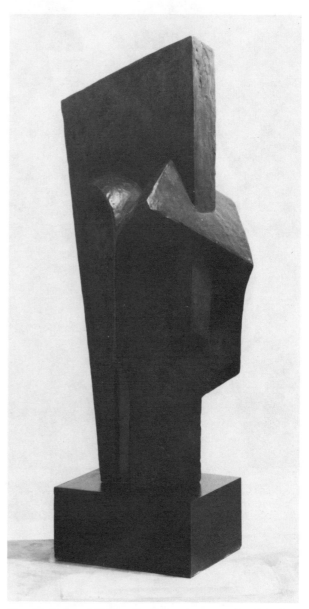

Figure 43 Jacques Lipchitz, *Head*, 1915, bronze, 25 ins high (Tate Gallery © SPADEM 1975).

Lipchitz, *Head*, 1915 (Fig. 43): Lipchitz said to the writer Jules Romain that he wanted to make sculpture 'as pure as crystal'. This would seem to be the nearest he came to achieving it. Its clarity goes even beyond that of Archipenko's *Head-construction*; the weight of its thicker planes compensates for its openness in a way that is not perhaps adventurous but makes for balance in much the same way as his curved elements balance with the assertive straight lines and planes. His *Man with a Mandolin* (Fig. 44) is a slight forerunner of the works Hamilton praises as being 'more

three-dimensionally and successfully Cubist'. It seems indebted to Picasso's 1915 *Harlequin* painting (Haftmann 170) but makes effective sculptural use of the large planes of the painting.

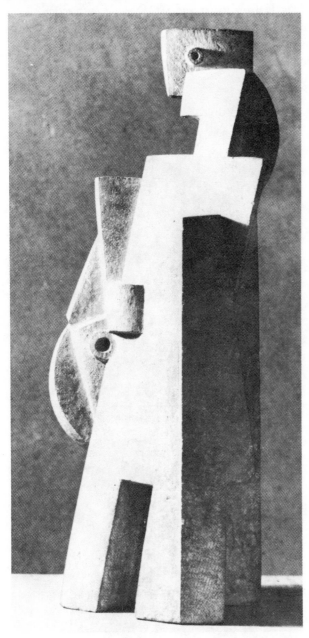

Figure 44 Jacques Lipchitz, *Man with a Mandolin*, 1917, stone, 29¾ ins high (Yale University Art Gallery, gift of Collection Société Anonyme © SPADEM 1976).

Intentions, Practice and Theory of Cubism

Here it should be made clear that I do not mean an established program when I speak of Picasso's or Braque's intentions, endeavors, and thoughts. I am attempting to describe in words the inner urges of these artists, the ideas no doubt clearly in their minds, yet rarely mentioned in their conversations, and then only casually. (D. H. Kahnweiler, 1915; see Chipp, p. 250.)

'You have to have an idea of what you are going to do, but it should be a vague idea.'
(Picasso, quoted in 1946; Ashton, 1972, p. 28.)

'Picasso: One simply paints—one doesn't paste one's ideas on a painting.
'I: Certainly, the painter paints things and not ideas.'
'Picasso: Certainly, if the painter has ideas, they come out of how he paints things.'
(Conversation recorded by the painter Renato Guttuso in 1964; Ashton, 1972, p. 17.)

In art, theory follows invention and is rarely the work of the inventor. Usually theory is the means whereby other artists are able to adopt and assimilate the invention and also the means whereby the invention is made graspable for the wider public.

Picasso and Braque made no statements during the climacteric years of Analytical and Synthetic Cubism; Braque's epigrammatic lines of 1917 (Chipp, pp. 260–61) do indicate his attitude to representation, etc. but they were recorded not only after the key years but also after a long break from working.

Following up references to the fourth dimension and to non-Euclidean geometry in the 1912 essay by Gleizes and Metzinger (Chipp, p. 212) and in Apollinaire's *The Cubist Painters* published in 1913 (Chipp, p. 223; this part of the book was written as a lecture in November 1911), historians have associated Cubism with Einstein's Special Theory of Relativity, published in 1905, and to Minkovski's formulation of the space–time continuum in 1908. The link between the artists and such difficult material was found in the person of Maurice Princet who worked for an insurance firm and was an amateur mathematician, is known to have lived for a while in the same building in Montmartre where Picasso, Braque and some of the other Cubists had their studios, and was particularly close to Marcel Duchamp. Cubism could thus be seen as a visual exploration of this exciting new theoretical world in which objects and locations lost their integrity. Add to that the doubts, expressed at the time, as to the solidity of matter and it becomes possible to welcome Cubism as the inevitable consequence of new insights into the nature of the physical world in which we live.

It has recently been argued very convincingly that the Cubists had no knowledge of Einstein or Minkovski, but that the writings of the French mathematician Poincaré (particularly his *La Science et l'Hypothèse*, 1902) and diagrams in an introduction to four-dimensional geometry (E. Jouffret's *Traité élementaire de géométrie à quatre dimensions*, 1903) did influence Metzinger (who had a taste for mathematics) and other Cubists, possibly including Picasso and Braque. Poincaré distinguished between the space of geometry and the space we perceive subjectively through sight, touch and motion. Gleizes and Metzinger are referring to this when they say that, 'To establish pictorial space, we must have recourse to tactile and motor sensations, indeed to all our faculties', i.e. not merely or even principally to our sense of sight, and go on to define pictorial space 'as a sensible [perceptible] passage between two subjective spaces' (Chipp p. 212).

A particularly striking diagram in Jouffret's book (Fig. 45) shows what is described as a 'see-through view' of the sixteen fundamental octahedrons of an ikosatetrahedroid.

63

Figure 45 E. Jouffret, Fundamental octahedrons of an ikosatetrahedroid, from *Traité élementaire de géométrie à quatre dimensions*, 1903, Paris.

Jouffret concerned himself with the question of visualizing four dimensions and he warns against attempting it other than through such two-dimensional analytical projections. This diagram, with its suggestion of an object revealing successive positions by means of its transparency, could have contributed directly to the armoury of pictorial devices Braque and Picasso employed in their Analytical paintings of 1910–12. Poincaré had proposed something that sounds very close to the supposed programme of Cubism, the representing of real objects by juxtaposing or superimposing

successive views of them from different positions, or simultaneous vision: 'Just as the perspective of a three-dimensional figure can be made on a plane, we can make that of a four-dimensional figure on a picture of three (or of two) dimensions. . . . We can even take of the same figure several perspectives from several different points of view. . . . In this sense we may say the fourth dimension is imaginable.' In an article published in August 1911 Metzinger had stated that the Cubists had 'uprooted the prejudice that commanded the painter to remain motionless in front of the object, at a fixed distance from it, and to catch on the canvas no more than a retinal photograph more or less modified by "personal feeling". They have allowed themselves to move round the object, in order to give, under the control of intelligence, a concrete representation of it, made up of several successive aspects. Formerly a picture took possession of space, now it reigns also in time' (See Fry, 1966, pp. 66–67). The following year, Gleizes and Metzinger felt they had to protest against too literal an interpretation of that process: 'We are frankly amused to think that many a novice may perhaps pay for his too literal comprehension of the Cubist's theory, and his faith in the absolute truth, by painfully juxtaposing the six faces of a cube or the two ears of a model seen in profile' (Chipp, p. 214).

The word 'simultaneity' did not become part of the Cubist vocabulary until the Futurists had used it in the catalogue of their debutante exhibition at the Galerie Bernheim-jeune in February 1912, and what they meant by it was neither the successive views shown simultaneously of Cubism nor the simultaneous colour contrasts of Delaunay (who adopted the word from the title of Chevreul's famous colour treatise of 1839, *De la loi du contraste simultané des couleurs*). For them 'simultaneity' meant the pace and energy of modern life, personal and mechanical, actual and perceptuals brought together in one work.

(For Jouffret, Poincaré and 'simultaneity', and the Cubists' references to them, see Henderson, 1971.)

Hamilton rightly points to the Futurists' echoing of the words of the French philosopher Bergson (p. 280). But Bergson's account of the intuition as the true means of access to living reality, and of this reality as a flux of sensory experiences and of perceptions (which are the action of memory), was delivered in limpid language and with an effective use of metaphor in books and public lectures in Paris and must be understood to have been common property among those who were attracted to his anti-mechanistic, anti-materialistic views. The most famous books were *Les données immédiates de la conscience* (1889), *Matière et Mémoire* (1896), and *L'Evolution créatrice* (1907), each of them available also in English in the year of original publication. (Hamilton argues that Matisse showed indebtedness to Bergson in his essay, *Notes of a Painter*, of 1908; see p. 169.)

I should like to suggest that the Cubism of Picasso and Braque reflects a variety of contemporary views and opinions, which would almost certainly have included aspects of, or generalized versions derived from, Bergson and Poincaré, as well as stylistic opportunities suggested by Cézanne, El Greco, African sculpture and so forth, and also their reaction against the over literary art of the Symbolists and against their own earlier work. And they were of the generation of Apollinaire, whom I propose both as symbol of an optimistic, empirical taste for novel aesthetic experience —to be matched, they must all have hoped, by an equally optimistic and avid public— and as a direct influence through his never-ending (until his early death in 1918) spoken and written monologues.

> Apollinaire was keenly aware of modern technology as a force inevitably altering the imagination of the artist. In an age of telephones, telegraphs, and X-rays, he felt time and space in new ways, and struggled to move out of conventional art forms to give voice to his pressing insights. . . .

Intuition, for the artists of Apollinaire's generation, not only freed the fantasy, as Apollinaire pointed out repeatedly, but also enabled the artist to free himself from linear history. In this abundant world of imagination and reality, the primitive could exist along with the signboards and telephones of modern life without contradiction. Spaces—or time spans—no longer had fixed boundaries. The arousal and proper use of the faculty of intuition would release whole areas of human endeavour for appraisal. The Senufa and Oriental sculpture would take their places, along with the motor car, in the vastly expanded imagination of modern man.

(Ashton, 1969, pp. 36–39.)

Exercise

All this would come, in my view, under the heading of intentions. I don't believe that Picasso and Braque had a theory or theories. What they achieved in their Cubist works is not easily defined. How would you summarize it? Look back over the illustrations of their work and note what it was that they did, and in doing established, with respect to subject matter and style, pictorial structure and language, and space.

Discussion

Here follow some comments under each heading; they are far from exhaustive and you should not hesitate to add to them as long as what you adduce is actually demonstrated in their art.

Subject matter and style

1 Named motifs The still life objects and the figures with instruments do not in themselves seem important, but they serve as stimuli, presumably to the artist and certainly to the viewer whom they seduce into riddle-solving examination of the work. Variations in format or style do not bear marked relationship to particular motifs. At times, the motifs are represented with something of their traditional presence, giving the viewer an impression that the object is embodied in the pictorial world; at other times, it is referred to through linear signals or hieroglyphs. The ordinariness of most of the motifs would seem to suit the artist's desire to manipulate forms and is part of the enticement offered to the viewer. (Picasso painted some portraits in the Analytical Cubist manner, and these must have posed a challenge in balancing abstraction—and the production of a painting of a particular sort—against retaining a more or less recognizable arrangement of features. See Chipp, p. 249, for the portrait of Kahnweiler. Picasso painted and drew portraits throughout his career; as far as I know Braque never did.)

2 Style The more the motifs in a picture are transformed or otherwise withheld from recognition, the more the style of the work becomes what is communicated. And that is a whole host of non-specific messages; which dominate depends on the recipient's expectations. At the time most people found Cubist paintings not only obscure but destructively so—an arbitrary process of vandalizing objects and (particularly wounding to self-regard) the human image. That overcome, one becomes keenly aware of ceaseless ambiguities, perceptual (is that a glass or part of a guitar?) and sensory (that plane is tilted towards me; no it isn't, or is it?). Professor Sir Ernst Gombrich has stated his belief that 'Cubism . . . is the most radical attempt to stamp out ambiguity and to enforce one reading of the picture—that of a man-made construction, a colored canvas.' The ambiguity he is referring to here is that which places a picture between the reality of the objects represented in it and the fact of its being a picture. I would maintain that that ambiguity too continues, surviving from ancient and Renaissance traditions, and that Cubism exploits it to an extreme degree. The viewer is all too ready to call a picture a person or a landscape—so much so that we have to remind ourselves forcibly that few things are less like, say, a naked body

cf Brecht

Verfremdungseffekt

than a piece of canvas coated with paint. Cubism invites this habitual identifying of art with things and continually prevents it from being achieved. Unlike Pavlov's dogs', our response does not fade, even several decades later, but at the time the experience must have aided the arrival of the totally abstract work of art, the unambiguously 'man-made construction'—clear in its status however mysterious it may have seemed in meaning. I prefer what Gombrich had written earlier: 'We know that artists of all periods have tried to put forward their solution of the essential paradox of painting, which is that it represents depth on a surface. Cubism was an attempt not to gloss over this paradox but rather to exploit it for new effects.' (Gombrich, 1960, p. 281 and Gombrich, 1968, p. 438.) This exploiting of paradox would seem to be the underlying subject matter of Cubism.

Pictorial structure and language

1 Analytical Cubism Fragmentation of motifs and of setting into varyingly sized and distinct bits that tend towards simple geometrical shapes. The assembling of these within larger structures that tend to emphasize the vertical axis of the painting. Fading of tone and quantity or density of marks towards the corners; sometimes omitting of corners through oval or circular canvases (or framing that leaves oval area visible). Contrasting and conflicting elements used in combination or singly: line with or without tone, changes of tone with or without demarcating lines, linear hieroglyphs with or without illusion-giving partial representations. Introduction of 'foreign' elements, e.g. lettering.

2 Synthetic Cubism Introduction of 'foreign' materials as elements through collage and admixture. Though these are almost always fragments, the effect is constructive since the units are larger and visible composed and affixed. Motifs become visibly secondary in that they appear as annotations introduced into the composition rather than starting points. Easier, more relaxed compositions: central stacking or lateral juxtaposing; marked tendency towards horizontal formats (rare in Analytical Cubism); frequent oval compositions on visible rectangular canvas (blatant separation of canvas 'support' and pictorial structure).

Space

1 Analytical Cubism Ambiguous in-out space effect through fragmentation of forms and unreliable relationship of line to tone, and through more or less equal treatment of motifs and setting or background. Generally, low relief effect; sometimes also hint of projection forward from canvas ground. All through illusionistic means.

2 Synthetic Cubism Mostly in 'real' space, in front of canvas, through physical collage or through apparent stacking of shapes (and increasing of physical density of paint through sand etc.). This emphatic projecting of the image is thrown into doubt or cancelled when Picasso starts painting backgrounds again, as in *Woman in a Chemise seated in an Armchair* (Plate 5) and *Harlequin* (Haftmann 170).

cf Beckett – Waiting for Godot

Cubist painting and Cubist sculpture

When Picasso made his sheet-metal *Guitar* at the beginning of 1912 he was not trying to make a metal guitar: he was trying to make a three-dimensional object that would have the same kind of ambiguous relationship with the guitars we know about and the sculptures we know about that his painted images had offered. Inverting the process Hamilton points to, the *Guitar* appears to have provided a spatial diagram from which Picasso was to move towards pictorial realization.

Other Cubist sculptures, the Gutfreund *Cubist Bust* and the Archipenko *Head-construction* . . . (Figs 37 and 40), do suggest the sculptural exploitation of diagrammatic suggestions in Cubist paintings, and this seems blatantly so in the case of Lipchitz's *Man with a Mandolin* (Fig. 43). Again others, such as Archipenko's *Médrano II* and Laurens' *The Clown* (Figs 39 and 41) seem fairly distant from Cubism and closer, in aims and methods, to Futurism (see Unit 9).

Notes

1 Need I warn you to beware of translations? Even if you do not know the language well it can be useful to put translations and the actual words side by side and perhaps get closer to the meaning and feeling of the original. Cézanne's words here were: '. . . traiter la nature par le cylindre, la sphère, le cône, le tout mis en perspective, soit que chaque côté d'un objet . . .'. The translation is so familiar that one is reluctant to fiddle with it. Nevertheless, where does the word 'proper' come from? Stricter renderings would be 'everything in perspective' and 'all of it in perspective'. Generally, Cézanne's statements do not fit his own work directly. In this case one might ask (a) whether perspective can do a lot with the sides of a sphere or a cone or a cylinder, and (b) where his paintings show this focusing of the spatial structure on to a 'central point'. To add the word proper is to imply the Renaissance system, *construzione legitima*, and thus to increase the gap between Cézanne's words and actions. Here we are primarily concerned with the effect of those words on a younger generation of artists.

2 The words are actually those of Julio Gonzales, a Spanish painter and sculptor who was a close friend of Picasso's, referring to Picasso's paintings of 1908: 'These paintings—all you have to do is cut them apart, the colours being only indications of different perspectives, of inclined planes from one side or the other. Then you could assemble them according to the indications given by the colour and find yourself in the presence of "sculpture" '. See Ashton, 1972, p. 60 and Cooper, 1970, p. 33.

References and Recommended Reading

Ashton, D. (1969) *A Reading of Modern Art*, The Press of Case Western Reserve University. (Especially Part One Chapter 3 and Part Two Chapter 1.)

Ashton, D. (1972) *Picasso on Art—A Selection of Views*, Documents of Twentieth Century Art, Thames and Hudson.

Clark, K. (1970) *The Nude*, Penguin.

Clark, K. (1974) *Another Part of the Wood*, Murray.

Cooper, D. (1970) *The Cubist Epoch*, Phaidon.

Francia, P. de (1969) *Léger's 'The Great Parade'*, Painters on Painting, Cassell.

Fry, E. F. (1966) *Cubism*, Thames and Hudson.

Golding, J. (1968) *Cubism : A History and Analysis*, published in paperback 1971, Faber.

Golding, J. and Penrose, R. (eds) (1973) *Picasso 1881–1973 : An Evaluation*, Paul Elek.

Gombrich, E. (1960) *Art and Illusion*, Phaidon.

Gombrich, E. (1968) *The Story of Art*, Phaidon.

Habasque, G. (1959) *Cubism*, trans. S. Gilbert, Zwemmer.

Henderson, L. D. (1971) 'A new facet of Cubism: the 'fourth dimension' and 'non-Euclidean geometry' reinterpreted', *Art Quarterly*, Winter 1971.

Karshan, D. (1974) *Archipenko*, Wasmuth, Tübingen (English text).

Léger, F. (1973) *Functions of Painting*, ed. E. Fry, Documents of Twentieth Century Art, Thames and Hudson.

Northern Arts and Arts Council (1973) *Watercolour and Pencil Drawings by Cézanne*, exhibition catalogue, Arts Council of Great Britain.

Penrose, R. (1958) *Picasso : His Life and Work*, Gollancz; paperback 1971, Penguin.

Rosenblum, R. (no date) *Cubism and Twentieth-century Art*, Abrams.

Rubin, W. (1972) *Picasso in the Collection of the Museum of Modern Art*, Museum of Modern Art, New York.

Soby, J. T. (1958) *Juan Gris*, Museum of Modern Art, New York.

Stein, G. (1959) *Picasso*, first published 1938, Beacon Paperback.

Tate Gallery (1970) *Léger and Purist Paris*, exhibition catalogue, text by J. Golding and C. Green, Tate Gallery.

Wadley, N. (1972) *Cubism*, Hamlyn.

Unit 8 Language of the Feelings: Figuration and Abstraction in Expressionist Art

Expressionism is a very broad term. Used, preferably, with a capital 'E', it is now applied habitually to a not very specific tendency in the arts that flourished particularly in Central Europe during, roughly, 1905–30. Some artists outside the area are often associated with this tendency because their attitudes and products were comparable. Thus Hamilton includes Fauvism, the French movement, in his chapter on Expressionism. I think this makes sense. I accept his point that the French movement and the German tendency have in common an emphasis on the *effect* of a work that is exceptional in degree if not in kind. But, given that common ground, there are many differences between Fauvism and the various activities to be found in Germany and Austria under the sign of Expressionism, just as it would be silly to try to ignore the difference, not just in quality but in underlying intention, between Matisse, leader of the French movement, and his various followers. In any case, Expressionism by any definition puts a premium upon individual self-expression and thus encourages self-differentiation.

Hamilton's Chapter 4 and some later pages in his book will provide the textual core of our study. In this unit I shall comment on and sometimes complement what he says, and of course add to the illustrations he and Haftmann offer. I shall also draw your special attention to the most interesting and useful texts Chipp quotes in his section on Expressionism. The schedule that appears below is meant to show how this collaboration works; it may also have the effect of making the whole thing look much more complicated than it is.

This unit may strike you as bitty and uncomfortable. Bitty it has to be, I think; the sense of discomfort comes from my need to present elusive ideas and effects in very few words. One of the pleasures of studying the history of anything comes from the narrative nature of the material. Where this unit is concerned, narrative is almost entirely left to Hamilton: he tells the story of modern art well and, especially with a broad subject like Expressionism, there seems little point in echoing it here.

A short Recommended Reading list appears on p. 114 It will be referred to in these pages in abbreviated form: author and date of publication.

The later work of Kandinsky and Klee, and the work of others who could come under this unit's title, will be discussed in Unit 12, *Artists of the Bauhaus*; George Grosz will appear in Units 13–14, on Dada and Surrealism. The theme of expressionism (with a small 'e') will arise in Units 15–16 in the guise of Abstract Expressionism. Klee's work will be discussed in a radiovision programme (RV 11).

Unit 8 Schedule of Recommended Texts in Hamilton and Chipp, and plates in Haftmann, in Relationship to Commentary in the Unit

Hamilton page	Hamilton heading	Chipp page	Haftmann plates	Unit page	Subjects discussed
157	Expressionism			73	Expressionism prepared in Symbolism; Delaunay
158	The Fauves: Matisse, Derain and Vlaminck		48–86	73	Related studies of perceptual psychologists
				73	Matisse, *Luxe, Calme et Volupté*
				73	Signac's essay *From Eugène Delacroix to Neo-Impressionism*
				74	Matisse, *Woman with a Hat, Madame Matisse, the Green Line*; the Steins; the Matisse school
		130		75	Matisse's *Notes d'un peintre*
				75	Matisse, *Le Luxe I* and *Le Luxe II*: style and dating
				76	Matisse, *Dance and Music*
				77	Matisse and Cubism (1914–17); his decorative works of 1910–13
				78	Matisse as Sculptor
176	Georges Rouault				
180	Modern German art		87–90	86	Complexity and diversity of German Expressionism; Expressionism as communication
185	Wilhelm Lehmbruck				
191	Paula Modersohn-Becker		143–44	87	Modersohn-Becker; Hans von Marées
193	Emil Nolde	146	91–106 (and 705–12)	89	Nolde; Hölzel
197	Die Brücke		107–40 (and 713–31)	93	Wilhelm Worringer
				93	Character and work of main *Brücke* artists
				96	Sculpture by Kirchner and others
205	Kandinsky in Munich	155	294–316 (and 786–95)	98	Kandinsky: writings, sources and contemporary echoes
215	Franz Marc and *Der Blaue Reiter*	178	268–93	101	*Der Blaue Reiter*: the almanac
				(107)	Major exercise: comparison of *Brücke* and *Blaue Reiter*)
				110	Herwarth Walden and *Der Sturm*
474	Art in Germany: 1920–40				
475	George Grosz and Otto Dix		688–92		
479	Carl Hofer and Max Beckmann	187	670–87	112	Beckmann
484	German sculpture: 1920–40				
486	'Entartete Kunst'				
487	Austrian Expressionism: Richard Gerstl and Egon Schiele		152–53		
490	Oscar Kokoschka	170	145–51 (and 736–44)		
494	Paul Klee	182	290–93 (and 763–83)		

p. 157: 'the history of Expressionism includes the earliest formulations of totally abstract art'

Hamilton implies here that this was motivated by the urge to express personal feelings. I would add that it was also prepared for by the Symbolists' and others' interest in the sensory effect of their work. Not only is there a special emphasis in Expressionism on communication but it is recognized that this communication must be borne by artistic means. A lot of Expressionist art—and much of the best —shows little concern for personal messages and much more for a constructive exploitation of what we can call (as Delacroix did long before) the musical qualities of form, colour, etc.

In France Robert Delaunay produced abstract paintings during 1912–13. That came under the heading of Cubism, yet these paintings were better known and better liked in Germany than in France. Had they been *produced* in Germany we should encounter them under the heading Expressionism, where perhaps they would be more at home.

p. 158: 'study of the expressive properties of pictorial form'

Hamilton refers to the 'psychological investigations of Theodor Lipps'. I want to stress here that Lipps and others, working in the field now called perceptual psychology, were systematically testing the emotional responses occasioned by colour and form. Some of the artists to be considered were aware of these investigations and extended them through their paintings and writings.

p. 158: Matisse, *Luxe, Calme et Volupté*

See Plate 8. I share Hamilton's reservations: the picture (not truly large—38 × 51 ins) is not 'a miracle of the creative imagination', but I can see why Dufy enthused and why Signac may have wanted to own it, because of its 'play in colour and line'. That will have appealed to Dufy who belonged to the lightest, most lyrical wing of Fauvism and responded to the boldness and the originality of Matisse's use of arabesques (mainly the figures and their shadows) within a rather strict, traditional, horizontals + verticals + diagonals, composition, as well as to Matisse's boldly antinaturalistic colours. Signac, who had been Seurat's chief disciple, had himself moved towards a more openly expressive use of the divisionist techniques, and saw here an extension of what he was doing. The subject of the painting is a traditional one—a scene of idyllic happiness suggesting a Golden Age—slightly updated by the dressed woman and the rather specific coffee pot, etc. Matisse had painted a study for this picture at St Tropez during the summer of 1904; Signac was then living in St Tropez. The painting itself was done in Paris the following winter and exhibited at the Salon des Indépendants in the spring of 1905.

p. 159: 'Signac's essay'

Seurat had died in 1891 without ever explaining his method. Delacroix's *Journal* was published for the first time in 1893–95. In that Signac found specific points of support for this method, as well as more generally stimulating remarks about colour and its use in painting, from a painter whose work the Impressionists and the Post-Impressionists joined in admiring. Signac's own essay is an impersonal statement on the nature of painting, offering precise instructions on harmony and rhythm as well as on colour and

line. Signac saw the justification for Neo-Impressionism in its clarity of means and result. This clarity, he implied, had a moral origin and force. In his diary he noted (14 April 1897): 'Divisionism is more a philosophy than a system'.

From Eugène Delacroix to Neo-Impressionism was published in 1899 by the Paris literary and artistic publishing house *La Révue Blanche*. Parts of it had appeared during May – July 1898 in the magazine of the same name. Matisse and his circle studied it closely, but I believe it to have been important not only to the Fauves and others in France but also internationally: most noticeably to Kandinsky and Klee and, less obviously, for Mondrian. These read French but it is worth noting that a German translation of portions of Signac's text appeared in the May–October 1898 issue of *Pan* and that the entire text appeared in German in 1903 (a second edition in 1910).

Signac's essay proclaimed the inherent rightness and goodness of bright, unmuddied colours, placed cleanly and with an impersonal touch in an evident and harmonious pictorial structure. His own subject matter was almost invariably landscape. Though obviously concerned with expression, he was not in the least concerned with delivering fervent messages.

I refer you to Unit 4 for a fuller account of Neo-Impressionist methods and aims. Aaron Scharf there warned you against seeing Neo-Impressionism as a subsection of Impressionism. Historians of modern art have been ready to see twentieth-century developments as springing largely out of a reaction against Impressionism, but have failed to see that Neo-Impressionism was itself such a reaction and one that later generations were very conscious of. Some of the words that Professor Scharf quotes from an interview given by Charles Henry in 1891 (Unit 4, p. 37) could almost stand as a motto over this unit. 'On the contrary', Henry is quoted as saying, 'I believe in the more or less imminent advent of a very idealistic and even mystic art based on new techniques'. The two most important artists to be discussed in this unit are undoubtedly Matisse and Kandinsky—an idealist and a mystic and both profoundly original.

p. 161: Matisse, *Woman with the Hat*

After painting this startling portrait of his wife Matisse painted another, *Madame Matisse, the Green Line* (Plate 9). Barr (1951) suggests that Matisse may have in some degree reacted against the earlier portrait, possibly helped to do so by the adverse criticism which it attracted. In important respects the second picture is an answer to the first and the thought of Matisse embarking on it while the first was causing such an uproar at the Salon d'Automne would seem to justify putting the two in opposition to each other.

Hamilton, in discussing *Woman with the Hat*, very rightly emphasizes the controlled nature of a process that seemed wildly aggressive then and still can shock. The forms surface out of jarring colour contrasts and even more jarring brushstrokes. The conventional pose must have heightened this impression: an elegant cliché treated barbarously.

The second portrait is equally vivid but its vividness is the product of firmly established colour discords and harmonies. The more direct pose is supported by broad colour areas that subtly stress what asymmetry and tension there is in the composition. Broad areas of colour (for the size of the painting) sometimes abut each other, sometimes have a coloured line as a common frontier. The green line of the picture's nickname acts as hinge to the two main planes of the face while also giving life to the pink half and restraining the luminous ochre of the other. The picture's method is not, however, dogmatic. There is enough tonal adjustment to the violet background where it meets the hair and to the green background where it meets cheek, neck and shoulder to create sufficient sense of space for the strong physical image.

p. 168: *Notes d'un peintre*

Chipp reprints Margaret Scolari Barr's translation (pp. 130–37). You should read this, both as the carefully weighed words of a master of modern painting and as an exceptionally intelligent attempt, from the inside, to set out the considerations and the method required by an art that is to express emotional responses with apparent spontaneity and vividness. It is also a very early document in this 'heroic age' and was eagerly consumed, more perhaps outside France than at home. As Chipp states (footnote, p. 130), Russian and German translations were published within one year of the essay's publication in French.

Although it is more pointed and structured than may appear at first reading, Matisse's essay does not amount to a programme for action. Much that he says is of wide and general validity and there is little that any group or movement could seize on as their particular orthodoxy. Notice, early on (p. 131), Matisse's assertion of the right to change his ways and also his complementary assertion that, whatever his ways, his goal is constant. Further on (p. 135), he stresses that his 'choice of colours does not rest on any scientific theory; it is based on observation, on feeling, on the very nature of each experience', and he distances himself from Signac's recommended reliance on theoretical knowledge. The sentence that seems to me most usefully and memorably to define both the goal and the methods of Matisse's mature art is 'I want to reach that state of condensation of sensations which constitutes a picture' (p. 132; a close and exact rendering of Matisse's original words).

p. 171: Matisse, *Le Luxe II*

Haftmann illustrates both versions, and a comparison of the two is most instructive (52 and 53). In the second almost all the colour areas are flat and the drawing of the figures has tautened immeasurably. There is a marked increase in monumentality—owing nothing to the classical traditions from which the subject derives, but closer to Byzantine and Oriental traditions. Notice the effect of turning the standing woman's visible foot, and the drawing of the same figure's right elbow and knee in the two versions.

The dating of *Le Luxe II* has been questioned. The first version was shown at the Salon d'Automne of 1907 as *Le Luxe (esquisse)*. The habitual dating of *Le Luxe II* springs from the assumption that Matisse painted it very soon after the first; there are reasons for arguing that some substantial interval came between them, during which Matisse refined his pictorial drawing and flattened his colour, and I incline to the view that *Le Luxe II* belongs to the year 1911. It appears in the backgrounds (if that is the right word) of *The Red Studio* (Haftmann 67) and *Le Grand Atelier* (Moscow), both painted in 1911, and it was exhibited (as Hamilton says) in Cologne and London in 1912 and in New York in 1913. It seems unlikely that Matisse would have sent a work to represent him that was already five to six years old.

p. 171: Matisse, *Dance* and *Music*

The *Dance* that Haftmann reproduces (68) is the almost full-size preliminary version with which the commission was clinched. Comparison with Shchukin's painting (Fig. 46) shows interesting changes, some that add to the energy of the figures and some (particularly in the figure at the right edge) that make the whole composition firmer. The colouring is much the same as that of *Music* (Fig. 47): reddish terracotta figures with brown hair, on top of a green hill against a deep blue sky.

Dance is Dionysiac; *Music* is Apollonian. Five unlinked figures, more or less male, sit or stand on the side of a hill and make music. They seem like notes on a stave,

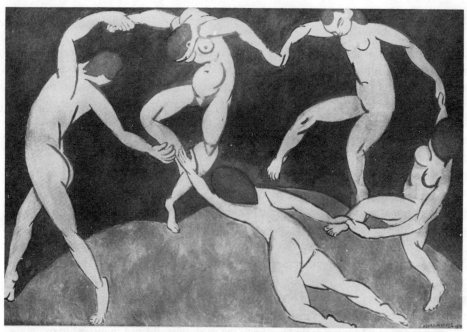

Figure 46 Henri Matisse, *Dance*, 1910, oil, 104 × 156½ ins (Hermitage, Leningrad © SPADEM 1976).

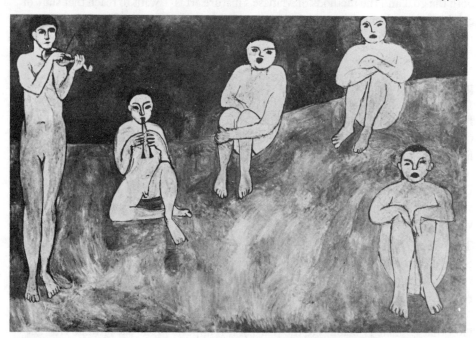

Figure 47 Henri Matisse, *Music*, 1910, oil, 104 × 155½ ins (Hermitage, Leningrad © SPADEM 1976).

especially the lumpier three to the right. In preparatory studies they are all more elegant and the hill is more varied in form and gracious in its decor: a dog lies sleeping in the foreground of one of them and simple flowers appear here and there. If *Dance* developed towards greater excitement, *Music* was pressed towards what would seem the greatest possible calm and stability.

Both paintings strike one as primitive, but this is not the stylistic primitivism, more or less directly learnt from African sculpture, of Picasso around 1907–08 (though Matisse was one of the first to acquire African carvings they do not make any self-evident appearance in his work). The immediate source of the dancing women is in Matisse's own *Joie de Vivre* (Haftmann 51), and it may be that some anthropomorphic representation of a few notes of music may have suggested the male figures.
One such source could have been the *Petit Solfège Illustré* of 1893, an introduction to the grammar of music with text by Claude Terrasse and illustrations by Bonnard. One of the preparatory drawings Bonnard did for these lithographs—the study for

Chapter II, page 8, in pen, ink and watercolour (exhibited in London in the mid 1960s but not now traceable)—showed squat, pink figures spaced like notes on a blue background and may well have been known to Matisse. He had not been interested in the work of Bonnard during the 1890s but there was mutual liking and respect between the two painters by this time. (We know that Bonnard visited Matisse's studio when the latter was working on *Dance*.) Matisse could also find support for his radical simplifying of forms and setting in the example of Gauguin: look, for instance, at Gauguin's print *Be in Love and You Will Be Happy* (Hamilton Fig. 40) for a similarly simplified squatting figure and a flat, two-colour background (and a dog, not unlike the one Matisse included in his preparatory studies).

The primitivism is partly in the subject—frenzied dancing by naked women on a bare hill; pastoral music performed by naked males (Shchukin's social delicacy required them to be emasculated). Compare *Music* with Hodler's *Day* (Haftmann 42) and other Hodlers for the disposition of figures effectively on one plane against a background formed of two broad elements. With Matisse's two paintings, as with Gauguin and Hodler, one feels that the subject has been drawn from the earliest ages of man: we see the first dancing, the first music.

p. 172: 'Matisse was never a Cubist'

Hamilton's sentence is very well judged. His Figure 90, *Bathers by a River*, shows how far Matisse could go in this direction.

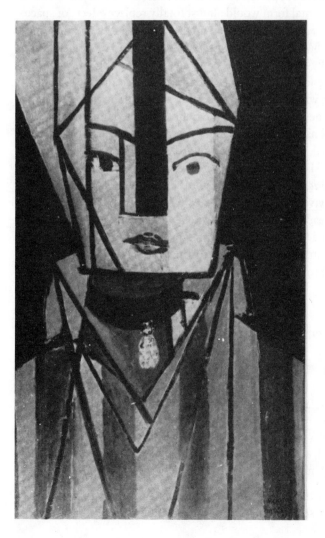

Figure 48 Henri Matisse, *Head, White and Rose*, 1914, oil, 30 × 18½ ins (Jean Matisse Collection, Pontoise © SPADEM 1976).

The climax of what was, in effect, a geometricizing tendency in Matisse's work coincided with the First World War. Matisse had tried to join the army but was rejected. He and his family spent part of the war in the south, at Collioure and Nice. During 1914–15 he saw a good deal of Juan Gris. A painting like *Head, White and Rose* (Fig. 48), for which Marguerite was the sitter, reflects influence from Gris and from other Cubists, such as Villon, in whose work geometry is most patent. At the same time it is apparent that Matisse, unlike them, did not start from a geometrical base but reached his simplified image from a naturalistic, objective starting point.

This architectonic tendency in Matisse's work during 1914–17 seems at first all the more surprising on account of the exceptionally delicate and fluid works that came during the preceding three years. It may be that the Shchukin commissions elicited a climacteric reaction. At any rate, the energy and concentration of those paintings is countered during the ensuing years by a decorative charm that belies the organizational austerity behind it. *The Red Studio* (Haftmann 67) is a famous example; *Interior with Aubergines* (Plate 10) is another.

In 1910 Matisse had gone to Munich to see an unprecedentedly large exhibition of Islamic art. The carpets impressed him particularly. He had earlier fallen in love with the Persian ceramics displayed in the Louvre. In 1911 he visited Moscow in connection with installing the Shchukin paintings; there, he felt, the essence of Byzantine painting was revealed to him through the icons he was able to see in collections and also in their proper habitat, the old churches and monasteries. He spent the winters of 1911–12 and 1912–13 in Morocco. In 1912 the Musée des Arts Decoratifs in Paris mounted an exhibition of Persian miniatures.

These experiences appear to have supported an instinctive move towards a decorative art in which colour and ornamental form would almost totally replace effects of space. The border of *Interior with Aubergines* is echoed in other paintings of the period (one of them, since destroyed, can be seen to the left in *The Red Studio*). The orchestration of that painting is exceptionally lavish: window, doorway, screen with contrasting material pinned to it, fireplace and the mirror between the fireplace and the screen, all compound the richness of the whole while also providing a controlling framework. There is some comparison to be made here with the richly patterned interiors, similarly lavish and making similar use of rectangular elements in order to structure the many optical events offered, of Bonnard and Vuillard in the 1890s (for examples see Haftmann 31 and 32, and Hamilton Fig. 51). It is clear that Matisse, after the primitivism of *Dance* and *Music*, is attaching himself to the *Intimiste* tradition but also pushing it to an extremity of vividness and complexity. Yet the same period and the same experiences could also lead him to subtler and no less beautiful results, as in the *Moorish Café* (Plate 11), a large but exceptionally condensed painting. It was shown, along with other paintings from Morocco, in Matisse's exhibition at the Bernheim-jeune gallery in Paris in April 1913.

p. 172: Matisse as Sculptor

Although Matisse frequently worked as a sculptor, his sculptures were long thought of as relatively minor aspects of his work. Today they are very highly regarded. In 1959 an exhibition of very nearly every Matisse sculpture was held at the Kunsthaus, Zurich: 68 sculptures were shown, to which one might have added the crucifix he made in 1950 for the chapel at Vence. Professor Albert E. Elsen's book (1972), concise and excellently illustrated, adds to these and links Matisse's sculptures to those of his predecessors and to his paintings. Much of what follows comes from Elsen.

In 1913 Matisse said to a reporter: 'I like to model as much as to paint—I have no preference. If the search is the same when I tire of some medium, then I turn to the

other—and I often make, "pour me nourrir" (to sustain myself), a copy of an anatomical figure in clay.'

On another occasion he said: 'I took up sculpture because what interested me in painting was a clarification of my ideas. I changed my method and worked in clay in order to have a rest from painting where I had done all I could for the time being. That is to say it was done for the purpose of organization, to put order into my feelings and find a style to suit me. When I found it in sculpture, it helped me in painting.' (Elsen, 1972, pp. 45–46). After a *Jaguar* (a free copy of a sculpture by Barye, 1899 – 1901) and a *Horse*, 1901, all Matisse's sculptures represent figures or parts of figures (heads, torsos, a foot). At first the influence of Rodin is paramount, though from the first he presses what he learnt from Rodin to conclusions outside Rodin's reach.

Figure 49 Henri Matisse, *Madeleine I*, 1901, bronze, 23⅝ ins high (Baltimore Museum of Art, Cone Collection).

Matisse detached himself gradually from Rodin's example through his study both of classical prototypes and of the relatively informal French sculpture of the eighteenth and the nineteenth centuries, including the fashionable work of the academies. He did not share Rodin's urge to produce grandiloquent statements on the human predicament.

Working from a model, but exaggerating the line of her pose, Matisse in 1901 modelled *Madeleine I* (Fig. 49). He did not approve of representing actual movement in free standing sculpture but permitted himself to range between the complexity of a twisted pose such as this one and four-square poses. Here the relatively unbroken surface of the figure (whose arms are truncated, one at the shoulder, one at the elbow) gives the undulating form a particular swiftness and lightness. It connects with painted figure studies of around the same date; it also has something in common with the streamlined little female, her back to us, to the left in the painting *Luxe, Calme et Volupté* (Plate 8).

If Elsen is right in dating the crouching *Small Torso* (Figs 50 and 51) to 1908 (the Matisse family date it 1929 but Barr too dates it around 1908), then we can see in it an especially illuminating instance of Matisse's transferring ideas between the media. The *Small Torso* echoes the pose of the flower picking girl to the left in *Joie de Vivre* and, turned around, that of the crouching girl in *Le Luxe I* and *II* (Haftmann 52 and 53). Seen in the three-quarter right front view, her silhouette has more than a passing resemblance to the squatting singers in *Music* (Fig. 47). Elsen states that this little sculpture did not have a modelled base on which to rest but was intended for picking up and turning in the hand.

Figure 50 Henri Matisse, *Small Torso*, 1908?, bronze 3 ins high, three-quarters front view (Private collection, Paris; photo: Patricia M. Elsen).

Figure 51 Henri Matisse, *Small Torso*, 1908?, bronze 3 ins high, three-quarters back view (Private collection, Paris; photo: Patricia M. Elsen).

La Serpentine (Figs 52 and 53) was modelled during the summer of 1909 at Collioure in the south of France. Not having a model there, Matisse based his figure on a photograph of the sort made for artists—girls in conventional art school poses. Between photo and sculpture, the figure has been rendered down: in the photo she is more than a little plump, while the sculpture is attenuated to a very remarkable degree. Matisse later wrote about this: 'I had to help me a photograph of a woman, a little fat but very harmonious in form and movement. I thinned and composed the forms so that the movement would be completely comprehensible from all points of view' (Barr, 1951, p. 139). A photograph by Edward Steichen (Fig. 54) shows Matisse at work on the figure, and the figure at a half-way stage between the model's fullness and *La Serpen-*

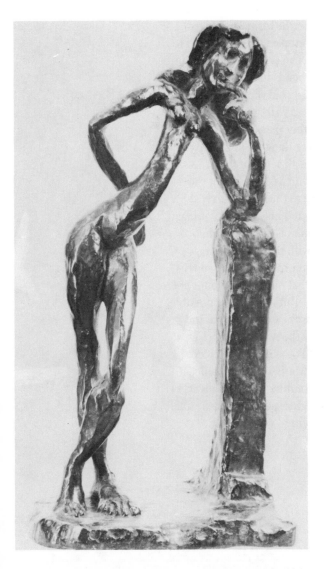

Figure 52 Henri Matisse, *La Serpentine*, 1909, bronze, 22¼ ins high, front view (Baltimore Museum of Art, gift of a Group of Friends of the Museum © SPADEM 1976).

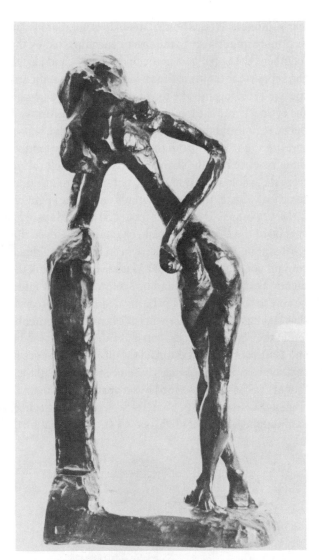

Figure 53 Henri Matisse, *La Serpentine*, 1909, bronze, 22¼ ins high, back view (Baltimore Museum of Art, gift of a Group of Friends of the Museum; photo: Victor Waddington © SPADEM 1976).

Figure 54 Edward Steichen, photograph of Matisse modelling *La Serpentine* (Museum of Modern Art, New York, Steichen Archive).

tine's thinness. Notice how Matisse does not merely pare down the forms and give ever more importance to the spaces encompassed by the various parts of the body. He lengthens the upper part of the body slightly and also the left arm so that it can rest on the support; at the same time he lengthens the right arm and bends its wrist so that the hand rests against the top of the left buttock, making a partly curved line that leads the eye back into the torso instead of ending abruptly. The head with its long hair, the pelvic region and the feet are locations of relative mass; the other parts of the sculpture are slight and swift in the sense that the eye tends to travel along them fluently— though notice how the slight emphasis on the left calf removes all sense of flimsiness from the whole as body and as structure (try to imagine it as thin as the thigh of the same leg). Again, the figure reminds one of the slight creature to the left in *Luxe, Calme et Volupté*. But she was modelled after Matisse had painted his large preliminary version of the *Dance* (Haftmann 68) and when, even though he was away from his Paris studio, his mind must have been full of thoughts to do with that important commission. I said before that Matisse did not think that the representation of movement was suited to free standing sculpture, so it would seem that modelling would not be able to help him with a painting dedicated to precisely that. But it is at least possible that making *La Serpentine* will have clarified his intentions for the long figure to the left in the *Dance*. I suggest you make the comparison between the two versions (Fig. 46 and Haftmann 68) and estimate the effect the changes have. (You will have noticed that some important changes have been made in all the feet.) Matisse also modelled a foot in 1909, a foot described by an anatomist as that of a 'masculine woman dancer' (Fig. 55; Elsen, 1972, p. 110). Its pose is tiptoe, the heel as high as possible. In the final painting the left figure's left foot is a stretched and further uplifted version of it.

Figure 55 Henri Matisse, *Study of a Foot*, 1909, bronze, 11¾ ins high (Collection Charles E. Slatkin Galleries, New York © SPADEM 1976).

There was nothing habitual about Matisse's attenuating of natural form in his sculpture. His *Madeleine I* had more or less classical proportions; there were accidental ancient prototypes for omitting limbs as well as plenty of recent precedent for it also in the work of Rodin. Rodin also at times attenuated the figure and if he wanted precedent for it he could find it at various points in the history of sculpture—in Romanesque and Gothic sculpture, for example, and in the Etruscan bronzes he could see in the Louvre and in his own collection. *La Serpentine* has something of an Etrus-

can bronze about her—the sleekness of the stretched torso, the emphasis on the lower half of the legs. It is possible that Matisse knew Rodin's collection; in 1899, when out of his limited funds he bought himself the Cézanne *Three Bathers* (see Unit 7, p. 13), he also bought Rodin's plaster bust of Henri Rochefort.

In 1908 both Matisse and Rodin moved into the former Hôtel Biron, which became the Musée Rodin after Rodin's death, so that they were in close proximity until Matisse and his family moved out to the Paris suburbs in the autumn of 1909. Rodin's most radically attenuated sculptures are the dancing figures he modelled under the impact of the dancers from Java and Cambodia who performed in Paris in 1906, and of the Russian Ballet—the Diaghilev company, with Nijinsky and Pavlova and Fokine as choreographer—that made its debut before an enraptured Paris in 1909 and returned every year until 1914.

These have an emphatic linearity that seems close to Matisse's in *La Serpentine*, yet Matisse distorts more freely and achieves a clear structure with focal points of rest and passages of transition rather than, as does Rodin, merely to capture, however brilliantly, a moment in a succession of movements. I illustrate Rodin's *Dance Movement F*, a particularly inventive example (Fig. 56).

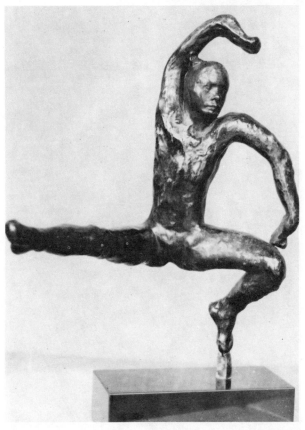

Figure 56 Auguste Rodin, *Dance Movement F*, 1910–11, bronze, 7 ins high (Rodin Museum, Paris © SPADEM 1975).

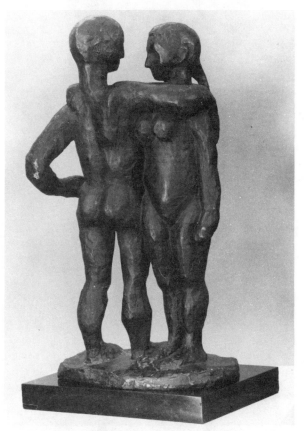

Figure 57 Henri Matisse, *Two Negresses*, 1908, bronze, 18½ × 9⅝ × 7¼ ins (Joseph H. Hirshhorn Museum and Sculpture Garden, Smithsonian Institute, Washington DC © SPADEM 1975).

Attenuation was only one of the expressive means open to Matisse—in *Two Negresses* of 1908 (Fig. 57), also based on a photograph, he gave the girls stockier bodies than the models—but it was, so to speak, in the air: Lehmbruck's *Kneeling Woman* of 1911, for example (Hamilton Fig. 97). Lehmbruck worked in Paris from 1910 until 1914 and was acquainted with Matisse; his elongation of figures was, however, unlike Matisse's in purpose and effect. Lehmbruck's elongation is a sort of Gothicization of Mediterranean types. The effect is certainly expressive, but he would seem to have had only one feeling or thought to express. Other sculptors about this time were making more obviously radical attempts to substitute new methods for the traditional one of repre-

senting forms by imitating them. Archipenko's *Walking*, 1912 (Hamilton Fig. 158) uses voids and hollows where we expect solids and protuberances. I see Matisse's process in *La Serpentine* as connected with this sort of development. A portrait bust of his daughter, *Head of Marguerite* (Fig. 58) is quite shockingly contracted: the profiles are fairly realistic but the full-face view is very narrow. The vitality of the head is such that it soon takes on normality.

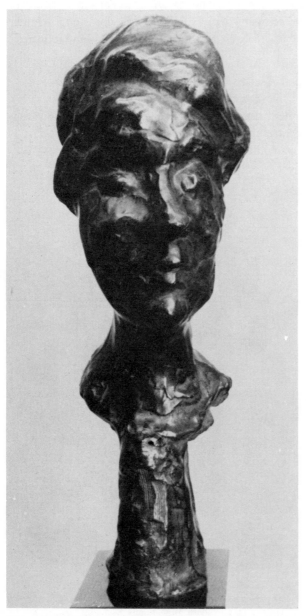

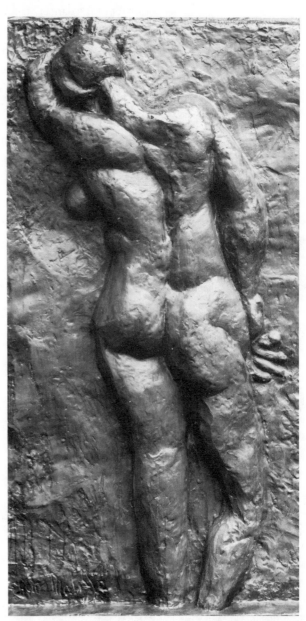

Figure 58 Henri Matisse, *Head of Marguerite*, 1915, bronze, 12⅝ ins (Collection Pierre Matisse; photo: Alfred Elsen © SPADEM 1976).

Figure 59 Henri Matisse, *Back O*, *c.* 1909, photographed by Druet (Musée Nationale d'Art Moderne, Paris; photo: courtesy of Service Photographique des Musées Nationaux).

Finally, I illustrate all four versions of *The Back*, plus what Elsen calls *Back O* which preceded them and which is known only from an old photograph (Figs 59–63). I suggest that you study these with some care. Consider also the relationship of these figures to the little Cézanne *Three Bathers* painting that Matisse had owned since 1899 (Unit 7, Fig. 4). Follow also Hamilton's implied invitation to compare them with Matisse's painting, *Bathers by a River* (Hamilton Fig. 90).

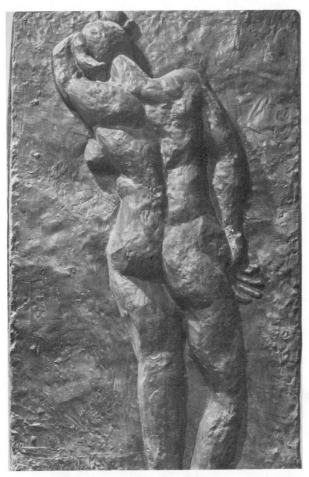

Figure 60 Henri Matisse, *Back I*, 1909, bronze, 74½ ins high (Tate Gallery, London © SPADEM 1975).

Figure 61 Henri Matisse, *Back II*, 1913, bronze, 74½ ins high (Tate Gallery, London © SPADEM 1975).

Figure 62 Henri Matisse, *Back III*, 1916–17?, bronze, 74½ ins high (Tate Gallery, London © SPADEM 1975).

Figure 63 Henri Matisse, *Back IV*, 1930, bronze, 74½ ins high (Tate Gallery, London © SPADEM 1975).

p. 180: 'Modern German painting and sculpture may seem to lack any consistent direction'

Hamilton may be right in saying this, but bear in mind that he is setting a whole swathe of German art against, in effect, two movements or episodes in French art. What is striking is (a) the rapidity with which phenomena that one can reasonably call Expressionist appear in the German speaking world, in art first and soon after in literature, music and architecture, and (b) to what extent Expressionist attitudes show through widely diverging activities, so that Expressionism often seems to be a matter more of motivation than of method or style. One is led to think that this motivation reveals something inherently Germanic. The Expressionists themselves are liable to trumpet forth their German-ness or their Nordic-ness. They saw Expressionism as a second attempt, Romanticism being the first, to break through an alien cultural veneer laid over it by the influence of Italy during the Renaissance and France thereafter in order to reveal the German soul.

'Intellectuals and learned men call me an Expressionist', wrote Nolde (admittedly an extreme case, but similar noises are made by others). 'I do not like this narrow classification. A German artist, that I am' (Whitford, 1970, p. 52). Thus for him Expressionism = *vox Germaniae*.

Of course, it's more complicated than that. Expressionists looked back to the Romantics—to Goethe and Schiller, Hölderlin and Novalis and philosophers such as Schlegel—as more or less immediate precursors. Many of them also looked to the period of the Reformation and to artists such as Dürer, Altdorfer, Baldung Grien and Cranach as forerunners who could offer a weighty and essentially German example to a nation experiencing an exhilarating and rather sudden rebirth. At the same time, German Expressionism, which included, and thrived on the presence of, a number of notable foreigners (Kandinsky is the most important) could not but be interested in what was going on in Paris, and fed at least as avidly as Paris on exotic and primitive artefacts.

Hamilton is right to stress the decentralized nature of German culture and also the advantages that accrue from this. Until the '30s the cultural centres of Germany—Munich, Dresden, Berlin, Cologne, Stuttgart, Frankfurt, Weimar and others (plus, in effect, Vienna)—could offer a whole range of opportunities and publics; in addition, there were many more potential middle-class patrons for new art in Germany than elsewhere, and often these were connected with art institutions, so that in 1920 or 1930 more good modern art could be seen in German public and private collections than anywhere else.

p. 180: 'a kind of communication'

In an article on 'Edvard Munch's Expressionism' (1953) the painter Oskar Kokoschka described expressionism as 'form-giving to the experience, thus mediator and message from self to fellow human. As in love, two individuals are necessary. Expressionism does not live in an ivory tower, it calls upon a fellow being whom it awakens'.

This vivid description strikes deeper than Hamilton's cool phrase. But it also raises the question whether all art is not a message between humans. Where Expressionism differs is in the *kind* of message that is purveyed and in the *means* used to purvey it. The message will tend to be about contemporary life, the artist's and his fellow humans', and will usually be offered direct, without recourse to allegory or symbolism. The artist invents or is drawn to subjects that reveal his meaning without depending on the viewer's education. His manner will often stimulate the viewer to an emotional response—both through direct sensory stimulation, often by means of colour, and

also through association, as when spiky shapes or the distortion of the human figure suggest aggression or pain or when brushstrokes suggest agitation in the painter. Specific messages, whether political or social, are surprisingly rare in Expressionist art (they are plentiful in Expressionist writing). Where art is entirely non-representational communication can still function through associational responses as well as through sense stimulation; artists like Kandinsky and Klee, much of whose work is totally abstract, were conscious of communicating through means analogous to those of music (unlike pioneers of abstraction like Malevich and Mondrian who could perhaps be described as abstract symbolists as opposed to abstract expressionists).

p. 191: Modersohn-Becker

Modersohn-Becker (the name also appears, not incorrectly, as Becker-Modersohn) was a remarkable painter. Art history allows little attention to artists who do not make much impact on the art that follows them. This is understandable but short sighted. In my view, the study of twentieth-century art has suffered from too great a concentration on public events such as movements and manifestos, as well as from presentation as a succession of changes of direction.

Hamilton's and Haftmann's reproductions (Hamilton Fig. 102 and Haftmann 143 and 144) unfortunately overlap: they illustrate only two works between them and those illustrate only one aspect of her varied work. When she died at the age of 31 (of a heart attack a few days after having a child) it looked as though she was about to become Germany's first and most devoted Cézannist. Before that she had been profoundly impressed by Gauguin as those illustrations show. (Hamilton rightly points to the fact that the old woman in his Fig. 102 is derived from Van Gogh, his Fig. 46; but this shows Van Gogh at a time when he was striving to paint like Gauguin; Modersohn-Becker makes the figure even more Gauguinesque and the spirit of her picture is much closer to Gauguin's poetic symbolism than to Van Gogh's heightened, tense realism.)

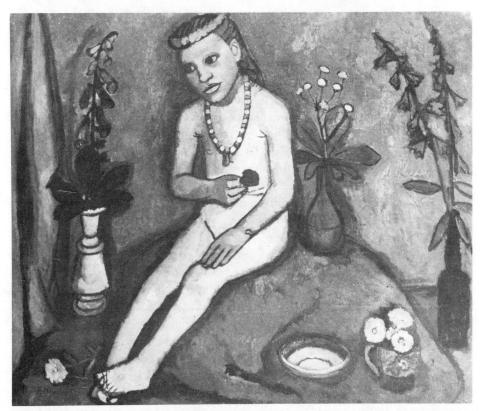

Figure 64 Paula Modersohn-Becker, *Seated Girl*, 1907, oil (Wuppertal Museum; photo: Studio Santvoort, courtesy Fr Modersohn).

Her painting *Seated Girl* (Fig. 64), done in her last months, still shows Gauguin's influence and little or nothing of Cézanne's. Had it been painted in Paris one would have associated it with the Fauve movement; in Germany it antedates the *Brücke* painters' shift from Neo-Impressionist to Fauve processes. Modersohn-Becker's repeated visits to Paris had brought her into contact with painters whose work bore the imprint of Gauguin in different ways. When she worked at the Académie Julian she was taught by Vuillard and Maurice Denis, among others, so that she had direct contact with a whole range of Gauguin based developments, but *Seated Girl* suggests contact also with the work of Matisse. *Mother and Child*, though probably not much earlier, is a painting of a rather different sort (Fig. 65). Both pictures are primitivist through simplification and through their innocent, unsophisticated subject matter. *Mother and Child* has a monumentality that the later painting shuns, at once classical in its presentation and balance and anti-classical in its lack of idealization.

Figure 65 Paula Modersohn-Becker, *Mother and Child*, 1906–7, oil, 33 × 50½ ins (Ludwig-Roselius Sammlung der Böttcherstrasse, Bremen, courtesy Fr Modersohn).

Such unclassical humanism would normally suggest the example of Cézanne, but in this case support probably came from the art of a painter who is still little known outside Germany yet whose achievements were, in this and other respects, comparable to Cézanne's. I refer to Hans von Marées whom Hamilton mentions as inspiring Fiedler's theory of 'pure visibility' on p. 181 but otherwise leaves to Novotny's volume on nineteenth-century art in the Pelican series (Novotny, 1971). Marées, in reaction against the academies' devaluation of antique and Renaissance classicism, had taken the human figure in landscape as his theme and, avoiding narrative and symbolism, had given his attention to creating a monumental and harmonious formal pictorial structure in which colour and form relationships, relentlessly simplified, would carry all essential communication. His art, like Puvis de Chavannes', was ideally suited to mural painting, but he had only one opportunity for that: in 1873 he painted a cycle of frescoes in the Zoological Institute in Naples (they impressed Klee deeply when he saw them as a young painter in 1902). Otherwise he tended to create a kind of mural setting for his major paintings by presenting them as triptychs complete with an elaborate painted setting (Fig. 66). Novotny speaks of 'Marées's imperturbable concentration on the most elementary bodily forms, and on relationships between body and space', but behind this imperturbability of effect lay ceaseless emendations and adjustments of the painting, as the massiveness of his paint surfaces indicates. Modersohn-Becker's picture echoes both his concentration and his large forms.

Figure 66 Hans von Marées, *The Hesperides II*, 1884–85, tempera on panel, 137 × 194 ins (Bayerische Staatsgemaldesammlung, Munich).

p. 193: Nolde, Hölzel

Nolde's is one of the big names of the Expressionist movement. What follows is intended to complement Hamilton's account and the illustrations provided by him and by Haftmann. You should also read Chipp's excerpt from Nolde's autobiography (Chipp, pp. 146–51) which includes the thoughts Nolde jotted down for a book he intended to do on primitive art.

> Beyond any other artist in the movement, he contributed a *mystique* of the soil, a *Blut und Boden* (Blood and Soil) factor. Undoubtedly important as a manifestation of Nolde's close identification with nature, this carried within it a certain peasant narrowness and potential cruelty that were expressed in his violently mystical and basically non-humanistic art. Nolde's approach to art, as to life, was emotional rather than intellectual; his work in every medium shows a consistently direct attack on the problem in hand. Few preparatory drawings were made for the paintings (there are some studies); and in woodcut he began to gouge the block without preliminary outlines on its surface, The water-colors, the final measure of his directness and spontaneity, are among the best in modern art.
> (Myers, 1963, p. 128)

Nolde's watercolours are indeed fine, especially when, in painting such things as flowers, he used colour richly and fluently without pushing it far beyond naturalism. His woodcuts, too, are amongst the most powerful works done in that medium. His mature oil paintings have a stridency that at times seems habitual rather than necessary but that at other times, as in the *Life of Christ* polyptych of which Hamilton speaks (p. 194 and Fig. 103), enables him to give new life and personal expression to traditional subjects that the twentieth century has rarely handled successfully. Figure 67 shows the whole polyptych; I also illustrate, to help with Nolde but also for the

Figure 67 Emil Nolde, *Life of Christ* polyptych, 1911–12, oil (Stiftung Seebull Ada und Emil Nolde).

Figure 68 Matthias Grünewald, Isenheim altarpiece (showing the Crucifixion, mourning over the dead Christ, and two saints), *c.* 1513–15, oil on panel (Colmar, Musée d' Unterlinden; photo: Giraudon).

better understanding of Expressionism generally, the famous Isenheim altarpiece by Matthias Grünewald, painted about 1513–15, which appears to have been part of every Expressionist's mental museum (Fig. 68).

Hamilton refers also to Adolf Hölzel as an important influence on Nolde (p. 193; on p. 134 he briefly discussed Hölzel's experiments with form and colour, and on p. 333 Hölzel is mentioned as Itten's teacher—but he eluded whoever prepared the index). Since writers generally skip lightly over Hölzel, I'll summarize his life, work and ideas here.

Born 1853 at Ölmütz in Moravia; 1871 family to Vienna, where he studies at the art academy: 1876 on further studies at Munich academy; 1882 visit to Paris; 1888

settles in Dachau; works in Impressionist manner; early 1890s starts his private school (partly for income's sake); Nolde amongst his early pupils; starts working out his colour theories and general concepts of art; 1903 his first substantial public presentation of his theories in lecture on 'Artistic Means of Expression and their Relationship to Nature and to the Picture', printed 1904 in *Kunst für Alle*; 1905 first firmly abstracted painting, *Composition in Red I*; moves to Stuttgart to teach at academy (until 1919); among his pupils were to be Johannes Itten, Oskar Schlemmer and several other substantial figures in German and Central European art; 1913 travelling exhibition of his drawings shown in Berlin, Munich and Stuttgart; 1914 commissioned by Theodor Fischer to create a series of murals for the entrance hall of that year's Deutscher Werkbund exhibition in Cologne, works on it with his students (including Schlemmer), also first commissions for stained glass compositions; 1916–18 Director of Stuttgart academy; 1916 exhibition 'Hölzel and his Circle' presented by the art society of Freiburg, bringing together work by Hölzel and his pupils; 1917 series of small, very experimental paintings entitled *Farbige Klänge (Kompositionen und Phantasien)* ('Coloured sounds, compositions and fantasies'); 1918 first retrospective exhibition of his work shown by the Kestner-Gesellschaft in Hanover (a remarkable society founded in 1916 to support modern art through exhibitions, lectures, publications, etc., and still active today); the entire exhibition was acquired by local stationery firm, the Gunther Wagner company, makers of 'Pelikan' products. Further exhibitions and commissions follow; he attempts but fails to achieve thorough reform of art teaching in the academies; 1933 second 'Hölzel and his Circle' exhibition planned for Stuttgart cancelled for political reasons; 1934 Hölzel dies, aged 81.

Some of his often apothegmatic statements:

> Absolute art is that art in which the power of the means of art is least 'abated'.
> The subject in a work of art does not create harmony, in the musical sense . . . the picture does not have any need of a subject.
> The picture makes demands which cannot be met from nature (in the usual sense of nature). That is the basic problem in painting.
> Every line expresses something.
> The fundamentals are: line (vertical, horizontal, diagonal, straight, crooked, curved), form (triangle, square, circle), tone (light, dark, middle tone), colour (red, blue, yellow). That is what you have to work with.
> For the creative artist art can only mean expressing inner experiences through the available means.

Once Hölzel had found his way through realism and Impressionism his work and thought started from a supposition akin to Maurice Denis's statement of 1890, itself reflecting the words and example of Gauguin: 'Remember that a picture—before being a battle horse, a nude woman or some anecdote—is essentially a plane surface covered with colours assembled in a certain order'. His preferred compositional basis was instinctual, sometimes with the support of an all over geometric grid on which to establish the main forms and rhythms. His process was not that of abstracting from natural appearances, but the opposite: to start with a dividing up of the picture surface into generalized forms and their establishing in terms of a colour harmony, and then the development and annotating of the emerging image towards a more or less recognizable subject. The themes were often biblical, in a very generalized way; thus several of his pictures are called *Adoration*, which could refer to worship in general or the particular stories of the adoration of the Christ child by the Magi or the Shepherds. Other paintings reflect landscape themes. Until 1927 he worked principally in oil on canvas, but Plate 12 reproduces a very remarkable oil + collage painting, *Gebet der Kinder* ('Children's prayer') of 1916. I read this composition as representing the Madonna and Child surrounded by a U-shaped ring of kneeling and standing figures.

A picture like *Heimkehr* ('Returning home'; Fig. 69) of 1910, rich in colour and consisting of boldly simplified forms that make a flat pattern, is very close in character and feeling to contemporary works by Kandinsky. After 1927 Hölzel worked principally in pastel. He always made experimental drawings; Figure 70 reproduces such a drawing: it shows clearly how free, instinctive marks and rhythmically placed patches could be the starting point for a figurative subject.

Figure 69 Adolf Hölzel, *Heimkehr*, 1910, oil on card, 17 × 21 ins (Private collection, courtesy Doris Dieckmann-Hoelzel).

Figure 70 Adolf Hölzel, *Abstract Composition*, 1931, pastel, 20 × 27 ins (Private collection, courtesy Doris Dieckmann-Hoelzel).

p. 197: Wilhelm Worringer

Accounts of modern art, and of Expressionism in particular, pay a good deal of attention to Worringer, a former student of Theodor Lipps, whose doctoral thesis of 1907, *Abstraction and Empathy*, was published as a book in 1908, to be followed by a book on Cranach, also published 1908, and *Form in Gothic*, from which Hamilton quotes, in 1911.

If Hamilton, referring to him only briefly, implies that Worringer's historical importance may have been exaggerated, I incline to agree with him. There is, first, the general point that ideas are successful in the way that his were only when they echo, and perhaps give clearer expression to, ideas or notions already abroad; second, there is little evidence that artists in general read Worringer's books and some evidence that some of those whom one would expect to have read them hadn't. It is said that Kandinsky met Worringer in 1908 and that Worringer's *Abstraction and Empathy* served to clarify Kandinsky's thoughts as expressed in *Concerning the Spiritual in Art*. 1908 was certainly a year in which Kandinsky's painting moved firmly towards abstraction, though it was some years before Kandinsky's abstract expressionism was born. There is little in *Concerning the Spiritual* that requires Worringer's influence. In July 1911 Macke wrote from Bonn to Kandinsky's friend Marc to ask whether Marc knew *Abstraction and Empathy* and recommending it. ('I have read it, and found parts of it very good.') In February 1912 Mrs Marc wrote to Mrs Macke to say that she has been reading the Worringer book which Macke has been good enough to lend her and her husband. In the same month Marc wrote to Kandinsky to say that he had just been reading *Abstraction and Empathy* and recommending Worringer as a disciplined and cool writer who might be asked to contribute to the second *Blaue Reiter* almanac they were planning. In other words, until then Marc had not read any Worringer, and Kandinsky had not proposed him as a contributor—indeed it seems that Marc and Kandinsky had never discussed his work.

There is no evidence that Worringer's writing had an impact on the *Brücke* artists.

Peter Selz gives a good summary of the main ideas expressed in *Abstraction and Empathy* and in *Form in Gothic* (Selz, 1957, pp. 8–14).

p. 198: 'four architectural students'

It is worth stressing that Kirchner was the only one who had had any professional art training. Also that, in moving from architecture to art, the four were going in the opposite direction to the several late nineteenth-century artists who hoped to serve society by abandoning art for architecture and design (the most famous of them is Van de Velde). What their impulse was is implied in Kirchner's reaction to a contemporary-art exhibition he saw in Munich, presumably in 1903 or '04: 'The paintings were dull in design and execution, their subjects totally uninteresting, and it was quite evident that the public was bored. Indoors there hung those anaemic, bloodless and lifeless studio daubs; outside there was life, loud and colourful, pulsating in the sunshine.'

Those last words describe the best *Brücke* art very well but it took some years before Kirchner, Schmidt-Rottluff and Heckel had reached the energetic, colourful, often slapdash primitivism that still radiates energy and excitement. Their subjects, like those of the Fauves, were drawn from their own lives: their immediate surroundings, themselves and each other in portraits, girls, especially naked girls frolicking on the edge of a lake during the summer holidays—not professional models, but their own girl friends, more like real life and cheaper too. Such art, they hoped, would make easy contact with other people, since it would be cheerful and bright and devoid of in-

tellectual difficulties. In fact they sold hardly any paintings until Expressionism became respectable after the 1914–18 war; it seems they all had some private means (and could have lived more elegantly than they did), and they did have some success in acquiring lay members of the *Brücke* who, in return for a subscription, received a little woodcut print in the form of a membership card (Fig. 71) and, from 1906 on, an annual print album containing a title page plus three prints.

Figure 71 Karl Schmidt-Rottluff, Passive membership card of *Die Brücke*, 1911, woodcut on orange card, 6¾ × 5 ins (Private collection; photo: Monika Leonhardt, Brücke Museum, courtesy Professor Karl Schmidt-Rottluff).

Brücke prints derive their idiom from Gauguin, Munch, primitive art objects which they could see in the Dresden ethnographical museum and Nolde; their best paintings —I should say those of 1908 to 1912, roughly, plus a very few later ones—owe a lot to Matisse, something to Munch and Nolde, and a little to German late mediaeval painting. On p. 200 Hamilton speaks of the influence of Cubism on Kirchner, but it seems to me that the kind of structure he employs for his street scenes (Hamilton Fig. 107, Haftmann 133 and especially Haftmann 132) comes from German paintings such as the fifteenth-century *Karlsruhe Passion* altarpiece by Hans Hirtz (Fig. 72): a lot of vertical forms disposed on a plan that makes much use of diagonals, and a liking for spikey, pointed shapes that in Hirtz's case belong partly to the particular subject and in Kirchner's case serve to express something of the edginess and stridency of modern city life.

Exercise

To get closer to *Brücke* painting, I suggest you make a careful comparison of two Kirchners: (a) the *Self Portrait with Model* (about 1909–10; Haftmann 129) and (b) *Erna with Cigarette* (1915; Plate 13). Both seem to me exceptionally fine paintings. When you have made a systematic comparison, read what follows.

Discussion

Colour In (a) the colour is exceptionally vibrant, partly through the intensity of the individual hues and partly through their mutual enhancement through contrast: orange versus blue, pink or red against green. In (b) the colours are less vocal: yellow, green, black and grey lie down peacefully if a little grimly together: the red touches in the woman's hair, lips, nostril and ear, and in the things on the table, do not markedly enliven the scene.

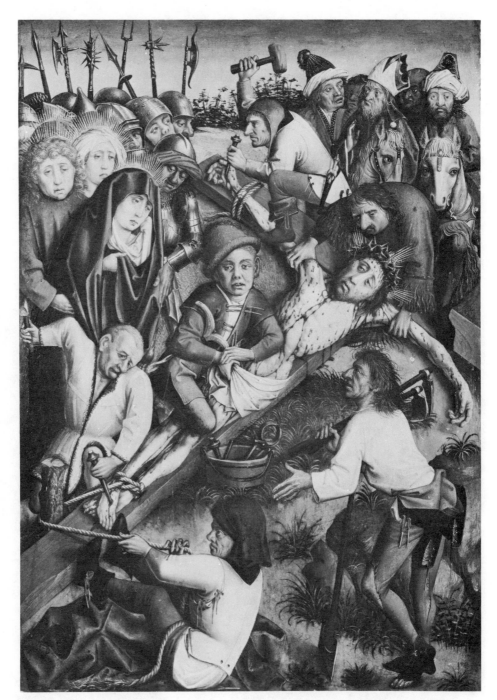

Figure 72 Hans Hirtz, *Christ nailed to the Cross (Karlsruhe Passion)*, (Staatliche Kunsthalle, Karlsruhe).

Structure The black jacket or jersey in (b) supplies the main division and formal theme of the painting—a rising triangle with the woman's head as apex. The tray makes an echoing triangle pointing downwards from the edge of the table which functions as a kind of horizon. The left half of (a) is devoted to the figure of the artist; its strong horizontal bands of colour contrast with the bittiness and verticals of the right half. In spite of its apparent spontaneity, the picture turns out to be constructed on a vertical division down the middle of the canvas and a horizontal division halfway up in the right half. (The rather obtrusive black band separating the man's dressing gown from the red seat to the right of it, serves to push the girl into the middle distance.)

Handling Although there are rough and broken passages in (a), most of it looks smooth and flat, even firm in places (compare the pink and green at top right with the background colour areas in Matisse's *Madame Matisse, the Green Line* (Plate 9), and

note the little green line beside the girl's nose, functioning here more as shadow, i.e. as tone, than as a colour capable of placing the adjacent colour areas in space). In (b) the brushwork is intentionally restless and jagged, echoing the sharp features, and suggesting intensity in the woman as well as in the wider human condition.

p. 200: Kirchner's Sculpture

Kirchner, Schmidt-Rottluff, Heckel and also Pechstein made occasional scuplture; with the first three one feels that it was to some degree a kind of byproduct of their woodcuts. At any rate, Kirchner's really very powerful double relief, *Man Dancing Between Women* on one side and *Ascent of the Alps* on the other was intended as a door in a house he hoped one day to build (Fig. 73). He carved it when recuperating from an illness in Switzerland and the subjects are thought to represent, respectively, his earlier unhappy sexual life and his present life amid nature and peasant activities. Stylistically it is close to Kirchner's woodcuts. Schmidt-Rottluff's *Two Nudes* relief

Figure 73 Ernst Ludwig Kirchner, *Man dancing between Women* and *Ascent of the Alps*, 1918, double relief, wood, each panel 72 × 35 × 4¼ ins (Collection Karlheinz Gabler, Frankfurt am Main, courtesy Roman Norbert Ketterer).

Figure 74 Karl Schmidt-Rottluff, *Two Nudes*, 1911, wood relief, 7¾ × 11 ins (Brücke Museum; photo: Monika Leonhardt, courtesy Professor Karl Schmidt-Rottluff).

Figure 75 Karl Schmidt-Rottluff, *Head*, 1917, wood, 14 ins high (Tate Gallery, London, courtesy of Professor Karl Schmidt-Rottluff).

(Fig. 74) could almost be a woodcut block. Cutting the wood gives his prints and this relief a firmness that his drawings lack. His *Head* of 1917 in the Tate Gallery is a different kind of object (Fig. 75). One of the several sculptures done by him in that year, it is close to African sculpture (of which he had a fine collection) and an aggressive, phallic object. Only Brancusi, in Paris, had pressed his sculpture to a comparably ruthless primitivism.

p. 205: Kandinsky

The two most important artists to be mentioned in this unit are, almost beyond argument, Matisse and Kandinsky. Hamilton gives a relatively generous amount of space to Kandinsky's ideas and work (pp. 205–13 and 337–40) and his name occurs frequently in the pages Hamilton devotes to the other artists associated with the *Blaue Reiter* almanac and exhibitions. Haftmann provides a good number of illustrations, also in two parts (295–306 and 786–95). We shall for the purposes of this unit be concerned mostly with the first section of text and plates—with Kandinsky up to about 1920. That means the greater part of his written work too: *Concerning the Spiritual in Art*, the basic Kandinsky text (Chipp provides a translation of Chapter 5 on pp. 152–55); his long essay 'On the problem of form' published in the *Blaue Reiter* almanac in 1912 (Chipp gives the whole of it, pp. 155–70); and a second book, *Point and Line to Plane* published in 1926 as volume 9 in the series of *Bauhaus-Bücher* but conceived, as Kandinsky emphasized in the preface, in 1914. How much of his texts you should read depends partly on how well you can cope with his kind of clear but somehow remote thinking. Translation adds its own distance. If you find the material difficult then I suggest you familiarize yourself with a few pages by reading them two or three times, rather than attempt the lot—say, the first pages of 'On the problem of form', from p. 155 to the very top of p. 162 perhaps. Here I shall draw your attention to one or two points. Kandinsky refers incessantly to 'inner' and 'outer'. On p. 205 Hamilton quotes 'inner sound of things' and 'The word is an inner sound'. In Chipp you will find 'an internal meaning and an inner resonance' (p. 153), 'the inner urge' and 'the internal condition' (p. 155), 'the inner development and the outer culture' (p. 156), the key statements 'The form is the outer expression of the inner content' (p. 157) and 'the most important thing in the question of form is whether or not the form has grown out of the inner necessity' (p. 158), and so on. There are also frequent references to 'soul' and 'spirit' which roughly indicate the passive or receiving and the active and creative forces in ourselves.

In 1913 Kandinsky published an article in the magazine *Der Sturm* which summarized his concept of inner and outer in the work of art. Part of it appeared in English the following year and that, slightly amended, is given as a footnote in the 'The Documents of Modern Art' reprint of *Concerning the Spiritual in Art* (1947). I quote the beginning of that footnote:

> A work of art consists of two elements, the inner and the outer.
> The inner is the emotion in the soul of the artist; this emotion has the capacity to evoke a similar emotion in the observer.
> Being connected with the body, the soul is affected through the medium of the senses—the felt. Emotions are aroused and stirred by what is sensed. Thus the sensed is the bridge, i.e., the physical relation, between the immaterial (which is the artist's emotion) and the material, which results in the production of a work of art. And again, what is sensed is the bridge from the material (the artist and his work) to the immaterial (the emotion in the soul of the observer).

Here is a clear statement of Kandinsky's view of communication in art. Abstract or

figurative, hard or soft edged, or whatever other secondary elements a particular moment in time or the particular means available to an artist may impose or elicit, the essential matter of art is the transmitting of this inner burden through external forms.

Kandinsky was a profoundly educated man, visually, verbally and also aurally; it is clear that music was of especial importance to him and one imagines that his view of art may have been clarified by his desire to understand how music functions. He had a special passion for Wagner.

Wagner wrote:

> Man will never be that which he can and should be until, by a conscious following of that *inner natural necessity* which is the only true necessity, he makes his life a mirror of nature, and frees himself from his thraldom to outer artificial counterfeits. Then will he first become a living man, who now is a mere wheel in the mechanism of this or that Religion, Nationality, or State.

This is quoted by George Bernard Shaw at the end of his *Appendix to the Quintessence of Ibsenism* (1891). The phrase 'inner necessity' is picked up by Shaw elsewhere. Perhaps Kandinsky read Wagner as well as heard him. He is even more likely to have read Schopenhauer, whom Wagner certainly had read: in *The World as Will and Idea* (1819) Schopenhauer wrote about music's unique ability to 'speak of the Will itself' directly rather than address itself through some objective representation of the world: 'The composer reveals the inner nature of the world, and expresses the deepest wisdom in a language which his reason does not understand; as a person under the influence of mesmerism tells things of which he has no conception when he wakes' (English translation, n.d.). It is evident that Kandinsky claimed the same sort of directness for art—and not only for abstract art as we might expect but, he insists in 'On the problem of form', in true realism as well ,'just now budding for the first time', that involves a disregard for the qualities of seen objects traditionally regarded as artistic in order to 'expose more surely the inner resonance of the thing' (Chipp, p. 161).

But it is likely that Kandinsky codified his views also through studying Goethe. The end of the nineteenth century saw a tremendous revival of interest in the multifarious works of that extraordinary man, and Expressionism is full of references to him, direct and indirect. In *Wilhelm Meisters Wanderjahre* (1795–96), for instance, Goethe suggests that scientific knowledge tends to make it more difficult for man to understand himself and the world. Astronomical instruments may help him to study the stars, but 'what he thus perceives with his senses is out of keeping with his inner faculty of discernment; it would need a culture, as high as only exceptional people can possess, in order to harmonize, to a certain extent, the inner truth with the inappropriate vision from without' (quoted by Erich Heller, 1961). Goethe had used similar words about his concept of the *Urpflanze*, the archetypal plant, which would reveal the essence of all plant life and even permit one to postulate plants that do not exist because it would hold the key to their 'inner truth and necessity'. 'The same law', he adds, 'can then be applied to all other living things'. (One imagines Klee, too, meditating on this.)

Kandinsky's fear of scientific progress—in *Reminiscences* (1913) he wrote that 'the disintegration of the atom was to me like the disintegration of the whole world'— echoes that expressed in *Wilhelm Meisters Wanderjahre*. It was probably deepened by the experience of travelling through Russia on behalf of the Moscow Society for Natural Science, Ethnography and Anthropology in 1889 to report in the survival of peasant laws and culture. Peasant costumes, the icons and decorations inside their houses, the carvings outside—it was like being inside a painting, he said. 'I did many sketches—these tables and various ornaments. They were never trivial, and they were painted so strongly that the object dissolved itself in them'. So the decorated object

disappears to some extent behind the decoration; in his own work Kandinsky was to make the nominal object disappear behind his emotively enhanced and reformed colour areas, and he saw this as a comparable process. But the instinct to look for content behind the subject came early (bear in mind Kandinsky's late start as painter): in 1904 he wrote to his friend Gabriele Münter: 'Sometimes, the beauty in a thing need not be seen right away. Some things at first sight must have the effect of incomprehensibility. After that the beauty will come to the fore, and only then, to the sensitive observer, the inner content' (quoted by Röthel, 1961). The purpose of science was to reveal facts and analyse processes; the business of art, he said, was 'to express mystery in terms of mystery'. One sees why Kandinsky was seriously interested in theosophy and anthroposophy which sought to bring method into the mysterious regions where man meets the supernatural. Rudolf Steiner's speculations started from Goethe, particularly, it seems, from Goethe's colour theories, and appealed to Kandinsky and other artists. It is no accident that the Goetheanum that Steiner designed for his society in 1913—a timber structure on a concrete platform under a heavy looking carapace of shingle—is counted as an early piece of Expressionist architecture (see A305, Units 9–10, *Expressionism*, by Tim Benton, p. 66). 'Nothing in this architecture is there for its own sake alone. Everything has as inner value . . .', said Steiner in a lecture about his building in 1914.

Romanticism and Symbolism had increasingly sought to fuse the inner world of subjective experience with the outer world of objective reality, and it could be argued that all the arts involve some degree of transmitting subjective material by objectifying it. With Romanticism too came the thought that the pool of subjective experience was most effectively delved into, and might be most effectively objectified, through unconscious activity. 'I believe', wrote Goethe to Schiller in 1801, 'that eveything the genius performs as genius originates in the unconscious'. Jean Paul (J. P. F. Richter), a particular favourite with the Expressionist generation, wrote in 1804 of the unconscious as 'the most powerful element in the poet'. The thought that artistic creation occurs most significantly and most richly not, so to speak, in one's head but in the pit of one's soul, brought with it an idea of creation as an organic process.

I hope I have said enough to suggest that Kandinsky's concept of art may be seen as a heightened and sharpened Romanticism, developed partly in response to an unease brought by urbanization and technology. Kandinsky's views were not his alone, but his acute expression of them, in words and in art, made him exceptionally important to his world and time. Not only in art circles: he was quoted by and invited to contribute to the literary and the musical worlds as well. And not only in Germany. *Concerning the Spiritual in Art* had an extraordinary success in German, being reprinted twice in the year of publication. It was read before the Congress of Russian Artists in St. Petersburg during the last days of 1911 and an English translation appeared in London and Boston in 1914. The ultra avant-garde manifesto *BLAST*, edited by Wyndham Lewis and published in 1914, included an excerpt from that translation and an enthusiastic note on the book by the painter Edward Wadsworth: 'He writes of art—not in its relation to the drawing-room or the modern exhibition, but in its relation to the universe and the soul of man. He writes, not as an art historian, but essentially as an artist to whom form and colour are as much the vital and integral parts of the cosmic organization as they are his means of expression.'

It looks as though the arts were looking for a programme of the sort Kandinsky offered. And if they did so before the 1914–18 war, they did so even more fervently after the war when technology had revealed itself as the slave of a civilization bent on self-destruction. Dada mockery of the pretensions of civilized man was one way of expressing one's nakedness amid the ruins; a more common one amongst artists and writers, in central Europe at least, was to grasp failure and assert the need to create a new kind of world, directed by inner necessity and inner truth.

Kandinsky had meanwhile pursued his thoughts further. His analytical mind had turned to considering the 'inner resonance' of the means of painting—the forms as well as the colours—and from this was to spring the didactic treatise *Point and Line to Plane* in which he takes formal elements and compositional arrangements one by one in order to present his response to them as universally valid. The same consideration of artistic input and outcome occupied him in Moscow after the 1917 Revolution had put art and design education and the running of the museums into the hands of avant-garde artists. In the process his own art developed a new firmness, as though, having determined the communication value of each pictorial element, he was loth to mitigate it in any way and preferred to assemble a host of such elements in a symphonic complex. This is how I understand his later work (Haftmann, 786–95). In his earlier work, with which we are primarily concerned here, there continued to be a mobility between abstractness and hints of figuration, and a combination of considered action and instinctive, partly unconscious playing with materials he was handling, that has greater warmth and life. It was to be of great importance to the new painting that developed at the end of the Second World War (see particularly Haftmann 303 and 306 and Hamilton Figs 116 and 117).

p. 215: *Der Blaue Reiter*

When you have read this short section in Hamilton (to p. 222), please read again the two paragraphs in which he describes the *Blaue Reiter* almanac. I should also recommend you to try to get hold of a copy of the German reprint or the English translation available now (see the Recommended Reading on p. 114). The original book is now a collectors' item; the reprint offers a good deal of additional art historical information on the contents of the almanac as well as useful background material.

Kandinsky and Marc created the almanac, and they were responsible too for the exhibitions put on by 'the editorial office of the *Blaue Reiter*'. Only to this extent was there a *Blaue Reiter* group or movement. Not all the artists associated with Kandinsky and Marc in Munich are represented in the almanac, by words or illustrations. There is no evidence that anyone other than Kandinsky and Marc decided the contents of the almanac or the exhibitions, though Macke certainly made suggestions.

The almanac featured a sentence from Delacroix: 'Most writings about art are put together by people who are not artists: hence all the mistaken concepts and judgments.' Most of the voices in the almanac are indeed those of artists, composers and poets, but this did not prevent Kandinsky and Marc from including an essay on Delaunay by the art historian Erwin von Busse, one on the characteristics of the new painting by the French critic Roger Allard, some thoughts on new music by a Russian doctor of medicine, N. Kulbin, nor of course a quotation from Goethe. (They had also intended, at one point, to include an article on literature by the writer and art propagator Alexandre Mercereau, who was close to artists such as Delaunay, Gleizes, Metzinger and Léger in Paris and was busy presenting the new art from Paris in Moscow, Budapest and Prague between 1910 and 1914.)

Hamilton rightly emphasizes the lavish use of various sorts of primitive art. Looking through the almanac one is struck by the insistent way in which these illustrations are made to appear ordinary. That is, they are not gathered together in a section of stimulating oddities that might interest the reader or supplement an article, but they are illustrations among other illustrations. The frontispiece is a Bavarian glass painting. The special, extra expensive, edition then offered an original woodcut by Kandinsky and one by Marc. Then came, in succession, a German fifteenth-century woodcut, a 'Chinese painting' (probably a piece of eighteenth-century *chinoiserie*, not actually Chinese), a Bavarian glass painting, Picasso's *Woman with a Guitar* (then in Dr

Kramar's collection in Prague), two children's drawings, a Macke painting, a Kirchner lithograph of dancing women, a wood carving from southern Borneo, and so on (Figs 76–80). Illustrations of all sorts accompany articles and other contributions that are in no way connected with them. In no way, that is, but the basic, 'inner' way—to show

Figure 76 Two illustrations from the *Blaue Reiter*, 1912; left: *St Martin and the Beggar*, redrawing of a mirror painting; right: *Death of a Saint*, Raymundsreut, Bavarian Forest after 1800, mirror painting (Heimatmuseum der Gemeinde, Oberammergau) (courtesy Piper-Verlag).

Figure 77 A German woodcut from the *Blaue Reiter*, 1912; a detail from Ritter von Turn, von den Exempeln der Gottesforcht und Erbarkeit, Basel, Michael Furter, 1495 (courtesy Piper-Verlag).

Figure 78 Two examples of Russian folk art from the *Blaue Reiter*, 1912; top: a folk print; bottom: a carving formerly in the Kandinsky Collection (courtesy Piper-Verlag).

the spiritual unity discernible behind the outer variety of all these different means of expression and thus the basic congruence between the revolutionary forms of the new art, literature and music and man's timeless aspirations. Kandinsky and Marc would seem to have taken this sense of basic congruence to its limits in their organization of the volume—perhaps without being entirely conscious of what they were doing. The sequence is both stimulating and disorientating. The articles don't complement each other and the illustrations don't complement the articles; specific works referred to in the text are illustrated many pages away. Schœnberg's article on the composer's attitude to his literary material is accompanied not by the facsimile of his setting of a Maeterlinck poem, *Herzgewächse* (that appears at the end of the volume, followed by

Figure 79 A 'Chinese painting' from the *Blaue Reiter*, 1912, probably an eighteenth-century imitation (courtesy Piper-Verlag).

Figure 80 Two illustrations from the *Blaue Reiter*, 1912; left: Sandstone tomb of Knight Rudolf von Sachsenhausen (died 1371), Cathedral, Frankfurt am Main (Historisches Museum, Frankfurt am Main); right: Iron sculpture from Benin, 16 ins high (Staatliches Museum der Völkerkunde, Munich).

two short songs by Berg and Webern), but by a German fifteenth-century woodcut, a French fifteenth-century ivory figure, a Kubin drawing, a Bavarian glass painting, an Egyptian shadow puppet, a wood carving from the Marquesas Islands and, confronting each other on opposite pages, an *Eiffel Tower* Delaunay painting and an El Greco *St John the Baptist* (both then in the Kohler collection in Berlin and destroyed in the Second World War, Figs 81 and 82). Before the Schœnberg article comes Macke's essay on masks; after it a poem by Michail Kusmin, translated from the Russian, and Roger Allard's 'The Characteristics of Renewal in Painting'. This essay is principally about Cubism, which it presents as *the* new language, initiated by Derain, Picasso and Braque, which others soon developed in 'more systematic works' (he stresses the contributions of Gleizes, Le Fauconnier, Metzinger, Léger and Delaunay). Two very early Cézannes accompany, but do not support, Allard's account. He barely mentions Matisse but there is a reproduction of Matisse's *Dance* obtained from Moscow. Otherwise one's reading of Allard's article is enriched by reproductions of a frieze of children's drawings, a German fourteenth-century embroidery of *The Beheading of St John the Baptist*, and one Cubist work: a landscape (then in a Moscow collection) by Le Fauconnier. A more significant Le Fauconnier— *Abundance* (Haftmann 225)— appears much later in the book, as does Matisse's *Music*. (Matisse had been asked to contribute an article but had declined, saying he was no writer.)

Figure 81 Robert Delaunay, *Eiffel Tower*, 1911, oil, size unknown (Formerly Kohler Collection, Berlin, destroyed 1939-45).

Figure 82 El Greco, *St John the Baptist*, *c.* 1600–10, oil, 43¼ × 27½ ins (Formerly Kohler Collection, Berlin, destroyed 1939–45).

Writing to Piper in September 1911 Marc had described the almanac as consisting of four main sections, dealing with painting, music, the stage and current art news respectively, but as published the almanac lacks all evident structure. It also lacks any attempt at topicality. One would have expected an almanac, i.e. an annual publication, to make itself especially relevant to the moment of publication. On second thoughts, though, one can understand the editors' decision to drop the news section. It would have been strikingly different in character from the rest of the book which impresses one as meditative and—at once international and remote from any particular location (except perhaps for Allard's Paris-centred piece)—detached from place and time. This

feeling is enhanced by the brevity of the captions that go with the illustrations. In some cases the list of illustrations at the back added a little to the information given, but under the illustrations themselves we read 'Chinese painting', 'A. Macke', 'Votive picture', 'German' and 'Benin' in the case of the two paired warrior reliefs, and so on. In a few instances there are no captions at all, and there are vignettes and decorated initials by Marc and Arp whose authorship is indicated only at the end of the book. (Arp, usually associated with the Dada group of 1916 and after, was at this time close to Klee and Kandinsky and visited Munich during the *Blaue Reiter* years.)

Among the contemporary works illustrated are examples by Kirchner, Heckel, Pechstein and Nolde (Hamilton appears to have missed the Nolde). It seems that these got in because of Marc's enthusiasm for them. He spent some time in Berlin at the end of 1910 and met there Nolde, Kirchner, Heckel, Müller and Pechstein. He was greatly impressed by them and their work and recommended them not only for the almanac but also for the second *Blaue Reiter* exhibition. But Kandinsky, according to whom the *Brücke* artists were until then quite unknown in Munich, had grave doubts. On 2 February 1911 he wrote to Marc: 'Such things must certainly be *exhibited*. But to immortalize them in the *document* of our contemporary art (and that is what our book should become), as in some measure decisive, direction-giving forces, does not seem right to me. In any case I should be against large reproductions . . . The small reproduction says: this *too* is done. The large one: *this* is what is done . . . ' So the full-page reproductions represented only the following living artists: Kandinsky, Marc, Gabriele Münter, Kubin, Kokoschka, and, among foreigners, Matisse (2), Picasso, Le Fauconnier and Delaunay (3). Among the other large illustrations no fewer than twelve were devoted to Bavarian glass and panel paintings and six to western mediaeval art. Three pages were devoted to children's drawings—not, it should be noticed, to the drawings and paintings of young children but all, in so far as one can tell, by children over 10 and mostly around 13 or 14 years old; not, in other words, the often rich and marvellously inventive art of the relatively unself-conscious child, but drawings by children old enough to have assimilated pictorial devices from the art of adults.

Exercise

All this leads us to the most searching issue to be considered in your study of German Expressionism: what are the chief differences between the *Brücke* and the *Blaue Reiter* groups and what do they have in common? As you answer this question you will be finding out also about the range of what can be called Expressionism.

Discussion

The following headings may help you, and I shall use them in suggesting some of the many answers to various aspects of it:

1 Organization and life style.
2 Attitude to primitive arts.
3 Characteristics of *Brücke* and *Blaue Reiter* painting.
4 Other means of expression and relationship to other arts.

1 The *Brücke* artists chose to share a semi-Bohemian, semi-worker existence. They lived and worked in rough surroundings, brightened by means of their art and their home-made furnishings; they also seem to have gone on energetic summer holidays together, painting their girl friends as lively nudes in and beside German lakes. Altogether, the simple life, unintellectual in effect (although they were solidly educated men), muscular and outgoing. The move to Berlin modified this to some extent, bringing notes of anxiety into some of their work. The *Blaue Reiter* artists, men and women, varied more widely in age, origin and mode of life. There was no attempt at forming a social unit. Kandinsky and Marc respected each other highly and must be

called friends, but they were friends of the polite and slightly distant sort that address each other by their surnames and use the formal *Sie*. Marc and Macke, from 1910 on, use Christian names and *Du* in their correspondence. So the *Blaue Reiter* artists were a loose association of people linked by their profession and by shared inclinations in their work rather than by personal bonds. In breaking away from Munich's avant-garde association, the *Neue Künstlervereinigung*, they were forming an art–political group in a city already well supplied with art organizations; *Die Brücke* was much more a solitary phenomenon. The *Brücke* artists hoped that others would associate themselves with them; those that did included the foreigners mentioned by Hamilton on p. 198; as he suggests, their membership was nominal and their contribution to *Die Brücke* was minimal. The *Blaue Reiter* artists were themselves an international lot; in addition they were active in seeking and developing international links. Kandinsky had spent years in Paris, was polyglot and during these prewar years kept in close touch with the art world of Moscow. Both Marc and Macke visited Paris repeatedly; in October 1912 they went together, to visit Le Fauconnier and Delaunay. *Blaue Reiter* exhibitions were emphatically international in scope, and the almanac had contributions from France and from Russia. There is also a markedly professorial air about *Blaue Reiter* activities. The tone may have been set by Kandinsky, who always kept his formal manners and didactic habits of speech, but it seems to have suited those around him, all of whom set great store by deep learning and philosophical speculations. Kandinsky's and Marc's move out of Munich into southern Bavaria and a simple peasant environment contrasts with the *Brücke* artists' town-centred existence, in Dresden and in Berlin.

2 Both groups were interested in primitive artefacts, and could study them in the museums of Dresden and Munich. Nolde and Pechstein visited the South Seas. The *Blaue Reiter* artists, Kandinsky particularly, were profoundly interested in folk art. Kandinsky's study of Russian folk contributed to his understanding of art as a powerful and rich means of communication that transcends barriers of education, language and time. He brought examples of traditional Russian woodblock prints (*lubki*; singular *lubok*) and folk carvings to Germany and displayed them in his home as well as illustrating some in the almanac, and it is clear that he saw such things, and the Bavarian glass paintings he also collected, as offering an alternative tradition to that represented by the academies. It is likely that his personal interest focused on these local forms of primitivism, and less on the Oceanic, African and American Indian masks and other objects that also appear in the almanac and were written about, in rather emotive and elusive terms, by August Macke. Taken together the interests of the *Blaue Reiter* artists embraced the whole range of what was then known in the way of primitive and archaic arts, including child art and, with Paul Klee, the art of the insane. What is more, this interest went beyond a taste for the surface appearances of these things. What it lacked in the way of anthropological information it made up for by enrolling primitive, archaic and exotic artists in a world brotherhood intent not on reproducing the visible but on penetrating through it to a more exalted, spiritual kind of expression.

In comparison, the *Brücke* artists' taste for Negro and Oceanic objects (and Kirchner's additional interest in Indian painting) expressed itself in more superficial ways. They too, of course, saw the formal language and direct use of relatively simple materials as an answer to academic idioms and methods, but their work shows that they felt they could catch the primitives' energy by imitating the appearance of primitive art. Nolde's jottings (Chipp, pp. 150–51) show that he valued it for its (apparent) lack of sophistication and for not being in the Mediterranean tradition. There is no comparable emphasis on earthiness and on any kind of kinship with Northern man in the *Blaue Reiter* artists' account or use of the primitive arts.

3 Summarizing the work of ten or more contemporary but different personalities must be tentative and partial but the following more or less general points stand out:

The work of the *Brücke* artists changed repeatedly and fundamentally. Kirchner's woodcut for the new group's first public statement in 1905 (Chipp, p. 149) shows that at that point they were willing to be represented by a design totally within the Art Nouveau idiom (compare this with Kirchner's title-page print for his 1913 account of the history of the group; Chipp, p. 177). When Nolde joined them, during 1906–7, they were eager to emulate his brisk, exaggerated kind of late Impressionism in which natural scenes were portrayed in natural but heightened colours applied thickly and with visible attack (see Haftmann 91). They did not follow Nolde's development into an at times quite vicious, caricaturish and very painterly idiom (Haftmann 97–100), nor into his slightly more sober but still strident style of 1910–12 (Haftmann 101–5 and, in this unit, Fig. 67). Their own development brought them close to Fauvism: bright colours, as expressive of natural light as of emotion, firm but not especially aggressive brushwork, and generalized, emphatic forms (see Haftmann 107–29, but omitting any works dated later than 1911; Hamilton Fig. 106, p. 199, illustrates Kirchner's debt to Indian painting). It is reasonable to bracket Kirchner's, Heckel's and Schmidt-Rottluff's work together in considering their pre-Berlin years. Subsequently they divide in style as also in their way of life: Kirchner develops his spikey, partly Gothic, idiom for his nervous scenes of Berlin street life (Haftmann 132 and 133); Heckel remains relatively faithful to the tense but more or less optimistic manner they had shared in Dresden (Haftmann 135 and 136); Schmidt-Rottluff pressed this manner towards greater muscularity and heat (see especially Haftmann 139).

The work of the *Blaue Reiter* artists is more distinct. They shared ideals and influences, but scarcely ever idiom or even subject matter. During the *Blaue Reiter* period, say 1911 to 1914, some of them—Marc, Macke and Klee—were profoundly affected by French Orphism and especially Delaunay, their work was marked by broad harmonies of colour organized flatly on the canvas, often in partial subservience to a structural grid by means of which natural form is geometricized and neatly interlocked. This could serve to present animals in landscape (Marc; Haftmann 267), middle-class people in streets and parks (Macke; Haftmann 282–87), and North African landscape (Macke and Klee; Haftmann 289). Kandinsky pursued his own complex and profoundly original development during those years, producing almost abstract works that embody images derived from religious folk art, mostly Russian and Bavarian and much of it apocalyptic imagery (this has been established by Rose-Carol Washton Long, 1975).

To oversimplify matters: *Brücke* painting (during the period when the artists were living and working together and had found a recognizable *Brücke* idiom, i.e. about 1908–11) was vivid, enthusiastically physical in its response to life; *Blaue Reiter* painting was constructive, poetic, in varying degrees remote from animal appetites and pleasures. *Brücke* painting was not markedly original in style; *Blaue Reiter* painting owed much to Orphism and thus represents a constructive phase in German Expressionism and, in Kandinsky's work (more indebted to Fauvism and primitivism), opened up a new area of expression and suggestion through undescriptive colour and through combinations of abstract and sketchy forms.

4 The *Blaue Reiter* almanac demonstrates its editors' and contributors' interest in music and implies a wide concern for all cultural phenomena. It also displays Kandinsky, Marc and Macke as authors. The last two texts in it are Kandinsky's essay 'On Stage Composition', and his stage composition *Der gelbe Klang* ('The Yellow Sound'). The latter is a sort of drama in six scenes plus an introduction for a variety of individual characters ('a child', 'a man'), groups ('five giants', 'indistinct beings', etc.) and off-stage singers. Kandinsky's 'composition' is a succession of stage and sound directions, stating how changes in light and colour are to coincide with certain musical effects, and providing the words to be sung or recited at various point. Thomas von Hartmann, a composer of Russian origin who lived in Munich from 1908 until 1911 and died in New York in 1956, had taken responsibility for the music for this more or

less abstract drama. (He contributed an essay on 'Anarchy in Music' to the almanac.) Kandinsky, a great admirer of Wagner, was here attempting to create a synthesis of action, colour and sound, elusive in meaning but appealing to the imagination and to the senses.

The *Brücke's* life style and cultural concerns were of a piece. Whatever inclinations they may have had as individuals to this or that art form, their shared and recorded activity (again, up to 1911) centred on painting and print making, the carving and decorating of usable pieces of primitivist furniture, and summer travels that connect intimately again with their painting. Kirchner wrote: his *Brücke Chronical* of 1913 (published 1916; Chipp pp. 174–78) was so inaccurate and self-advertising that it led to the breaking up of the group; he also wrote art criticism, principally in support of his own work, under the pseudonym L. de Marsale, and autobiographical essays, later, under his own name.

p. 474: Herwarth Walden and *Der Sturm*

Walden's activities were so important—and also, though outstanding, in many ways so typical of the German cultural scene—that more information and comment is warranted.

In the journal he brought together, as Hamilton says, avant-garde writers and art (i.e. illustrations and articles about art). In his gallery he presented a glittering succession of exhibitions of German and foreign work. I shall summarize this below but, impressive as that summary must be (no other private or public institution could match it anywhere) it would still leave too narrow a picture of what Walden offered. He had studied music and was something of a composer and performer; he had also written about opera and theatre and had edited a theatre magazine. Already in 1903 he had formed arts association that brought leading writers, artists, architects and others—a sort of intellectual élite—together for readings and discussions (some of the names best known today among them were Rilke, Kraus, Heinrich and Thomas Mann, Wedekind, Loos, Van de Velde and Corinth). His first wife was the admired poet Else Lasker-Schüler; in 1912 he married the Swedish painter and musician Nell Roslund. He collected works of art of the type that he also exhibited and in 1914 made this collection open to the public. In 1916 he opened a *Sturm* art school (among the listed teachers were three who were to become part of Gropius's team at the Weimar Bauhaus: Lothar Schreyer, Georg Muche and Klee). Art school for him meant, as the programme stated, 'instruction in the expressionist arts of the stage, of acting, of elocution, of painting, of poetry, of music'. And Expressionism meant to him all new art forms that were opposed to the naturalism of the academies and of Impressionism. He himself wrote books on the subject. In 1917 he formed the '*Sturm* Drama Association', offering readings and debate on the theory and practice of Expressionist theatre. And so on; he was as much concerned to create and inform a public for the new arts as to support these and make them accessible. His house and gallery were as much meeting places as workshop and office and arena.

Some *Sturm* gallery exhibitions:
1912: First exhibition, March: *Blaue Reiter* and Kokoschka; Italian Futurism (taken over from Paris); modern French graphic art; 'French Expressionists' (mostly Fauves); modern Belgian painting including Ensor; one-man shows of Kandinsky and others.

1913: One-man shows of Archipenko (the Russian sculptor working in Paris), Delaunay, Klee, French Cubism; Marc, Severini (the Italian Futurist) and others; and the *Erste Deutsche Herbstsalon* (first German Salon d'Automne, in imitation of the

open annual Paris exhibition established in 1903), which showed 366 works by more than 80 artists working in Germany, America, France, Italy, Russia, Switzerland and Spain. (No other *Herbstsalons* followed, because of the war.)

1914: One-man shows of Campendonck (associated with the *Blaue Reiter* group; (see Hamilton Fig. 123), Chagall, Duchamp-Villon, Futurism, Gleizes, Jawlensky, Klee, Macke, Villon. Meanwhile exhibitions organized by the gallery tour Europe (some even go to Tokyo).

1915: One-man shows of Campendonck, Kokoschka, Macke, Marc, Max Ernst, Muche....

The gallery, the journal and other activities continued into the later 1920s, but by the time of his fiftieth birthday in 1928 (publically celebrated by a host of intellectuals) there were financial difficulties as well as growing differences of opinion with his collaborators and antagonistic cultural pressures. In 1932 Walden emigrated to Russia. There he was associated with Brecht and other German speaking immigrants. In 1941 he was arrested by the Soviet police and nothing further is known (Fig. 83).

Figure 83 Oskar Kokoschka, *Portrait of the Poet Herwarth Walden*, 1910, black ink on graph paper, $11\frac{1}{4} \times 8\frac{3}{4}$ ins (Courtesy of the Fogg Art Museum, Harvard University, Purchase — Friends of Art and Music at Harvard).

One tends to assume that Beckmann belonged to a younger generation than the leading Expressionists. In fact, he was born in the same year as Schmidt-Rottluff, one year after Heckel, four years after Marc and Kirchner. (Kandinsky, that late starter, was much older.) So Beckmann grew up in much the same world as they, and underwent similar experiences and stimuli. His growth was more gradual and his knowledge of, and sympathies with, recent and older art were wide ranging. As a young man he enjoyed the personal interest and support of one of the best informed and intelligent art critics of the age, Julius Meier-Graefe.

The *Great Death Scene* was painted in August 1906 shortly after his mother's death from cancer (Fig. 84). The composition, arranged in parallel bands both in plan and in its two-dimensional effect, has a stridency and an unapologetic display of horror that herald his great post-war paintings. Notice too how an appearance of almost documentary realism is created by forms some of which are much distorted. But his handling of light and dark has yet to change a great deal, and with it his handling of paint which will lose its soft, atmospheric touch. Above all, his compositions will avoid the neoclassical neatness of this one, which has the effect of keeping the dreadful scene away from us, the other side of the footlights so to speak. The picture owes something to Munch's example, and Munch praised the young artist for the work. But his ambitions lay elsewhere. Where is hinted at in two large paintings he did in the following years: a *Resurrection* (1908) that included figures in modern dress and was based on compositions by Rubens and El Greco, and a *Sinking of the Titanic* (1912), a powerful, modern Baroque painting organized in diagonal sweeps and recalling Daumier in the painting of the many figures. By this time Beckmann had a very substantial reputation. Large exhibitions of his work were shown in Frankfurt in 1911, Magdeburg 1912 and Berlin (Paul Cassirer gallery) 1913.

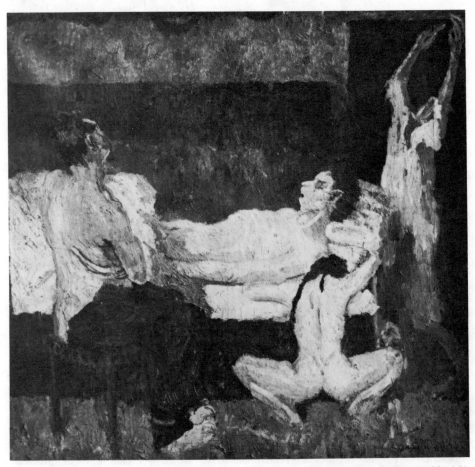

Figure 84 Max Beckmann, *Great Death Scene*, 1906, oil, 50¾ × 54¾ ins (Collection Gunther Franke, Munich).

Hamilton stresses the influence of Corinth's 'harsh retelling of biblical history with contemporary overtones'. What Beckmann was to achieve was a way of retelling contemporary history that evaded anecdote, eluded the traps of caricature and satire, and gave his specific subjects (and his general subject, humanity's struggle with its own inhumanity) a weight and universality one could call biblical.

The war experience no doubt helped. So too did the Berlin paintings of Kirchner, which drew Beckmann's attention to German late mediaeval painting and its sharp, clear and inescapable power of narrative.

Exercise

Compare the *Great Death Scene* with *Night* (1919; Haftmann 672 or Hamilton Fig. 283) and with *Family Picture* (1920; Plate 14). How does Beckmann give his post-war compositions their extraordinary impact while also making them permanent symbols of human existence? When you have made your comparison, read the notes that follow and see to what extent they agree with your findings.

Discussion

1 There is a lot going on. Both *Night* and *Family Picture* are full of incident, in one case repellent and also, alas, appealing, in the other appealing but ultimately repellent. Our emotions and reactions are brought into conflict. There is a lot to read, to scan and understand, with objects and actions suggesting symbolic meanings behind their everyday facts. The action in *Night* seems unambiguous, but why are the heads of two of the aggressors bandaged, and what is the woman behind the table doing or not doing? The family in *Family Picture* is Beckmann's own. He lolls in front of the piano (note the snuffed out candle), apparently admiring his yellow shoes and clutching a horn; his wife is adjusting her hair (Is she going out? Is she looking at us?); a sister-in-law sits at the table, gloomily doing nothing; mother-in-law hides her face (Why?); a servant sits reading a newspaper; son Peter, likewise, is reading (the child and the servant are the only people doing anything bearable). The silence is heavy; the people don't connect.

2 Both these paintings show the tilting of the stage space and the division of the picture surface by means of angular lines and accents that recall Kirchner and the mediaeval painters. In addition, Beckmann closes the background and pushes it and everything in front of it towards us, almost into our laps. Any space making hint of perspective is countermanded by the tilting and projecting of forms; there is no dim-inution of the size of things towards the background, nor any loss of vividness of light or colour. The colour is almost cheerful, and comes in strong, bright patches that please the eye but conflict with our sense of propriety. The colour of *Night* is not unlike that of *Family Picture* but is generally colder and lacks the green-orange glow of the candles. The inside of the gramophone horn is a strong, cold red.

(I have an irrepressible conviction that Picasso had seen reproductions of one or other of Beckmann's paintings of this type by the time he painted his famous *Guernica* in 1937 (Haftmann 561). Beckmann showed in Paris at the Galérie de la Renaissance in 1931, but it would have been enough to have seen a magazine or book illustration. Several of the compositional devices used in *Guernica* echo Beckmann, and also the use of a ceiling light as a sort of psychological as well as compositional climax.)

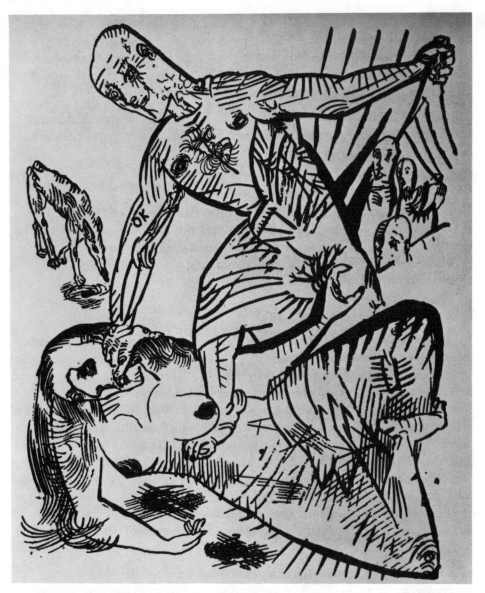

Figure 85 Oskar Kokoschka, drawing for *Murder, Hope of Women*, ink on paper, 15 × 11½ ins (From the Kokoschka Collection of Reinhold Count Bethusy-Huc, on loan to the Victoria and Albert Museum, London).

Recommended Reading

General

Apollonio, U. (1959) *Fauves and Cubists*, Batsford.

Dube, W. -D. (1972) *The Expressionists*, Thames and Hudson.

Duthuit, G. (1950) *The Fauvist Painters*, New York.

Myers, B. S. (1963) *Expressionism : A Generation in Revolt*, Thames and Hudson.

Negri, R. (1969) *Matisse e i Fauves*, Fratelli Fabbri, Milan.
 For illustrations.

Richardson, T. and Stangos, N. (1974) eds, *Concepts of Modern Art*, Penguin.
 Sections 1 and 2.

Whitford, F. (1970) *Expressionism*, Hamlyn.

Willett, J. (1970) *Expressionism*, Weidenfeld and Nicolson.
 A paperback in the 'World University Library' series, offering an excellent brisk survey of Expressionism in all the arts and relating these phenomena to the political context.

Matisse

Barr, A. H. (1951) *Matisse : His Art and his Public*, Museum of Modern Art, New York.
 The best edition, with colour illustrations, published before the artist's death and therefore not quite complete, but in every other respect a model book, giving a fairly full account of the work and life of its subject, well supported by illustrations and documentary texts.
Diehl, G. (1954) *Henri Matisse*, Tisné, Paris.
 Good illustrations, interesting French text.
Elsen, A. E. (1972) *The Sculpture of Henri Matisse*, Abrams, New York.
Flam, J. D. (1973) *Matisse on Art*, Phaidon.
 Matisse's undogmatic views, expressed in his own occasional essays and when interviewed, illuminate his own work but also apply to almost all art and artists.
Fourcade, D. (1972) ed., *Henri Matisse, Ecrits et propos sur l'art*, Hermann, Paris.
 Much fuller and better organized than the preceding, and of course consisting mostly of Matisse's own words.

Kandinsky

Grohmann, W. (1959) *Wassily Kandinsky, Life and Work*, Thames and Hudson.
 A fat monograph by an art historian who knew Kandinsky personally; uncritical and soft, but full of information and illustrations.
Kandinsky, W. (1947) *Concerning the Spiritual in Art*, The Documents of Modern Art, George Wittenborn.
Overy, P. (1969) *Kandinsky, The Language of the Eye*, Elek.

Additional References

Heller, E. (1961) *The Disinherited Mind*, Penguin.
Kokoschka, O. (1953) 'Edvard Munch's Expressionism', *College Art Journal*, 12, p. 320.
Long, R. -C. W. (1975) 'Kandinsky's Abstract Style: The Veiling of Apocalyptic Folk Imagery', *Art Journal*, 34/3, Spring 1975, pp. 217-28.
Novotny, F. (1971) *Painting and Sculpture in Europe, 1780–1880*, Pelican History of Art, Penguin.
Röthel, H. K. (1961) *Paintings on Glass*, New York.
Schopenhauer, A. (n.d.) *The World as Will and Idea*, translated R. B. Haldance and J. Kemp.
Selz, P. (1957) *German Expressionist Painting*, University of California Press.
The Open University (1975) A305 *History of Architecture and Design 1890–1939*, Units 9–10, *Expressionism*, The Open University Press.

Unit 9 Futurist Art and the Dynamism of Modern Life

Note on the Set Books 118

Introduction 119

Background 121

Marinetti and the Birth of Futurism 123

The Futurist Painters (up to October 1911) 126

International Futurism (late 1911 to 1914) 137

The War and the Futurists 154

Futurism and Expressionism 156

A Note on Vorticism 158

Hamilton's account of Futurism (pp. 279–91) is admirable as far as it goes and you should read it. In my view the movement and its products deserve rather fuller treatment in his survey and positively demand it in our course. Haftmann has some useful illustrations (232–257), but again these are rather fewer than the occasion would seem to demand and, of course, he does not go outside his field, painting. The illustrations in this unit will complement his and Hamilton's. Chipp reprints five manifestos. At least three of these—'The Foundation and Manifesto of Futurism', 'Futurist Painting: Technical Manifesto' and the 'Technical Manifesto of Futurist Sculpture' (pp. 284–304)—should be read with some care, both for the general manner and messages and for the specific instructions they give about the methods and duties of the new art. (On p. xii Chipp appears to ascribe the authorship of the first three reprinted manifestos to Marinetti. It is more or less certain that the second and third of these were drafted by Boccioni; they may have been touched up or styled by Marinetti but the matter is not his.)

Introduction

Futurism was an Italian movement. It lasted from 1909 until about 1915. It was launched in 1909 by means of a general manifesto, aimed at the literary world and written by an Italian poet. It attracted a small number of Italian artists who, first in words and then in action, invented and promoted a range of painting and sculpture that rapidly achieved international notoriety and fame and exercised some influence on avant-garde art in other countries. Futurism was the first movement to base its claim for attention on a headlong assertion of its own novelty and the irrelevance to modern times of all other art. According to Futurism, art's purpose was nothing less than to change the world, by giving expression to aspects of the present that the world seemed intent on ignoring, by challenging stability as a truth and a value, and by making propaganda for specific social and political aims.

Exercise

A lot in the preceding paragraph should have given you pause for thought. Consider the statements in it again. How many of them strike you as remarkable or odd?

Discussion

Here are some points that you may have noticed, and further comment on them:

1 Futurism was an Italian movement. For the Renaissance period one thinks of Italy first and foremost. By the seventeenth century Italy is one great art-producing country among others. In the eighteenth century France gets most of our attention. Canova (1757–1822) was the last Italian artist of truly international importance in his own time and subsequently. I don't recall any mention of Italy or Italian artists in this course until now, except for references to the past. So the appearance of an Italian movement is in itself surprising. It was indeed very much part of their consciousness that Italy had become a cultural backwater, burdened by a glorious past but inoperative in the present, and it is this that gave such stridency to their tone.

You must not of course think that Italy produced no valuable art in the nineteenth century. She did, but it did not significantly shape the course of later art and it was more or less unknown outside Italy. Martin (1968) gives a short and balanced account of painting and sculpture in Italy during the later part of the century, and some of these artists were of importance to the Futurists. But the fact remains that Italian nineteenth-century art was of only local interest and largely reflected ideals and methods pioneered elsewhere. It took a major effort for the Italians to leap into the forefront of modernism.

2 Futurism lasted from 1909 until about 1915. You may recall my warning (at the start of Unit 7) against seeing the history of modern art too exclusively in terms of movements and against seeing movements as the neat and coherent organizations they sound like. Futurism was the most neat and coherent of the lot. It started at a particular time, had specific members, and it ended when Italy's involvement in the war dispersed them. Two leading Futurists were killed in the war; in the others the war occasioned a change of heart. Newcomers to Futurism seemed to the offer some continuity into the post-war period, and there was a positive attempt to reawaken Futurism in the '20s, but their quality and energy was markedly less and there is no mistaking the demise of Futurism proper in the war it so warmly welcomed.

3 Words preceded action. This is something new in the arts. It represents the adoption for creative work of a sequence familiar from political history. Privately, of course, many an artist has expressed hopes and ambitions he could approach in his

work only later—look at Delacroix's journals or Van Gogh's letters—but the Futurists as a group publicly announced their political and cultural aims and indicated their artistic methods before giving evidence of either in their work. It's not surprising that they didn't catch up with all their words. The gap between propaganda and performance was very noticeable at first; later on, less noticeably, their work tended to diverge and thus other gaps appeared. We shall have to watch out for these.

4 Futurism's assertion of newness; art as a revolutionary force. Since classical times art has been associated with upholding ideals and representing valued truths. Edification was its prime purpose; giving pleasure a second aim that tended, with the passing of centuries, to become dominant. That art could also be a force for social and political change is an idea that surfaced in the eighteenth century and became convincing with the French Revolution and Romanticism. But—in spite, for instance, of Baudelaire's demand that artists should reflect the realities of everyday existence—the social implications of even the most progressive art studied so far in this course have remained implications. In Futurism we have a movement that denounces the art of the past and the society that still honours it, and that unambiguously confronts the world with new attitudes. They offered models of a new world and worked, not only through paintings and sculpture, to make it come about. They glorified destruction and reconstruction. The nature of what they demanded, their behaviour and also the unhappy political developments with which they are associated, can only be understood in terms of the historical and economic background.

Background

Italy had become a national political unit in 1861, governed by a constitutional monarch and a parliament. At first the capital was at Turin, former capital of the state of Piedmont; the king of the new Italy was the former king of Piedmont and he retained his name, Victor Emmanuel II (an odd name for the first king of a new state). The Piedmontese system of enfranchisement was extended to the whole country and fitted badly: only about two per cent of the population had the vote (this was raised to about seven per cent when the system was reformed in 1882).

In any case, the unification of 1861 was incomplete. Austria held Venice and its extensive hinterland (the Veneto), Trento in the Alps and Trieste at the head of the Adriatic Sea. The Pope held Rome and had French troops to protect him. When the Austro-Hungarian Empire tottered under Prussian assault in 1866 the Italians seized Venice and the Veneto. When the French called their troops home because of the Franco-Prussian war of 1870, the Italians seized Rome. For decades the Popes withheld their support from the unified Italian state, so that for a long time, in a predominantly Roman Catholic country, the state and the Church were pulling in opposite directions—leaving an opening, one can now see, for forces that were opposed to both. Formal peace between the two was not made until 1929 and the establishment of Fascism and Mussolini. Rome had become the capital of Italy in 1871; the imbalance between north and south, between the industrially and agriculturally developing cities and plains of Piedmont and Lombardy and the declining agricultural regions (because of poor soil, ancient methods and cheap grain imports from America and Russia) of Calabria and Sicily, continued to exist. At times it became worse, and it continues to this day in an only partly moderated form.

Futurism was a Milanese movement. By the end of the nineteenth century Milan challenged Florence as the intellectual and cultural capital of Italy. Milan was also becoming the dominant industrial centre. The city itself was growing fast. It was one of the first in Europe to experiment with electric lighting: the powerful Santa Radegonda hydroelectric power station began operating in 1884. By 1914 Milan was the commercial and intellectual capital of the country, and so it is today.

The 1890s were a period of violence and unrest. The Italian was citizen of an underdeveloped country. He was also the most heavily taxed citizen in Europe; on the strength of his money Italy developed a complex and exceedingly autocratic bureaucracy. Socialism and anarchy thrived, especially in the north; right-wing groups developed in opposition to them. The last years of the old century saw brutally repressed uprisings including one in Milan in 1898, when cannon fire was used against the crowd and fifty people were killed; the general responsible received a decoration for his action from King Umberto I. Two years later the king was assassinated by an anarchist.

The following decade brought relative peace. All over Europe the twentieth century opened with years of economic expansion and Italy participated in the upward trend. Her motor industry thrived particularly (the first Italian motor-car factory had opened in Turin in 1895 and four years later became Fabbrica Italiana Automobili Torino, or Fiat). Her electrical industry developed so well (principally in the north again) that there was hope that Italy might one day free herself from the large and expensive coal imports on which her industry was founded. During this decade both international socialism and right-wing nationalism established themselves as properly organized forces in Italian society. Fascism proper was born after the war—in Milan, in 1919— but economic crises that affected Italian industry and agriculture during 1907–10 made it easy for a socialist like Mussolini to abandon socialism, move over to the nationalist right taking a lot of his associates with him, and to campaign for Italy's intervention in

the 1914–18 war. As a result of that war two popular aims of the nationalists were achieved: Trento and the Trentino were ceded to Italy in 1918 together with the German-speaking South Tyrol (with the result that there is still unrest there), Trieste became a free port in 1917 and part of Italy in 1918.

But the war was welcomed as something more than a means of undoing ancient wrongs of this sort. It was going to prove Italy's unity, and also her maturity and equality among the other European nations. It was going to purge the Italian system of old impurities and bring fresh blood pulsing through veins stiffened by the lack of challenging occasions. It was going to put an end to the soft, sweetly cloying arts of Puccini and the crepuscular poets, and also of the proto-Hollywood epics of the Italian cinema. It was going to be an adventure of a new sort, with warriors clad not in armour but in armoured machines—an extension of motor racing and the cyclists' Tour of Italy. Marconi's wireless telegraph would send commands and news abstractly and instantly through the ether; the machine gun, pioneered by the British, would despatch the enemy with comparable speed and impersonality.

German ideas, as well as German business methods and bureaucracy, had a deep influence on Italian aspirations and institutions at the turn of the century, and with them came Nietzsche's thrilling call to action beyond the frontiers of known civilization. Gabriele d'Annunzio (1863–1938), the best known writer in Italy and a hero figure to his time, tried to live the Superhuman role. During the war, for which he campaigned vociferously, he served as a dashing pilot and in 1919 he led a private army to liberate Fiume, south of Trieste, from the Austrians. The spirit animating the Futurists was not unlike his. Marinetti, initiator of Futurism, dedicated his second volume of poetry to d'Annunzio in 1914; its title is *Destruction*. He sang of war, 'the only cure for the world, a superb blazing of enthusiasm and generosity, a noble bath of heroism without which the races fall asleep in slothful egoism, in economic opportunism, in a miserly hoarding of the mind and will'.

Marinetti and the Birth of Futurism

Filippo Tommaso Marinetti was born in Alexandria in 1876, into a rich, north Italian family with business connections in Egypt. His education was mainly French and Marinetti, bilingual, divided his adult life between Paris and Milan, writing for both the French and the Italian publics. His first literary enthusiasm was for the unmannerly realism of Zola. To this he soon added an interest in Walt Whitman, in Verhaeren (roughly an urbanized, Belgian Whitman), Nietzsche and the French philosopher Bergson (see Unit 7, p. 65). Marinetti's writings are mostly in French: ambitious, voluble, assertively modernist in form (the use of free verse, for instance, i.e. unrhymed lines of uneven length) and imagery (urban, nocturnal images often, with mechanical speed and electric light as recurring objects and images of passion). He became a well known part of the literary avant garde in France and Italy; in 1905 he began to publish a magazine from his house in Milan. *Poesia* offered an international range of new prose and poetry, mostly by the younger generation of Symbolists, and it helped to establish Marinetti as a cultural middleman and propagandist.

His first play, *Le Roi Bombance*, was published in 1905. It is 'a parable of the digestive system', by means of which 'Marinetti savagely denounced the moral corruption of society and the hypocrisy of so-called religious and democratic practices. . . . The general philosophy of the play is positive, however, and the story's hero ,the poet L'Idiot, strikes a hopeful note' (Martin, 1968, p. 34). In January 1909 his second play, *Les Poupées Electriques (The Electric Dolls)*, was performed in Turin in an Italian version. Dedicated to Wilbur Wright (one of the American brothers responsible for the first heavier-than-air flight), it is a traditional domestic tragedy of love and marriage except for the fact that much of the interest centres on the behaviour of a male and female robot, constructed for his own purposes by an American engineer. The play was hissed and whistled off the stage. Marinetti came on to tell the audience that he was deeply honoured by the concert they had performed for him.

That same month, Marinetti published a volume of poems by Enrico Cavacchioli, prefacing it with the Futurist Manifesto (i.e. in Chipp, the numbered paragraphs starting near the top of p. 286 and going on to the end of the document; as published in *Le Figaro* a little later, the text included a subheading, *Manifesto du Futurisme*, before the first numbered paragraph). Before the end of January Marinetti sent out a circular to newspapers, critics and writers announcing the foundation of Futurism, and praising himself and a group of friends for raising this noble banner.

In other words, when Futurism was launched in Paris, on 20 February 1909, with the publication of the entire document on the front page of *Le Figaro*, it was not entirely new—but it was new to everyone outside Italy, and that day is generally taken as the birthday of Futurism. Perhaps Marinetti was disappointed by an insufficient Italian response; he certainly wanted an international public for his movement. An Italian version of the document appeared in *Poesia* later the same year, in the 'April–May–June–July' issue. In April 1909 Marinetti's play *Le Roi Bombance* was given its first performance and created an enormous scandal, much to Marinetti's satisfaction.

Exercise

Please read 'The Foundation and Manifesto of Futurism' (Chipp, pp. 284–89). Note Marinetti's style and imagery, and see to whom his words are addressed and what action they propose. Then check your observations against those following.

Discussion

1 Marinetti's first image—the Oriental copper lamps housing electric light bulbs—

seems to me symbolic of what he says generally in his opening paragraphs. He speaks of trams, locomotives, automobiles, cyclists, but cannot stop romanticizing such things as beasts. (In 1908 he had renamed a 1905 poem, formerly 'To the Automobile', 'To my Pegasus'). He tells a fantastic tale of speed and danger and a crash, but in disorientated terms that suggests drugs or drink rather than the hard realities of technology. He wants, it seems, a high temperature, a dizzymaking sense of excitement. The manifesto proper begins on a less romantic note but the temperature rises again to the climax of paragraph 11 with its insistent combination of industrial fact and romantic simile. There follows a section where he reiterates, with special reference to Italy, his attack on the museums and expands it to a general denunciation of love of the past. 'The oldest among us are thirty' is a twice delivered lie. He ends with the reiterated Romantic image, 'Erect on the pinnacle of the world . . .'

2 Marinetti appears to address his manifesto 'to all living men', but he seems to be lecturing writers and especially poets. The reference to 'painters and sculptors murdering each other' turns out to be part (a contradictory part) of his denunciation of museums.

3 Negative and positive actions are proposed. Negative is the attitude to the past, the destruction of its vestiges, the spurning of accepted modes of beauty. Positive is the emphasis on audacity, aggressive movement, and the range of subject matter to go with them: war, etc., 'the great masses agitated by work, pleasure, or revolt' (notice that he and those he is appealing to stand outside these masses), the industrial world and the larger, more dramatic machines it produces. There are no specific literary instructions. What forms of writing? To be addressed to fellow literati or to those masses? Books or broadsheets?

On 8 March 1910 Umberto Boccioni read the 'Manifesto of the Futurist Painters' from the stage of the Teatro Chiarelli in Turin. This was signed by five Milanese painters: Boccioni, Carrà, Russolo, Bonzagni and Romani. The last two dropped out shortly after and their place in the movement was taken by Balla, working in Rome, and by Severini, working in Paris. These five were the Futurist artists. They were attracted by Marinetti's ideas and were at times helped by him financially. Apart from that they had their individual personalities, previous histories and talents. 'The Manifesto of the Futurist Painters' does not go much beyond Marinetti's manifesto. It assumed the ability of painting to respond to his challenge; the nature of painting and its primacy among the visual arts are not questioned nor are there more specific guidelines beyond such statements as 'we should draw inspiration from the tangible miracles of contemporary life'.

Five weeks later they published the 'Technical Manifesto', dating it 11 April 1910.

Exercise

Please read this manifesto (Chipp pp. 289–93) and note what specific instructions it offers to painters.

Discussion

I distinguish two general instructions, appearing in varying guise, and one more direct hint about method:

1 That it is the business of painting to render 'the dynamic sensation', which is a reflection of the fact that the artist is a living organism existing in an unstable environment;

2 That objects *as experienced* are both equal and immaterial (meaning, by 'experience', a multiple process of seeing, remembering, responding emotionally);

3 That the painting method will be Divisionism—both for brightness and for

transparency and thus to convey overlapping images. Balla, Boccioni and Severini probably had first-hand knowledge of French Divisionist painting; they and the other Futurists also had access to a two-volume treatise on painting (published 1905–6) by the Milanese painter Gaetano Previati; it includes a long discourse on Divisionism.

To summarize the situation in April 1910: five painters of varying ages—Balla aged 38, Carrà 30, Severini 28, Boccioni 27 and Russolo 24—were cosignatories of a manifesto that committed them to a new, bright and energetic art that would give visible form to their apprehension of the ever-shifting, never stationary world about them. The problem now was how exactly to produce it.

The Futurist Painters (up to October 1911)

It seems to have been Boccioni who first made contact with Marinetti. Born in 1882, he grew up in Calabria and Sicily. In 1900 he went to Rome where he met Severini; both of them liked and learned from the older man, Balla, who had recently returned home from a period in Paris and was expert in Divisionism. Boccioni appears to have travelled a good deal: to Paris, perhaps in 1902, certainly in 1906, '7 and '8; also to Munich and St Petersburg. In 1907 he moved with his mother and sister to Milan. During these early years his work was searching and contradictory; it shows little or no awareness of new trends in Paris. The drawing *Homage to Mother* (Fig. 86), a study for a triptych he never executed, shows him generally indebted to the English Pre-Raphaelites. He stresses in it aspects of modern life that they too would have been ready to feature: the railway viaduct and factories behind the studious young man on the left, and the treadle sewing machine in the forefront, centre. It is not entirely fanciful to see the middle portion of the triptych as a secular crucifixion, with two

Figure 86 Umberto Boccioni, *Homage to Mother (Veneriamo la Madre)*, 1907, pencil on paper, $15\frac{3}{8} \times 22\frac{3}{4}$ ins (Collection of Mrs Malbin, New York; photo: Joseph Klima).

Figure 87 Umberto Boccioni, *The Dream: Paolo and Francesca (Il Sogno: Paolo e Francesca)*, 1908, oil, $55\frac{1}{4} \times 51\frac{1}{4}$ ins (Galleria Blu, Milan).

female figures attendant upon a third, the Mother, at the foot of a cross formed by the window's mullion and transom. It is a firm drawing, but old fashioned, suggesting the 1880s. The painting *The Dream : Paolo and Francesca* (Fig. 87) entirely lacks the drawing's emphasis on flat shapes. Here the forms are soft and three-dimensional, and the whole belongs to the area where late Symbolism and Art Nouveau meet, which is also the area dominated in Italy by Previati.

By this time Boccioni was capable also of cooler, less emotionally loaded work. His *Portrait of the Sculptor Brocchi* (Fig. 88) combines a meticulous Divisionist technique in the landscape with freer brushwork in the figure. To link the light-filled background to the figure seen against the light, Boccioni has had the boldness to let the light distort the structure of the man's face. That was painted in Padua; Boccioni's *Self Portrait* (Fig. 89), painted in the developing suburb of Milan called Porta Romana, where Boccioni had settled with his mother in 1908, is in effect a double portrait—of himself and of his new environment of workers' dwellings and factories new and under construction. In *Factories at Porta Romana* (Fig. 90) the environment becomes the hero, at least until one becomes aware of the small but accentuated figures of the workers that give it scale and purpose. Here again the light striking on the main building is allowed to transform it.

In mid February 1910 Boccioni got himself introduced to Marinetti. They agreed instantly on the need for Futurist painters and a painters' manifesto, and Boccioni soon sat down with two previous acquaintances, Carrà and Russolo, to draft a statement.

Figure 88 Umberto Boccioni, *Portrait of the Sculptor Brocchi*, 1907, oil, 41¾ × 49⅝ ins (Collection of Dr Paolo Marinotti, Milan).

127

Figure 89 Umberto Boccioni, *Self Portrait*, 1908, oil, 27½ × 39⅜ ins (Pinacoteca di Brera, Milan).

Figure 90 Umberto Boccioni, *Factories at Porta Romana*, 1909, oil, 30 × 58 ins (Collection Banca Commerciale Italiana, Milan; photo: Scala).

Boccioni's interest in dramatically presented present-day subjects may have been awakened in him by Balla. Born in Turin in 1871, Giacomo Balla worked first for a lithographer and attended art classes in the evening. In 1893 he moved to Rome and there set out to be a painter. Following the example of a Socialist painter, Giuseppe Pelizza, he specialized in paintings reflecting the life of the worker. His father, who died when Giacomo was only eight years old, had been a chemist and a photographer. *Bankruptcy* (Fig. 91) suggests that photography had influenced Balla's vision very powerfully; it also demonstrates his characteristic objectivity of method in order to convey an emotionally charged subject. The three panels of *The Labourer's Day* (Fig. 92) are delicately adjusted to each other in their angle of vision and their colour to suggest dawn (top left), noon and evening. Thus an apparently factual record becomes a symbol of toil through a cumulative arrangement the linking theme of which is location and time. That Boccioni responded to Balla's symbolic use of objectivity is clear but the differences between his urban landscapes and Balla's are worth noting

Figure 91 Giacomo Balla, *Bankruptcy (Fallimento)*, *c.* 1902, oil, 46½ × 63¼ ins (Formerly collection Dr Cosmelli, Rome, courtesy Elice e Luce Balla).

Figure 92 Giacomo Balla, *The Labourer's Day (La Giornata dell'operaio)*, *c.* 1904, oil on cardboard, 39½ × 53⅜ ins (Collection Signorine Elice e Luce Balla, Rome).

also: Boccioni's preference for a high viewpoint, for instance, which has the effect of distancing and thus abstracting the scene. In a letter of 1907 to Severini, Boccioni says that 'Balla absolutely lacks decorative vision—the only thing which can make a great work of art. . . . His universe does not throb!' (Martin, 1968, p. 75). This implies that

Boccioni wants to combine Balla's realism with the kind of lasting expressive force that a monumental pictorial structure can yield. A combination of his own *The Dream: Paolo and Francesca* and *Factories at Porta Romana*? The mind boggles, yet this is almost exactly what he will achieve as a Futurist. Meanwhile it is worth noticing an instance where Balla may have been in debt to Boccioni (assuming that the dates we have are correct). Balla's *Affections* triptych, exhibited in 1910 and presumably a new work then, is very close to Boccioni's *Homage to Mother* in its theme, use of figures and general layout, and even manner: though the triptych is painted to give the interior a soft, atmospheric effect, the shapes that make the interior and the figures are clearly stated (Martin, 1968, plate 38).

Almost all of Carrà's early work has been destroyed or lost. Born in 1881, Carlo Carrà worked as a muralist's apprentice before going to the Brera Academy in Milan for art training. In 1908 he won the competition for a design for the membership card of the *Famiglia Artistica*, a Milanese art society, using the *Victory of Samothrace* (Fig. 112, p. 151) as his motif. He joined the directorate of the society and tried to give new life to it by bringing in young artists. He knew both Boccioni and Russolo by 1910; in March they exhibited together at the *Famiglia Artistica*. What little we know of Carrà's early work indicates an involvement in Pre-Raphaelitism and Art Nouveau.

Figure 93 Luigi Russolo, *Nietzsche*, *c*. 1909, etching, $4\frac{7}{8} \times 5$ ins (Raccolta delle Stampe Achille Bertarelli, Castello Sforzesco, Milan © SPADEM 1976).

Luigi Russolo, born 1885, was the son of an organist and director of a music school. Like his brothers he was taught to play musical instruments; unlike them he also had a taste for painting. It seems he also wrote poetry; at any rate he is said to have been part of Marinetti's *Poesia* circle and he is credited with a good head for philosophical speculation. One of the very few early works known of his is the etching of Nietzsche (Fig. 93): the stern profile is linked by Art-Nouveau-ishly swirling locks to a female

head, a muse or—it has been suggested—a personification of madness.

Gino Severini, born 1883, plays a role of special significance in the movement because from 1906 he resided in Paris yet remained in touch with his old friend Boccioni. He could thus supply useful information to the Futurists and also bring to their work a critical judgment reflecting Paris standards. It was his criticism of their work in 1911 which persuaded the artists that a visit to Paris, with time to study new tendencies there, would be an essential prerequisite for a Paris exhibition. Yet Severini himself was not fully aware of Cubism until in 1911 Braque rented a studio close to his for a time and introduced him to Picasso. Severini's liveliest pre-Futurist painting is an urban landscape, *Spring in Montmartre* (1909), a Divisionist picture, clearly constructed to capture the perspective created by the steps and the trees leading down from the front of the Sacré-Coeur.

We can briefly summarize what the five painters brought to Futurist art as follows: Balla, Divisionism plus a realism influenced by photography, and subjects illustrating a worker's life; Boccioni, all that plus a taste for Symbolist imaginative subjects involving his mother as sitter and symbol; Severini, Divisionism and Parisian refinement; Carrà and Russolo, latter-day Symbolism as performed in Northern Italy by Previati and a few others. The manifestos implied that they would come close together stylistically; Boccioni certainly seems to have hoped for visible unanimity. Balla and Severini were geographically separate, so that it was in effect Boccioni, Carrà and Russolo who exhibited together (again, in December 1910, in the *Famiglia Artistica*, and in April/May 1911 in the 'Free Art Exhibition' organized on behalf of the Workers' Association in Milan), and it was they who were able to participate in the Futurist *soirées* organized by Marinetti. These were evening performances at which manifestos were read, poetry was declaimed and Futurist music (by Francesco Balilla Pratella, who also produced manifestos) was played. They were designed as much to rile the public as to inform it, and they were liable to end in fights. Chipp reproduces a Boccioni cartoon of one such event (p. 287). They were held at various times in Milan, Turin, Venice and other north Italian cities, and also in Rome and in Naples. At the Futurist *soirée* in Turin, on 8 March 1910, Boccioni read out the 'Manifesto of Futurist Painters', as we have seen. Severini said later that he was glad not to have been involved in these events, news of which reached Paris and probably caused him some embarrassment in front of his Paris colleagues. They, like the Italian critics, were only too ready to point to the sometimes yawning gap between Futurist promises and production. Particularly galling was the attitude of the Florentine painter, poet and critic, Ardengo Soffici, well known in Paris and influential in Italy, who wrote on art for the Florentine journal *La Voce*. When some Boccionis were shown in Venice in the summer of 1910 Soffici mocked them roundly: 'Umberto Boccioni, the arsonist, the anarchist, the ultra-modern Boccioni is a well-behaved little painter . . . who risks nothing, stays on the straight and narrow and paints just like they did in Belgium thirty or forty years ago'. That must have hurt. In May 1910 Boccioni had written to a friend expressing honest doubts about his work: 'I am sure there is something big dormant in me but perhaps that is true of everybody; real greatness lies in the work, and there I'm scared. I shall work and work . . . and then? In art love alone does not lead to fruitfulness, nor does passion lead to creation. For that we need something that lies outside our control . . . Futurism has given me strength, but it has also put on my shoulders a responsibility that frightens me. I feel that I must deliver a thousand times more than previously, and I ask myself whether I can fulfil what I promised.' When Soffici reviewed the Free Art Exhibition, which included a total of fifty works by Boccioni, Carrà and Russolo and attacked their art even more viciously, they and Marinetti took the train to Florence, found Soffici and some of his friends in a café and engaged in a shouting match that ended in blows. There are several accounts of the fracas, and no two alike. Later, in 1912, Soffici and the Futurists were to become allies.

Figure 94 Umberto Boccioni, *Mourning (Lutto)*, 1910, oil, 41½ × 53 ins (Collection Mrs Magarete Schulze, New York).

Many of the works shown in these exhibitions cannot now be identified. One of the paintings Boccioni exhibited in December 1910 is *Mourning* (Fig. 94). With its emotional display and its Munch-like use of expressive line (compare Hamilton Fig. 60) this seems far from the Futurist programme. Marinetti frowned on all expressions of sorrow. Boccioni, however, saw this painting as an important attempt to find generalized and abstracted modes for the expression of particular feelings. He wished to achieve this, he wrote in a letter of November 1910, 'with painterly sensations, that is with beautiful colours and beautiful forms—and this to the horror of those painters who consider a colleague on the road to damnation, if not in total ruin, when they notice that he is thinking.' In the same letter Boccioni refers to a 'picture of 3 × 2 metres in which I have attempted to produce a great synthesis of work, light and movement. It is perhaps a transitional work, and *one of the last, I believe!*' This is *The City rises* (Plate 15; see also Haftmann 234).

Exercise

Study *The City rises*. In what ways and to what extent does this painting embody the announced intentions and methods of Futurism? Consider its overt subject matter, its deeper content and its general effect.

Discussion

1 Subject matter: Men and horses are straining to move heavy substances that are not shown. The background, right, tells us that this is a building site: there is a partly completed building. Behind it stand factories with smoking chimneys. The background also shows, left, more factories and a tram.

2 The power of concerted effort seems to be the theme behind these details. Boccioni originally intended to call the picture *Labour*. Note the difference between this dramatically staged and acted scene and both Boccioni's and Balla's earlier scenes of work which now seem very calm and distant.

3 General effect: It is a large painting, yet shot through with energy. Not just
because of the well represented straining figures and super-equine horses. Everywhere
light bursts through forms and between forms, mingling human and animal limbs,
weaving together objects far and near, and giving a supernatural vivacity to the whole
scene. The Divisionist touches have here become long, thin strokes, deliberately
placed sometimes to pick out a form and sometimes to contradict it.

4 How Futurist is it? Everyday modern reality is there, and also the movement and
the brightness that the 'Technical Manifesto' promised. The smoking chimneys too
were promised, and if we are surprised to find the horse as hero in place of the
machine we must remind ourselves of Marinetti's identification of his car with
Pegasus and of the 'three snorting beasts' that represent cars in his manifesto. Could
Boccioni not find a subject that would combine striving men and machines, or was
there some reluctance actually to confront the marvels of technology? Or was the
problem that it would be difficult to paint their effort and high spirits? (The horse as
an image both of violent force and of constructive energy appears in Munch (1912),
Kandinsky (1912) and Marc (1911–14); Marianne Martin sees a connection also with
a 1889 lithograph, *Pegasus Captive*, by Redon; Martin, 1968, p. 87 note 3.)

Boccioni's *Brawl in the Milan Galleria* (exhibited in the Free Art Exhibition;
Haftmann 232) is from the same months and should be dated 1910–11. Here too light
plays an energizing and mobilizing role. The named subject refers to a fight between
two women in Milan's famous arcade and the interest of the passers-by in this sporting
event. The positions of many of the figures, and the way the light seems to simplify
and abbreviate their limbs, must owe something to photography.

Figure 95 Luigi Russolo, *Lightning (Lampi)*, 1910, oil, 39½ × 39½ ins (Galleria Nazionale d'Arte Moderna,
Rome; photo: Oscar Savio © SPADEM 1976).

Russolo's painting *Lightning* (Fig. 95) belongs to the tradition of urban landscapes by
the Divisionist method but manages to reach out towards Symbolism in its subject

and somewhat masochistic mood by setting the puny power of man's electric light against nature's. Carrà's *Funeral of the Anarchist Galli* (Hamilton Fig. 167) recalls a violent occasion the painter witnessed in 1904. A large painting also, this is in several respects a counterpart to *The City rises*, but here the underlying theme is destruction rather than construction and the chief means through which this is given is the contrast of repeated dark shapes and the light that flashes between them. Carrà reworked the upper third of the canvas after May 1911, introducing something like a Cubist pattern. In many other respects this painting seems to me to echo the tradition which Futurism was pledged to destroy. Within a few years Carrà was to start publishing articles and books on the Italian Renaissance painters, Uccello, Giotto and Masaccio, and it seems that he began to study their work in 1911: behind the surface modernism of the *Funeral* lies the art of these great founders of Renaissance mural painting: their way of organizing a crowded scene and his are fundamentally the same. At the same time the dark *versus* light patterning of figures and shadows gives notice of a diagrammatic idiom that Carrà, Balla and also Russolo were to explore later. The colour of the painting is gloomy — the opposite of Boccioni's. A heavy red sun shines a lugubrious, at times hellish light on to the turbulent crowd; the dark forms are brown and black, their shadows are a greyish blue; where light falls on the figures it is represented by strokes of red and orange.

Figure 96 Gino Severini, *The Boulevard*, c. 1910, oil 25⅛ × 36⅛ ins (Tate Gallery, London, courtesy Mrs S. Estorick © ADAGP 1976).

Severini as a Futurist in Paris had the advantage of knowing Cubism (after 1911) in its various manifestations. He also suffered the disadvantage, as a Futurist, of being detached from the cultural and social limitations that gave the movement its biting edge at home. As far as he was concerned such statements as 'No masterpiece without the stamp of aggressiveness' need ever have been written. Like many other Paris painters he was willing to find his subject matter in the real world and to process it in ways that were plainly not those of the academies, but it was no part of his intention to shock the public or assault its regard for a well painted picture. *The Boulevard* (Fig. 96) is an agreeable, decorative painting. Its subject is familiar and underneath its divided surface we can easily discern a reassuring geometrical structure. What is new, and what may be called Futurist, is his way of treating light as dense matter, equal in its presence to the figures, the horses, the cabs etc., that make up the scene. Slabs and patches of light interrupt the objects; everything is presented in the guise of larger or

smaller geometrical forms. In a sense, the Divisionist technique has been married to the breaking up of the forms of objects. It seems likely that Delaunay's example (see Haftmann 195) contributed in various ways.

Marianne Martin stresses the influence, particularly on the work of Boccioni, Carrà and Severini, of the 'Unanimism' conceived and celebrated by the French poet Jules Romains in a volume published in 1908. Apollinaire noted in 1912 that the Futurist paintings often had titles that echoed the vocabulary of Unanimism and the ideas behind it. These are not easily defined however. Jules Romains appears to have had a piercing sense of human togetherness in the modern city, and in a largely optimistic way. He saw the energies of the anonymous and swarming millions as a beneficial and joyous force, and their physical forms and those of the objects around them as extensions and fragments of each others' and one's own as one moves among them. Certainly pictures like *The City rises* and perhaps *The Boulevard* express mass sentiment and mass action in a new and optimistic way that is the opposite to Ensor's (see Hamilton Fig. 56) or Munch's. Severini claimed later that he did not at this time know about Unanimism, but he did not need to: it was all around him. Mrs Martin quotes some lines from a Romains poem that fit his picture well. Translated they read: 'What is it that transforms the boulevard in this way? The motion of the passers-by is scarcely physical. Those are not movements so much as rhythms and I don't have need of my eyes in order to see them.' Romains' unfocusing from visual detail to seize on a more general sensory apprehending of life around him accords well with the Futurists' call for a wide, undifferentiated experience. Both reflect the teaching of Bergson (Martin, 1968, pp. 96–97, and 1969).

In the 24 August 1911 issue of *La Voce* the Futurists could read the first Italian account of Cubism, written by Soffici. He had seen the 1911 Salon des Indépendants in Paris where Cubism made its first concerted appearance. Apollinaire was his friend and we can assume that he had had access to Picasso and Braque. Furthermore, in the summer of 1911 Severini visited Milan and is likely to have brought with him articles and reproductions relating to Cubism as well as his own personal knowledge. The Milanese Futurists were now armed with second-hand information about Cubism.

This is most clearly reflected in Boccioni's painting *The Street enters the House* (Hamilton Fig. 169 and Unit 6, Plate 5). A description of the painting, such as 'the painter's mother, standing on the balcony, watches men working on a building site' might suggest a picture not unlike Boccioni's *Self Portrait* of 1908 (Fig. 89).

Exercise

Compare Boccioni's *The Street enters the House* with his *Self Portrait*, and then also with Russolo's *The Revolt* (Hamilton Fig. 168).

Discussion

The title of the new Boccioni says half of it. Street and house mingle; the equivalence of seer and seen, of persons and animals and inanimate objects seems complete; a horse emerges from the woman's side; steps lead up into her left shoulder. She reappears with her balcony to right and left, on a smaller scale. The houses themselves seem to move, almost as energetically as the figures below. Light adds to the bustle. The woman dominates our first encounter with the picture, and her head holds the centre, but gradually we identify with her and her experience of the scene rather than go on observing her. The subject or subjects of the *Self Portrait* remain separate from the observer; they are celebrated from a respectful distance. Here we are drawn into the mother's experience, which is also the painter's. The instability of the objects in the picture forces us into checking and rechecking their positions in relationship to each other; thus the passage of time is not merely symbolized, it becomes an ingredient in our experience of the painting.

Russolo's *The Revolt* indicates a very different reaction to Cubism. Like many another artist with only a partial knowledge of what a real Cubist painting might look like, Russolo seized on the notion of Cubism as a discipline rooted in geometry. (Soffici in his article characterized Picasso's paintings as having the character of a 'hieroglyphic', and this may have encouraged Russolo to find a firmly abstracted total image.) *The Revolt* looks like a diagram. A wedge of crowd enters from the right; pre-echoing the wedge are shock waves of energy represented by thin arrowheads of light which both break up and demarcate the forms of the houses. These shock waves suggest the forms made visible by high speed photography in more recent times; to Russolo they represented the metaphysical energy of the crowd while also giving a suggestion of movement and force. Both the Boccioni and the Russolo are indebted to Delaunay's Eiffel Tower paintings of 1910–11 (Hamilton Fig. 154, Haftmann 202). Delaunay's paradoxical breaking up of structures known to us as essentially vertical and stable in order to give them heroic life supplied the Futurists with a powerful means of describing energy and the flux of sensations. But comparison of his series with the Boccioni makes one aware of the absence of figures and human purpose; the Delaunays seem dream-like now. And comparison of both with the Russolo shows how lyrical and optimistic their pictures are, seen against the bare and threatening forms of his. *The Revolt* is without all formal grace; it also seems to be without commitment since we cannot tell whether Russolo sides with the rebels or not.

In mid October 1911 Boccioni and Carrà, and perhaps Russolo too, went to Paris for a short visit. They had spoken to Severini of holding a Futurist exhibition in Paris that autumn; he advised postponement until they had sized up the opposition. Marinetti was to participate in a poetry evening arranged in connection with the Salon d'Automne; this and Severini's own connections would give the Milanese access to the avant-garde world of Paris. Marinetti provided the funds.

Boccioni wrote to friends from Paris in rather superior terms: he was seeing all the new art there was but little in it surprised him. Yet it is clear that he and Carrà returned from Paris with the feeling that they would have to 'work like madmen' (Boccioni's phrase) if they were to make a good impression. The first foreign showing of Futurism had been fixed for three months hence at the Galerie Bernheim-Jeune and there was no time to lose.

International Futurism (late 1911 to 1914)

Until now Futurism had been a local affair. The foundation manifesto had appeared in Paris. It is possible that some of the Cubists, such as Léger, were influenced by the 'Technical Manifesto of Futurist Painting'; it is probable that a wider range of people in Paris and elsewhere were stimulated by the manner and the matter of Marinetti's rhetoric. But no Futurist art had been seen outside Italy, and there was no way in which the wider art world had taken cognizance of it.

In February 1912 the first foreign exhibition of Futurism was shown at the Galerie Bernheim-Jeune in Paris. In March it was in London, at the Sackville Gallery. In April-May it was at the *Der Sturm* gallery in Berlin (the second exhibition in Walden's new gallery). In May-June it was in Brussels, at the Galerie Giroux. From then on the story gets more complicated. A Berlin banker had bought 24 of the 35 paintings in the show; after Brussels these formed a separate touring show organized by Walden and seen in a long list of German and other cities, including Munich, Vienna and, in March 1913, Chicago. Meanwhile the original exhibition was replenished and sent to Amsterdam, Rotterdam, The Hague and Munich.

The paintings were not left unsupported: a catalogue introduction based on a lecture Boccioni delivered in Rome in 1911 gave a fairly succinct account of their ambitions and methods (see Chipp pp. 294–98). Marinetti lectured, and otherwise increased public understanding and irritation, in Paris, London (at the Bechstein Hall, on 19 March) and Berlin. *Der Sturm* magazine reprinted Futurist manifestos in translation; a volume of Futurist poems in translation was also published in Berlin in 1912. By the end of that year anyone in western Europe interested in new developments in art must have known of Futurism. Of course, the response varied. The rhetoric of Futurism and the novelty and angularity of their pictures invited caricature (see Unit 1, p. 5). Local avant-garde groups were, then as now, liable to disparage new-comers and claim both long familiarity with their basic ideas and disdain for them. As usual we have to interpret what facts and recorded opinions are available to us.

Thus we know that in Paris the exhibition was much visited and reviewed, but also that Picasso, Braque, Delaunay and the Cubists generally cared little for it. But it is also reported that Picasso admired the work of Boccioni, and at least one Paris art critic, André Muller, writing in the magazine *Excelsior* (1 October 1912), considered that the Cubist works then on show at the Salon d'Automne revealed adjustments in the direction of Futurism, particularly in respect of colour. A safe summary of the effect of the export of Futurism might be that it gave positive stimulus to those who felt the modern world called for new forms in painting capable of expressing the dynamic and complex mentality described by philosophers and psychologists, and it repelled those who equated art with grace and the preservation of time-honoured values. Futurism proved that, if one's taste permitted it, one could go a very long way from traditional ways of describing the world without losing touch with human experience. The word 'futuristic', meaning embodying a possibly foolish vision of a brash and uncomfortable world-to-come, came into use at this time.

The 35 paintings that formed the Paris–Brussels Futurist exhibition — by Boccioni, Carrà, Russolo and Severini (his first appearance in Futurist company; a Balla was listed in the Paris catalogue but did not arrive and was dropped from the catalogue after Paris) — represent a very remarkable effort. We must look at some of the new work that was created between October and February.

Boccioni, *The Forces of a Street* (Plate 16): A comparison with *The Street enters the House* (Hamilton Fig. 169 and Unit 6, Plate 5) brings out some interesting differences. The later painting is a night scene; it suggests both the noctambulism and some of the

imagery of the initial manifestos; 'nocturnal vibration', 'glaring electric moons', possibly 'drunks reeling with their uncertain flapping of wings around the city walls', and so on. The street in it is at once spaceless and an infinitely receding tunnel formed by the rays of electric lights. Lights from the trams and the open doorways add to the dialogue between man made light and nature's darkness. Other wheeled things are hinted at. Figures are insubstantial, shadowy, made and unmade by the lights. The absence of any major figure, as lead-in and as experiencer is striking; the new painting feels much more impersonal. A study related to it (Fig. 97) reveals the sort of pattern that underlies Boccioni's composition: the contrary motion of trams and lights make a descending zig-zag, but all is contained neatly within the edges of the composition. Motion is towards us, not across.

Figure 97 Umberto Boccioni, Study related to *The Forces of a Street* and *Simultaneous Visions*, 1911, pencil on paper, $17\frac{1}{4} \times 14\frac{5}{8}$ ins (Civica Raccolta delle Stampe Achille Bertarelli, Milan).

Boccioni *States of Mind: The Farewells, Those who go, Those who stay* (Figs 98–100): Boccioni attached special importance to this group. He had painted a previous set of pictures with the same titles earlier in 1911; in Paris he spoke of them to Apollinaire who said subsequently that he considered them (Boccioni's verbal account of them, that is) 'puerile and sentimental' and he may have said something to that effect to Boccioni; after his visit to Paris Boccioni repainted them completely. Mrs Martin illustrates the three earlier paintings together with drawings for them (Martin, 1968, plates 60–65); I illustrate one of the earlier set here. Comparison between the earlier

Figure 98 Umberto Boccioni, *States of Mind: The Farewells (Stati d'animo: Gli Addii)*, 1911, oil, $27\frac{3}{4} \times 37\frac{7}{8}$ ins (Collection of Nelson A. Rockefeller; photo: Charles Uht).

Figure 99 Umberto Boccioni, *States of Mind: Those who go (Stati d'animo: Quelli che vanno)*, 1911, oil, $27\frac{7}{8} \times 37\frac{3}{4}$ ins (Collection of Nelson A. Rockefeller; photo: Charles Uht).

Figure 100 Umberto Boccioni, *States of Mind: Those who stay (Stati d'animo: Quelli che restano)*, 1911, oil, $27\frac{7}{8} \times 37\frac{3}{4}$ ins (Collection of Nelson A. Rockefeller; photo: Charles Uht).

and the later versions suggests a very substantial advance. The first version of *The Farewells* (Fig. 101) recalls *Mourning* (Fig. 94) in its emphasis on human expressiveness and gesture supported by a fluent, diagonally structured composition. In *The Farewells* lines that may be steam and motion but may also (as in Munch; Hamilton Fig. 59) be communicators of emotion, rise diagonally across the canvas; human gesture lies in the opposite direction. In the centre we see an oval form made by the heads, shoulders and arms of a disengaging couple. The artist has chosen a high viewpoint and this lends an air of veracity to his pattern. In the final version some of these features remain: part of the diagonal swirls, now more certainly established as steam and smoke, and several embracing groups (or the same group glimpsed at varying distances and angles). But the centre of the picture, and its effective hero, is the locomotive. Its front — shown frontally and in profile — is telescoped with the engine driver's cab bearing the stencilled-looking number 6943. To the right of that, lines and some shading hint at railway trucks and carriages; to the left we glimpse a landscape dominated by pylons through vertical and horizontal lines that echo the coaches but seem to be abstract. Both versions are emotional; in the second version the locomotive is enrolled both as the occasion and as the man-made object of and symbol for this emotion. Boccioni still uses the swirling lines with their Art Nouveau connotations, but now he links them to a pictorial structure and to a process of analysis that is close to Cubism. The number, which dominates the picture, reflects Braque's introduction of similar numbers in *The Portuguese* a few months earlier (Unit 7, Plate 3). Similar changes occurred between the first and second versions of *Those who go* and *Those who stay*. In both versions of both subjects expressive lines are prominent; in one case they rise diagonally and are associated with speed, in the other they go downwards and are associated with sadness. In the second versions they have been integrated in complex

pictorial symphonies the thematic material of which ranges from hard visual facts (such as the Roman figures 'I' and 'III' on the doors of the compartments) to the broad arcs symbolizing motion and the kaleidoscopic but controlled impression of forms suggesting the faces of people on the train and the near and distant buildings they are passing, or the slowly moving forms of the non-travellers drifting home in a relatively stable environment.

Figure 101 Umberto Boccioni, first version of *States of Mind: The Farewells*, 1911, oil, 28⅛ × 37¾ ins (Civica Galleria d'Arte Moderna, Castello Sforzesco, Milan).

The title *States of Mind* comes from Bergson. The full text of his *Introduction to Metaphysics*, published in France in 1903, became available in Italy in 1909, together with parts of other Bergson writings, edited in one volume by Giovanni Papini. We can assume that Boccioni saw this book:

> Consider the movement of an object. My perception of the motion will vary with the point of view, moving or stationary, from which I observe it. My expression of it will vary with the symbols by which I translate it. For this double reason I call such motion relative: in the one case as in the other I am placed outside the object itself. But when I speak of an absolute movement, I am attributing to the moving object an inner life and, so to speak, states of mind. I also imply that I am in sympathy with those states, and that I insert myself into them by an effort of the imagination. . . . Every feeling, however simple it may be, contains virtually within it the whole past and present of the being experiencing it, and consequently can only be separated and constituted into a 'state' by an effort of abstraction or analysis.

Bergson goes on to discuss an artist's rendering of a subject and the viewer's apprehension of it: the artist may feel 'the throbbing of its soul' but will have to produce 'an external and schematic representation' (Golding, 1972, p. 7).

It is striking that in the second version the figures and faces are schematized according to a recipe of curving lines and shell forms that owes little or nothing to Cubism. It is a range of forms that the sculptor Archipenko was to experiment with in works of 1912 and 1913. Boccioni visited him in March 1912, but by that time the new *State of Mind* paintings were on show (for Archipenko see Unit 7, pp. 58–61).

Boccioni's text for the Futurist exhibition catalogue (Chipp, pp. 294–98) makes a bow
to the Cubists before going on to separate the Futurists from them, refers repeatedly
to 'states of mind' as a central concern of Futurist representation, goes a long way
towards describing his triptych in detail (p. 297), and also introduces some new con-
cepts into Futurist painting and its theory. 'Force-lines' which express the inner
energies of every object yet 'tend to the infinite' will clearly serve to lend a unifying
structure to a composition, and this suggests that Boccioni, possibly smarting from
Apollinaire's criticism, had hunted for a means of finding a pictorial system by
which to link the disparate objects his kind of 'what one sees' plus 'what one remem-
bers' pictures required. It is important to notice that he insists on the absence of any
guiding vocabulary or language: each situation, each emotion will require the artist to
find its particular pictorial form, so there are 'no fixed laws', and the three paintings of
the *States of Mind* triptych must be different in idiom — which they are. This variety
of idiom would not have seemed permissible to a Cubist.

Figure 102 Carlo Carrà, *What the Tram said to me (Quello che mi disse il tram)*, 1911, oil, 20½ × 27 ins (Collection Dr Giuseppe Bergamini,
Milan © SPADEM 1976).

Among the exhibited Carràs were the *Funeral of the Anarchist Galli*, with added
Cubist touches as already discussed, and *What the Tram said to me* (Fig.102). This is
a rich and rather friendly painting that reads like a pictorial counterpart to paragraphs
in the 'Technical Manifesto' (see Chipp p. 290 — where, for American reasons, the
Italian word 'tram' is translated 'motor bus'). There is a lot of Cubist fragmentation
but the tram is allowed to dominate easily, with little distortion of its main form.
The colours are mainly brown, red and orange, and the general tonality is low.
Another painting by Carrà, *Woman and Absinthe* (Martin, 1968, plate 87) comes even
closer to Cubism in form and also in its almost monochromatic colour appearance.

The dominant colour is a greenish brown that hints at the drink and, together with the repeating Cubist lines, symbolizes its intoxicating effect.

Russolo's most striking exhibit was *The Revolt* (Hamilton Fig. 168), which we have already discussed.

Figure 103 Gino Severini, *Yellow Dancers (Danseuses Jaunes)*, 1911 or early 1912, oil, 18 × 24 ins (Courtesy Fogg Art Museum, Harvard University, gift of Mr and Mrs Joseph H. Hazen © ADAGP 1976).

Severini's contribution included the elaborate *The Pan-Pan Dance at the Monico*, in many respects an indoor counterpart to the more idyllic *The Boulevard* (see Martin, 1968, plate 172; the painting was destroyed in the Second World War), and also a painting of a new type, *Yellow Dancers* (Fig. 103). This is a firmly schematized rendering of what is, in experience, a schematic subject: two dancers going through similar motions, isolated by the beam and pool of a spotlight from other objects. To put it another way, the spaceless and unusually integrated subject plus environs of this painting may stem in part from the particular, much abstracted situation that a stage, a spotlight, costume and choreography contribute to it, excluding the multiple experiences that Futurism normally feeds on. Mrs Martin wonders whether this painting may not have stimulated Delaunay to produce his nearly abstract *Windows* series painted during April–December 1912; see Unit 6, Plate 1. But Delaunay's earlier paintings, such as *Window on the City* (Haftmann 195), show him already well advanced on the way to his 1912 series, and I suspect that the influence goes the other way, as in the case of *The Boulevard*.

In many respects 1912 marks the apogee of Futurist art, with each of the artists seen at his best and much of the work travelling about accompanied by various forms of verbal exposition. The only artist missing from our roll call is Balla, working in Rome at some remove from the others. For him too 1912 marks a climax. In this year he painted *Rhythms of the Bow* (Fig. 104), a developed example of his quasi-scientific interest in images of motion, as found in photography. The title is misleading in that the picture shows the action of the violinist's left hand, fingertips pressing on the strings, rather than the movement of the bow which is indicated only by the fine bunches of lines descending from the violin to the bottom edge of the painting. There is no attempt to introduce any other category of information—the sort of music being

played, the mood of the performer or of any listeners, or anything like that. The same sort of thematic concentration led Balla to diagrammatic representations of dynamics, as in *Automobile and Noise* (Haftmann 250) where the title punctiliously indicates a combination of themes, and also to exploring effects of light through the calculated deployment of colour quantities in a tacit pattern. Balla began a series of works entitled *Iridescent Interpenetration* (Plate 17 shows a similar painting). The series continued into 1914. These paintings have been seen as precursors of the Op Art produced principally in Britain and the United States in the 1960s but neither Balla's colour, which is gentle, nor his scale, which is modest, permits him the sort of colour vibration that has usually been associated with Op Art. It makes better sense to see Balla as one of the several painters working in pure colour and more or less abstract arrangements about this time—Delaunay in 1912, Kupka from 1910 on (Hamilton Fig. 209; Haftmann 363), Klee from 1914 on (Haftmann 291, 292) and so forth. Haftmann and Hamilton reproduce other Ballas of 1913–15 which appear to show him looking for the point where describing an object and a diagrammatic indication of motion might coincide. See particularly Haftmann 251 (*Racing Automobile, Abstract Velocity* is its full title) and Hamilton Fig. 173.

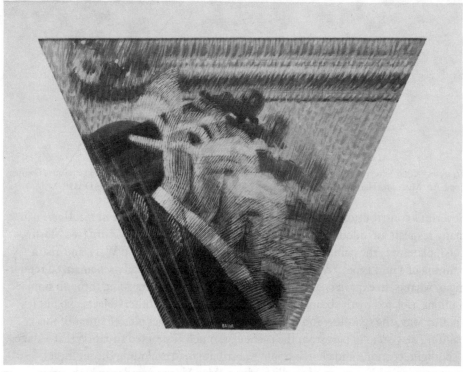

Figure 104 Giacomo Balla, *Rhythms of the Bow (Ritmi dell'archetto)*, 1912, oil, 20½ × 29½ ins (Tate Gallery, London, courtesy Mrs S. Estorick).

The years 1913–15 witness the slow disintegration of Futurism as a movement. The end of 1912 brought, at long last, a full and comforting alliance between the Futurists and their Florentine critic, Soffici. He and Giovanni Papini (the Italian editor of Bergson) founded a new magazine intended to give particular attention to art and more especially to function as a platform for Futurist theory and practice. The first issue of *Lacerba* appeared on 1 January 1913 (the title is meaningless but its sound carries hints of 'tatters' — *lacerare*, to tear, to rend — and of an unripe or bitter thing — *acerbo*, unripe, sour, bitter, hence *l'acerba*). Meanwhile the Futurists were increasingly conscious of differences of temperament and interest between them. They tended now to speak out independently instead of as a group and there are signs of an unfraternal urge to shout each other down. Marinetti in his 1912 'Technical Manifesto of Literature', and also *Lacerba* generally, encouraged Futurists to explore the kind of anti-rational forms of expression that will later, and in other places, become known as Dadaism. It was in this spirit that Russolo abandoned painting to become the first

composer of noise music. He published a manifesto, 'The Art of Noises' (1913) and developed a noise machine, the *Intonarumori*. This manufactured sounds relatable to the noises of everyday life as opposed to notes of definite pitch (it did not reproduce actual everyday noises), and these sounds he organized harmonically and rhythmically. He gave performances of his music in Milan, Genoa and, for twelve successive evenings in October 1914, at the Coliseum in London. After the war he continued to work in much the same way. In June 1921 he gave three concerts in Paris which are said to have impressed the young French avant garde in music: Milhaud, Honegger and especially Varèse.

Carrà's painting, probably of 1913, *Simultaneity : Woman on a Balcony* (Fig. 105), is again close to Cubism but not especially to Analytical Cubism. Gleizes' *Man on a Balcony* of 1912 (Hamilton Fig. 148) is certainly comparable in its subject and also in the unabashedly three-dimensional development of the forms of the figure. But Carrà's forms are much tougher as well as a good deal more directly sensuous than Gleizes', and the only Cubist with something comparable to offer in this respect is Léger. In Léger's *Women in Blue* (also of 1912; Haftmann 219) the swelling forms are not those of the woman herself, but generally his painting has the formal generosity and the dramatic play of large forms against small that we find in the Carrà. Note also that the Futurist veto on the nude is effectively broken here. Altogether Carrà's *Simultaneity* is far from Futurism's aggressive modernism even if, as the title advertises, it adheres to aspects of Futurist dogma.

Figure 105 Carlo Carrà, *Simultaneity: Woman on a Balcony* (*Simultaneità: Donna al balcone*), 1912, oil, 57⅞ × 52⅜ ins (Collection Dr Riccardo Jucker, Milan © SPADEM 1976).

The following year Carrà was to produce a masterly collage in his *Free-Word Painting — Patriotic Celebration* (July 1914, Plate 18). Its powerful radial composition with touches of paint to give depth in selected areas and a rich assortment of newspaper, label and leaflet fragments plus writing, adds up to a piece of entertaining soap-box oratory such as Cubist collage had not even hinted at. Many of the words, written and collaged, are onomatopoeic; indeed the whole work has the aural presence of a loudspeaker in full flood. Marinetti had argued for a literature of freely deformed and remodelled words in yet another manifesto, 'The Imagination without Wires and Words in Liberty'. His concern there was with giving a new vitality to typography, where the use of different founts and multicoloured inks was to be supported by freely expressive handwriting and also all available signs in order to extend the meaning of the invented words. Chipp reproduces (p. 291) a 'words in liberty' work, printed in 1919 as a magazine cover but referring to the battle of the Marne in September 1914 and presumably conceived about that time; it was published as a leaflet in February 1915. Carrà's slightly earlier collage is conceived on a more classical model, whereas Marinetti's points towards Dada and Russian Constructivism, but it makes a similar use of stretched words, nonsense words and onomatopoeic lettering. It is also rumbustiously humorous with its deployment of 'flatulence', 'deaths', 'odours', etc., and also its upside down presentation of 'Odol', the famous German mouthwash (a great commercial success because of the cunningly shaped bottle in which it came), upside down. By 1915 Carrà was switching to a primitivist and also classical manner. In 1916 he became acquainted with De Chirico in a military hospital and joined him in his Metaphysical Painting, a sort of Surrealism based on the poetic exploration of still-life objects heavy with implications.

In Severini's *White Dancer* of mid 1912 (Haftmann 246 as 'Dancer') we are made more aware of the luminosity of the dancer's white skirt that occupies the greater part of the canvas—almost *is* the canvas—than of her person and rhythmical movements, clearly indicated as these are. In *Dynamic Hieroglyphic of the Bal Tabarin* (autumn 1912; Hamilton Fig. 172) he produced a lighter and altogether more cheering equivalent to the rather overwrought *Pan-Pan Dance at the Monico*. Here too light dominates one's impression; there are sequins stuck on to the paint surface to produce glinting lights that seem to come from inside the picture. But how Futurist are these paintings? Movement, a complex of sensations signalled by a range of means in the *Bal Tabarin*, these fit Futurism's programme just as the greater degree of formal abstraction and the variety of signs, symbols and means fits this particular stage of modernism. But their content suggests the *fin-de-siècle* world of Toulouse-Lautrec.

Yet Severini was soon to move on to something peculiarly twentieth-century and, in my view, un-Futurist. Like Delaunay, again, he focused his interest for a while on the capacity of rhythmically organized colour areas to suggest sensations of light, without the interference of any other kind of subject matter. In 1913 he wrote 'The Analogies of Dynamics: Futurist Manifesto' (not published until 1957); its opening paragraph reads: 'We want to enclose the universe in a work of art. Objects no longer exist'—echoing Delaunay's cosmic vision. *Spherical Expansion of Light* (*Centrifugal*) (Plate 19) is a good example of the kind of painting that followed. In it a *pointilliste* technique of small, neat dabs of paint is employed more for the sake of luminosity and vivacity than to enable forms to penetrate each other. A softer version of the technique is used for *Sea=Dancer+Vase of Flowers* (Fig. 106) where the ambiguous subject matter indicated in the title is subsumed in light giving forms. The formal organization here has something of *White Dancer* about it, so it may incorporate some hints of a dancer; otherwise the formula of the title suggests the theory of analogies that Marinetti had put forward in the 'Technical Manifesto of Literature' in 1912. He claimed that linking named objects to others, however remote or contradictory they might seem in the light of reason, by juxtaposing them plainly, would serve to express 'the immense love which joins distant and seemingly different and hostile things'. It

is an entirely poetic idea, prepared for in the practice of the great Symbolist poets Rimbaud and Mallarmé and foreshadowing a basic method of Surrealism. The word 'love' seems justified, astonishing as it is to find it in a Marinettian context.

Figure 106 Gino Severini, *Sea = Dancer + Vase of Flowers (Mare = Danzatrice + Mazzo di Fiori)*, 1914, oil on canvas with aluminium, $36\frac{1}{4} \times 23\frac{5}{8}$ ins (Collection Mr and Mrs Herbert Rothschild, Ossining © ADAGP 1976).

The different ways that Balla, Carrà and Severini went during 1912–14 all led away from the tub thumping ways of 1909–10 Futurisms towards less revolutionary and more exclusively art centred goals. There was nothing in those early manifestos that permitted an exploration of light or of movement in its own right. There was little hint in the new work that a whole culture needed replacing; when this is hinted at in their later statements, we feel that the Futurists are making a ritual gesture. Had it been a promotional device in the first place? I think not: there had been real passion behind it. But it had been useful promotionally and now that they were known outside their own frontiers they felt less need of it.

Boccioni kept closer to the original spirit of Futurism than the others. He also, during 1912–14, went off on one of the most remarkable adventures in modern art— Boccioni turned to sculpture. He continued to paint and to draw but his most important works after the *States of Mind* triptych are his sculptures—even though only a fraction of what he made remains.

Perhaps he sensed a vacuum. In March 1912, after seeing the Futurist exhibition installed and launched in London, and before his and its departure to Berlin, he visited Severini again in Paris. Severini records that 'at this time Boccioni showed a very great interest for sculpture. Every day and at every opportunity he would discuss it and talk about it. Supporting his wish to go more deeply into the problem of sculpture I took him to Archipenko, Agero, Brancusi and also to Duchamp-Villon, then the most go-ahead sculptors among the avant garde.' In August 1912 Boccioni

wrote to Severini from Milan: 'It is terrible. . . I am wrestling with sculpture! I work, work, work, and don't know what I am giving out.' By that time he had published his 'Technical Manifesto of Futurist Sculpture' (April 1912: words first again, action after; Chipp pp. 298–304).[1] This includes many negative comments on the state of sculpture, but is concerned principally to seize for sculpture the freedoms from representational duties and from material limitation that Cubism and Futurism had won for painting. He wants the sculptured object too to demonstrate its involvement with its environment and display its inner dynamics. And there is no need for sculpture to be limited to a few honourable materials when anything may serve to realize an artist's vision, including electric lights, kinetic motors and applied colour. In June 1913 Boccioni presented his sculpture in a one-man show at the Galerie La Boëtie in Paris.

Figure 107 Raymond Duchamp-Villon, *Torso of a Young Man*, 1910, bronze, 22 × 14 × 16 ins (Collection Stanford University Art Gallery and Museum © ADAGP 1976).

One year from inception to public presentation. We should have to be satisfied if the work on show had been interesting and marked with promise. Instead, some of it is brilliant and if other (lost) pieces imply struggle and reorientation that only makes his success the more remarkable. There was indeed something very like a vacuum. When Boccioni visited Archipenko and the others they had little to show him that was relevant to his direction. Brancusi alone was in full flow and his interests must have seemed the opposite to Futurism's: he was in search of the succinct, all expressive but totally concentrated image. Archipenko was on the brink of opening up the sculptural mass (see Hamilton Fig. 158, also Unit 7, Figs 39 and 40); perhaps he had something of this to show Boccioni. Duchamp-Villon was engaged on clarifying his anatomies but his aims were essentially classical: see his *Torso of a Young Man* (Fig. 107; see also Hamilton Fig. 162). We shall have to ask ourselves whether Boccioni owed anything to Rodin, of whom he could say little good in his manifesto (remember that Rodin was still alive, a giant casting a broad shadow over the

sculptural scene); the Italian sculptor Medardo Rosso, whom he praised, could offer little beyond a general encouragement to Futurism at large through his highly original use of modelling to give sculpture a painterly breadth suited to such subjects as *Impression of an Omnibus* and *Conversation in a Garden* (Hamilton Fig. 30).

To a large extent Boccioni's sculpture is a development out of his own painting. *Fusion of a Head and a Window* (Fig. 108) relates to a number of studies of a head seen against a window and may remind you of the first Boccioni we looked at, *Homage to Mother* (Fig. 86, p. 126). We have seen, in his paintings, light and then objects being shown as breaking through or combining with his sitters: here, by means of several materials (including plaster, wood, metal rods and a bun of real hair) he makes a tangible version of what he had drawn and painted before. The result is one of his least ingratiating images, though it's clear that the subject had venerable significance for him. *Head + House + Light* (Fig. 109) is a more coherent piece. The body of the sculpture is in plaster but other materials are incorporated to produce the balcony railings and the 'lines of force' extending the sculpture at several points. Again there are paintings that prepare for this piece: see for instance, *Substance* (Haftmann 236).

Figure 108 Umberto Boccioni, *Fusion of a Head and a Window* (*Fusione di una testa e di una finestra*), 1912, destroyed, known only from an old photograph (Archives Museum of Modern Art, New York).

Figure 109 Umberto Boccioni, *Head + House + Light* (*Testa + casa + luce*), 1912, destroyed, known only from an old photograph (Archives Museum of Modern Art, New York).

Boccioni's first full sculpture in the round is *Development of a Bottle in Space* (Hamilton Fig. 170). This display of the dynamic forces implied by a partly filled bottle has a serene beauty that seems to invalidate it as a Futurist work, yet it fulfils the formal part of the Futurist programme quite exactly even if, as in contemporary Ballas, concentration on a limited theme cuts out all direct social function. In his catalogue preface for the exhibition Boccioni refers to 'my spiral architectonic construction' and to 'form-force which issues from the real form'; 'the form-force is, with its centrifugal direction, the potentiality of the real form'. *Development of a*

Bottle in Space is most closely linked to such phrases; it is clear that concentration on the formal implications of a single still-life object helped Boccioni to formulate his thinking.

Figure 110 Umberto Boccioni, *Unique Forms of Continuity in Space (Forme uniche della continuità nello spazio)*, 1913, bronze, 43½ ins high (Tate Gallery, London).

His masterpiece, however, is a more ambitious and also less perfect sculpture, *Unique Forms of Continuity in Space* (Fig. 110 and Hamilton Fig. 171). It is the culminating piece of a series in which he explored the theme of a striding figure, all of them with titles designed to draw our attention away from the human presence and to the dynamism of the sculptures. The theme of a striding figure is familiar (perhaps this worried Boccioni as well as tempting him): Rodin's *St John the Baptist preaching* was a well known sculpture; a cast of his *Walking Man* (Fig. 111), a highly dramatic version of the earlier piece, was set up outside the French embassy in Rome in 1912 amid great publicity. Archipenko may have been working on the figure called *Walking* when Boccioni visited him; Boccioni may also have seen the Duchamp-Villon *Torso* (Fig. 107). And looking at *Unique Forms* there is, to my mind, no ignoring its echoing of the famous ancient sculpture demoted by Marinetti in the first manifesto, the *Winged Victory of Samothrace* in the Louvre (Fig. 112). Its fluttering draperies compensate for the fact that the figure is perched on the prow of a ship, not striding; they may have helped Boccioni to pull out portions of the human anatomy, particularly on the legs, to create the sense of motion. That sense is also strengthened by supporting the legs on two separate blocks instead of a continuous base, an effective detail in Duchamp-Villon's *Torso*. Otherwise, the formal develop-

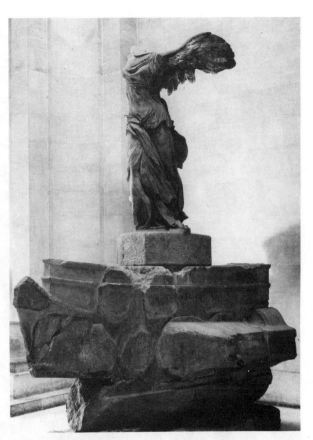

Figure 111 Auguste Rodin, *Walking Man*, 1905, bronze, 83¾ ins high (Joseph H. Hirshorn Museum and Sculpture Garden, Smithsonian Institution Washington © SPADEM 1976).

Figure 112 Winged Victory of Samothrace, Hellenistic marble sculpture (Louvre, Paris; photo: Bulloz).

ment of the figure is more like that of *Development of a Bottle*: the surface of the figure, in opening up, seems to spiral outwards, producing curved and shell forms of the sort we have already noticed in the painting *States of Mind: Those who stay* (Fig. 100); they are also seen in paintings more contemporary with the sculpture, such as *Elasticity* (Haftmann 238) where horse and rider are given energy without mass principally through such forms, and in *Dynamism of a Cyclist* (Fig. 113) where the hollow forms of the pedalling (almost striding) figure quite overwhelm the mechanical device. These observations must not make us forget the sculpture as a whole, however. It is a monumental work though not very large; it should stand on a fairly high base and be looked up at. It is, in short, the Nietzschean Superman, an image of destruction and regeneration, a knight of the future caparisoned by his own muscular and spiritual vigour.[2]

Boccioni's sculpture exhibition in Paris numbered eleven pieces. Of these three remain. All were perishable—none had been cast in bronze at the time—and it seems that callous handling plus a positive act of vandalism saw off most of them. Only one remains of whatever sculptures Boccioni made after March 1913, and that is the *Dynamic Construction of a Gallop: Horse + House* (Plate 20). Made of wood, cardboard and metal, and partly painted, this delicate construction has required restoring over the years and may not now be perfect in every detail. The concept of motion distorting not only the moving object but also the environment through which it moves is of course basic to Futurism, and Boccioni had returned to it recently in paintings such as *Plastic Dynamism: Horse + Building* (Fig. 114) where the horse is unusually stretched and the whole design is marked by an exceptional precision. Marianne Martin (1968, p. 194) suggests that Boccioni may have been responding to a new emphasis placed by Marinetti upon order and clarity in a further Futurist manifesto, 'Geometrical and Mechanical Splendours and Numerical Sensibility', published in *Lacerba* in April and May 1914. In it Marinetti stresses the new beauty

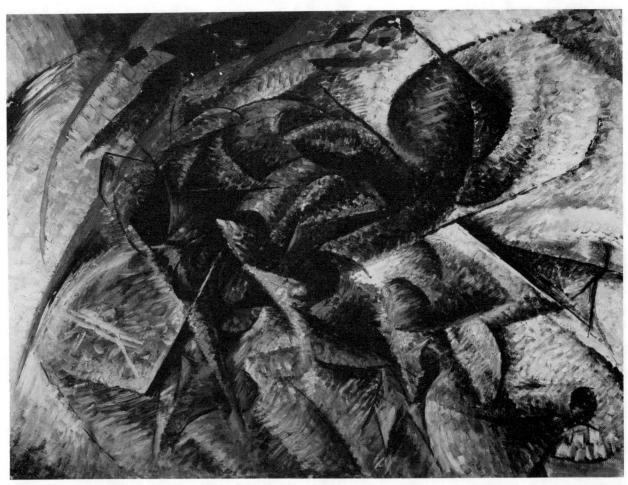

Figure 113 Umberto Boccioni, *Dynamism of a Cyclist (Dinamismo di un ciclista)*, 1913, oil, $27\frac{1}{2} \times 37\frac{3}{8}$ ins (Collection Gianni Mattioli, Milan).

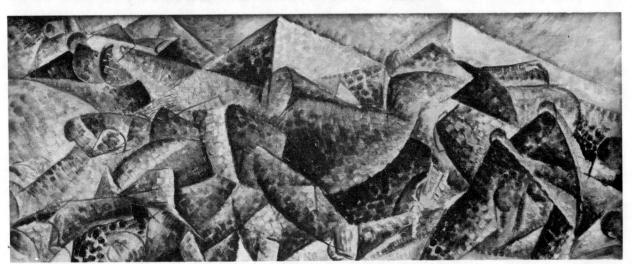

Figure 114 Umberto Boccioni, *Plastic Dynamism: Horse + Building (Dinamismo plastico: Cavallo + Caseggiato)*, 1914, oil, 16×44 ins (Civica Galleria d'Arte Moderna, Milan).

inherent in 'essential concision and synthesis; the happy precision of gears and of well oiled thoughts; the coming together of convergent energies in one single victorious trajectory'. But we have already seen the sort of images that this would suggest in the nearly diagrammatic paintings of Balla, Boccioni's friend, and there is at least the possibility that Marinetti was echoing an enthusiasm he found in his colleagues. Boccioni's sculpture is less expressive of a 'single victorious trajectory' than his painting, but this is compensated for by the thin support on which he erected his sculpture, almost freeing it from the limitations imposed by gravity, and also by his suggesting of hollow and more or less weightless forms even where he is using solid material.

Colour serves further to dematerialize the forms. One wonders what Boccioni's next step might have been. As it is, the further history of sculpture with Boccioni's aspirations will be found in Russia, where Marinetti lectured in 1914, where a parallel Futurist movement had already developed, and where, in 1915, Tatlin exhibited three-dimensional constructed sculptures hanging in space. Tatlin cannot have known Boccioni's *Dynamic Construction*; he certainly saw some of Picasso's constructed sculptures in Paris in 1913, and it is possible that he saw the sculptures Boccioni had brought to Paris. We can, however, assume that he knew Boccioni's sculpture manifesto and his catalogue introduction. It may even be that Boccioni's words about a 'spiral architectonic construction' were the seed that grew into Tatlin's *Monument to the Third International* (see Unit 10, Fig. 27).

The War and the Futurists

The war brought both the end of Futurism and a sort of apotheosis. The Futurists had praised war as a form of social cleansing; they had recommended a zealous and mettlesome way of life. Now they had a formal opportunity for it.

Marinetti, very active in the campaign to get Italy into the war on the side opposed to the Austrians, volunteered when Italy joined the Allies in 1915 and was wounded in 1917. So did Carrà who was wounded in 1916 and thus met De Chirico. So did Russolo, who was also wounded, and so did Boccioni. Boccioni at first wrote enthusiastic letters from the front: 'War is a wonderful, marvellous, terrible thing! . . . Magnificence, immensity, life and death! I am happy! . . . I am happy and elated to be a simple soldier and a modest collaborator in this grandiose work! Hurrah for Italy!' Yet he seemed a chastened man when, at the end of 1915, he returned to Milan on leave. He worked, wrote and lectured, and seemed generally to be searching for the roots of his art rather than for further extensions of it into unknown regions. 'There is nothing more terrible than art', he is quoted as saying. 'All that I see at present is play compared to a well-drawn brush-stroke, a harmonious verse, a well-placed musical chord. Everything compared to that is a matter of mechanics, of habit, of patience, of memory. There exists only art.' I need not stress the degree to which such words represent an abandoning of Futurist attitudes. In July 1916 Boccioni was recalled to active duty. A lung disorder could have exempted him but he went. He fell from his horse during an exercise and died the following day, on 17 August.

Figure 115 Photograph of Russolo, Carrà, Marinetti, Boccioni and Severini in Paris, 1912 (Courtesy Scottish Arts Council).

Another volunteer was the young architect Antonio Sant'Elia, whose catalogue text for a 1914 Milan exhibition of the 'New Tendencies' group of architects of which he was a member was republished soon after as the 'Manifesto of Futurist Architecture' in *Lacerba* (August 1914). The work and ideas of Sant'Elia are well discussed in A305 Units 9–10, *Expressionism*, pp. 38–41, and need not be dealt with fully in the present course. Figure 116 is a representative example of his work, illustrating his vision of a modern metropolis, devoid of anything belonging to the past, devoid too of urban clutter and dirt and perhaps assuming the exclusive use of hydroelectric power

(though I'll admit that architects don't normally show in their proposals the mess the inhabitants are going to make), and inviting easy congruence and passage of humans (a Utopian rendering, perhaps, of the Unanimist dream). It responds to the Futurist vision of a world in which the new technical forces are a welcomed partner in life rather than a servant kept below stairs, but it also would seem to make all Futurist art unnecessary in that what he offers is a complete environment that supplies all the actual and symbolic excitement the Futurists had felt they should supply through their paintings. Sant'Elia was killed in action in October 1916.

Figure 116 Antonio Sant'Elia, *Apartment House with External Lifts on Three Road Levels*, 1914, pen and ink on paper, $10\frac{1}{2} \times 8\frac{1}{4}$ ins (Civico Museo Storico G. Garibaldi, Como, courtesy Eredi di Sant'Elia).

Futurism and Expressionism

The work of the Futurists was created and launched against and in the context of the Paris avant garde, and that is how we tend to see it. They would have wished it. Much as they exclaimed against Paris, it was their Mecca and their testing ground, as well as the source of some of the means by which they turned notions into art. Cubism was the contemporary challenge they had to meet, as the might of the Renaissance was the great challenge from the past. Yet Cubism was essentially a classical art. Futurism in its intentions and in almost all of its performance was anti-classical. Should it be seen as a form of Expressionism?

Exercise

Consider this question at several levels. How comparable are the contexts of Futurism in Italy and Expressionism in Germany? How comparable are the aspirations of the two movements—one a close organization with a programme signed by its members, the other a much broader range of people and work? Can you see any specific instances of influence of the new Italian art on the German? Haftmann provides some suggestive illustrations of German, British and American paintings (259–66).

Discussion

The question I have raised is a broad one and I cannot answer it exhaustively. Here are some pointers.

1 Nationalism Futurism never ceased to regard itself as an Italian movement first and foremost, devoted to changing Italian civilization and Italy's standing. Expressionism in Germany embraced national feelings and fed on a new regard for the art of Dürer and his contemporaries, partly because their work seemed to embody German qualities that, in subsequent art, were overlaid by Italian and French manners. Some Expressionism is more Nordic in its allegiance—Nolde for instance—than specifically German. But Expressionism also saw itself as an international movement, bringing together all anti-academic and also anti-Impressionist tendencies. The *Brücke* group sought international members and allegiances; the *Blaue Reiter* group was multinational and its almanac was emphatically international.

2 Revolutionary Art The Futurists made it their duty to invent a new art through which to express their view of a new world. Expressionism's hope for a new art was founded more negatively: if the restrictions, the conventions, the politenesses of respectable art could be jettisoned a more vigorous art would emerge, closer to how people actually feel. In some cases this led to a concentration on the means of art and thence to new art forms; it also brought an awareness of art forms produced, it seemed, without such restrictions (actually produced to strict conventions too), the primitive art of Africa and elsewhere. The Futurists showed no interest in primitive art. The Expressionists' urge was to make contact and to share strong feeling; the Futurists wanted to shock, impress and convert.

3 Technology The Futurists used the technology of the end of the nineteenth century as general stimulus, as occasional subject and as an all-over symbol. The Expressionists generally neither welcomed the technological world nor resisted it: their concern was more with human constants, the aspirations and the fears that shape lives. Some of them felt that technological progress made it more difficult for men to know their own roots and thus to be true to their nature. The Futurists saw man in an urban context only.

4 Individualism Futurism started with a shared programme and for some time maintained group activity even if individual character could not be denied. Expres-

sionism benefited from the formation of mutually supportive groupings but always emphasised the value of individual expression. To convert the world you need concerted action and a definable goal; individualism can only offer individualism as its goal.

5 *Delaunay* The example of Delaunay was important to Futurism and Expressionism, but mostly in different ways. The Futurists learned from him mostly how to enrol the urban scene in the complex drama they wanted to represent. The Expressionists learned from him principally how to use flat patches of colour in order to construct a lyrically expressive picture. (Delaunay was critical of Futurism, but it is at least possible that such a painting as *The Cardiff Team* (1913; Haftmann 203), a fresh and almost noisy painting in which the Eiffel Tower, Blériot's plane and advertising hoardings are the background to, and mingled with, a rugby football match, was stimulated by Futurist example.)

6 *Specific Instances* Haftmann rightly implies the influence of Futurist example on Otto Dix, Georg Grosz and Lyonel Feininger (Haftmann 259, 260 and 262 respectively). He might certainly have added Franz Marc: see Haftmann 277–79 for the impact of Futurism's explosive diagonals on Marc's previously stable and peaceful compositions.

7 *Cubo-Futurism and Expressionism* In Unit 7 (p. 53) I referred to Futurism as a carrier of aspects of Cubism into other countries. The term Cubo-Futurism was actually used, principally in Russia, to refer to this combined form of modernism; it implies some difficulty in distinguishing between the French and the Italian movements. It is probably true to say that what we might call adulterated Cubism, as in Futurism, was more acceptable to the average Expressionist than pure Cubism, which he would have found devoid of human significance and too exclusively concerned with pictorial processes.

A Note on Vorticism

Hamilton provides an excellent account of Vorticism, the English movement which thrived very briefly (roughly from 1912 to 1915), was led by the writer and painter Wyndham Lewis, and for decades remained England's only wholehearted venture into modernist art. You should read this. A fuller account of the movement, combining entertaining detail with a wealth of historical information is available in the Arts Council's catalogue *Vorticism and its Allies*, written by Richard Cork (Arts Council, 1974).

I shall limit myself to drawing your attention to two very impressive works, both by 'allies' rather than members of the movement but very much of Vorticism as it appeared before the public.

The first is David Bomberg's *The Mud Bath* (Fig. 117). This large painting originated in Bomberg's observation of bathers in and around a pool in Whitechapel, London. Bomberg pushed his composition far beyond the recording of human activity. Almost completely abstracted figuration, unrepresentational colour (the figures are blue and white, the pool is red, its surround is ochre, the vertical post is black and brown), a total absence of modelling so that every form can be read clearly and equally. 'My object is the *construction of Pure Form*', wrote Bomberg. Done in 1914 after studies developed over two years, this is one of the masterpieces of its rich decade—yet it remains little known in Britain and unknown abroad.

The other is Jacob Epstein's *The Rock Drill*. Hamilton illustrates the sculpture as it exists today (Hamilton Fig. 179). This is merely a fragment of the complete work. In 1915 he exhibited the sculpture as a formalized figure, modelled in plaster, astride an actual rock drill. I reproduce the reconstruction of the complete work made for an Arts Council exhibition in 1974 (Fig. 118). In his 1940 autobiography Epstein was to

Figure 117 David Bomberg, *The Mud Bath*, 1914, oil, 61 × 90 ins (Tate Gallery, London, courtesy Mrs Bomberg).

write: 'It was in the experimental pre-war days of 1913 that I was fired to do the rock drill, and my ardour for machinery (short-lived) expanded itself on the purchase of an actual drill, second-hand, and upon this I made and mounted a machine-like robot, visored, menacing, and carrying within itself its progeny, protectively ensconced. Here is the armed, sinister figure of today and tomorrow. No humanity, only the

Figure 118 Jacob Epstein, *The Rock Drill*, in the position of 1913/15, reconstructed 1974 by Ken Cook and Ann Christopher, plaster figure mounted on a mechanical drill (Photograph courtesy Ken Cook and CompAir Construction and Mining Ltd, Camborne).

terrible Frankenstein's monster we have made ourselves into.' We must allow for the experience of 1914–18 and the fact that these words were written on the eve, or at the beginning, of the Second World War. Epstein was moved by (however short lived) 'ardour for machinery'. The image he has put before us is not exclusively one of horror: there is awe in it, a marvelling at the power of man + machine. In its complete form it was the boldest and one of the most powerful sculptures of its time. After it was exhibited and of course denounced (the reviewer from the *Evening News* described it as 'a nightmare in plaster, a kind of gigantic human locust, all angles and curves and flat surfaces, a cubist-futurist abortion of indescribably revolting aspect'; Arts Council, 1974, p. 74), Epstein dismantled it, reduced the torso to its present form and had it cast in bronze. He does not say what his thoughts at the time were. I doubt that it was a response to criticism. The large plaster figure was a fragile thing; perched on its drill stand it took up a great deal of space; in any case it would have been difficult to work with it looming over everything one did. A diminished and

simplified version of the figure could be cast in bronze much more simply and cheaply than the whole figure, and it could stand on a pedestal or a shelf and look after itself. In the studio practical issues can often be decisive.

Notes

1 Mrs Martin offers a more correct translation of an important part of this manifesto. In the first paragraph on p. 302 of Chipp, is a sentence which Boccioni stresses by putting most of it in capitals. This sentence should read:
'We therefore cast all aside and proclaim the ABSOLUTE AND COMPLETE ABOLITION OF THE FINITE LINE AND THE CLOSED SCULPTURE. LET US BREAK OPEN THE FIGURE AND ENCLOSE THE ENVIRONMENT IN IT.' (Martin, 1968, p. 126.)

2 I have several times on previous pages referred to individual Futurists' interest in photography. Here too chronophotography undoubtedly contributed to Boccioni's translation of a pose into a motion. He specifically requested that photographs of a figure in motion, made by Anton Giulio Bragaglia, should not be exhibited alongside his sculptures. Bragaglia in 1913 wrote a manifesto 'Futurist Photodynamism', which made the usual attacks on the representing of static objects; by capturing the dynamism of real life photography would be able to raise itself to the level of art.

Boccioni's nervousness at a possible comparison between his work and Bragaglia's reveals more than a debt; it reveals a standing irritation. Much of the criticism levelled at Futurism by the Cubists and others centred on accusing the Futurists of too close a reliance on photographic and also cinematographic sources. Thus Delaunay wrote in his notebook, after seeing the Futurist exhibition in 1912, 'Your art has velocity as expression and the cinema as means! Your future is already past!' And went on at astonishing length. Schlemmer noted in his diary (March 1916) that Futurism was really a form of Impressionism and offered things done better by the cinema. Such criticisms are not totally unjust—the Futurists certainly benefited from photography and perhaps also from the cinema, and on occasion stayed too close to their sources—but of course their art offers much else. I recommend Aaron Scharf (1974) pp. 200–8 for a well informed discussion of the Futurist artists' debt to photography.

Bragaglia also made a Futurist film. *Perfido incanto* (*Treacherous Enchantment*), made in 1916, was a partly realistic and partly surrealist love story, scripted by Bragaglia and others. The public was scandalized and amused, according to taste. *Archivi del Futurismo*, volume II illustrates some stills from the film (Gambillo and Fiori, 1958, II, pp. 495–98, Figs 1–15). For a fuller discussion of Bragaglia's contribution to Futurism and to photography see Tisdall and Bozzolla (1975).

References and Recommended Reading

Note Any account of Futurism written today must base itself partly upon
Marianne W. Martin's book (Martin, 1968). John Golding's review of it was both
complimentary and complementary and I recommend it whether or not Mrs Martin's
book is used; his lecture on Boccioni's *Unique Forms* ranges more widely than the
title suggests and is the best available text on Boccioni's work in sculpture (Golding,
1969 and 1972 respectively). My second general source for this Unit was Christa
Baumgarth's highly concentrated paperback (Baumgarth, 1966). *Archivi del
Futurismo* (Gambillo and Fiori, 1958) is a two-volume documentation of Futurism in
photographs and texts and will be very useful whether or not you can read Italian
(some of the texts are in French and others in English, the language of first
publication).

Apollonio, U. (1973) *Futurist Manifestos*, Thames and Hudson (paperback).

Arts Council (1974) *Vorticism and its Allies*, exhibition catalogue, Arts Council of
 Great Britain.

Banham, R. (1972) *Theory and Design in the First Machine Age*, Architectural Press
 (paperback).

Baumgarth, C. (1966) *Geschichte des Futurismus*, Rowohlt (paperback).

Gambillo, M. D. and Fiori, T. (1958) *Archivi del Futurismo*, two volumes, De Luca.

Golding, J. (1969) review of Martin (1968) in *The Burlington Magazine*, CXI No. 795,
 pp. 386–88.

Golding, J. (1972) *Boccioni's Unique Forms of Continuity in Space*, Charlton Lecture
 on Art, University of Newcastle-upon-Tyne.

Joll, J. (1960) *Intellectuals in Politics*, Weidenfeld & Nicolson—for Marinetti.

Martin, M. W. (1968) *Futurist Art and Theory*, Clarendon Press.

Martin, M. W. (1969) 'Futurism, Unanimism and Apollinaire' in *Art Journal*,
 XXVIII/3.

Northern Arts and Scottish Arts Council (1972) *Futurismo 1909–1919*, exhibition
 catalogue, Northern Arts and the Scottish Arts Council.

Procacci, G. (1973) *History of the Italian People*, Penguin Books.

Scharf, A. (1974) *Art and Photography*, Penguin (paperback).

Taylor, J. (1961) *Futurism*, Museum of Modern Art, New York.

The Open University (1975) A305 *History of Architecture and Design 1890–1939*,
 Units 9–10, *Expressionism*, The Open University Press.

Tisdall, C. and Bozzolla, A. (1975) 'Bragaglia's Futurist Photodynamism', in *Studio
 International*, 190, 976, July-August 1975.

Cubism McMillan tutorial. 16.5.78.

Les Demoiselles d'Avignon. precedents in
Europ. tradition of nude paint... - also Cézanne's
Bathers - also Olympia - by

form of organisation - of functionalism.

- suave tonality - opp of colour drawing

- facets

Brecht - cut up scenes & reararange -

7th July.

Either

Give an account of the formal techniques
employed by Futurist artists, citing specific
examples + examining critically their
effectiveness.

 or.

What, in your opinion, is Cubism?

John Golding. bk. on Cubism.

Futurists - violent colour.

- see behind appearance of things into
the order of things

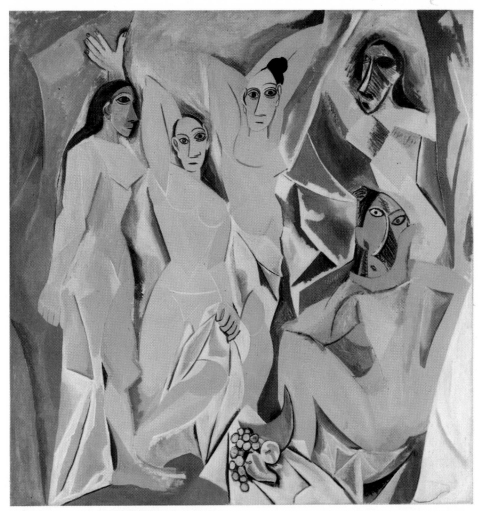

Plate 1 Pablo Picasso, *Les Demoiselles d'Avignon*, 1907, oil, 96 × 92 ins (Collection Museum of Modern Art, New York, acquired through the Lillie P. Bliss Bequest © SPADEM 1975).

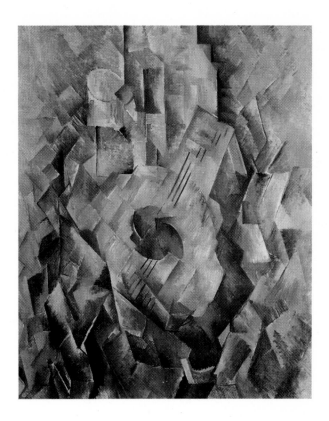

Plate 2 Georges Braque, *The Mandolin*, early 1910, oil, 28½ × 32 ins (Tate Gallery, London © ADAGP 1975).

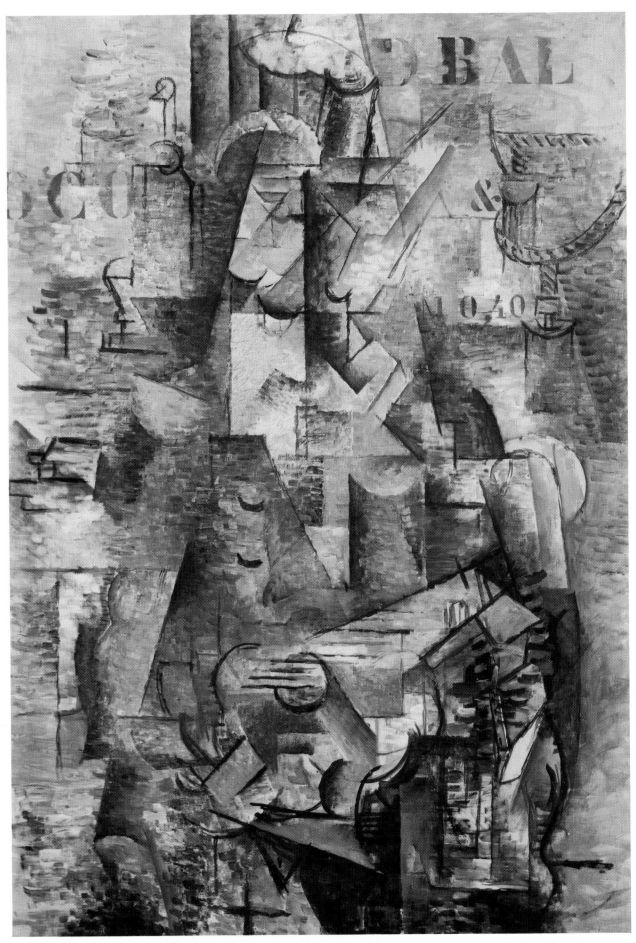

Plate 3 Georges Braque, *The Portuguese*, 1911, oil, 45¾ × 32 ins (Kunstmuseum, Basel; colorphoto: Hinz, Basel © ADAGP 1975).

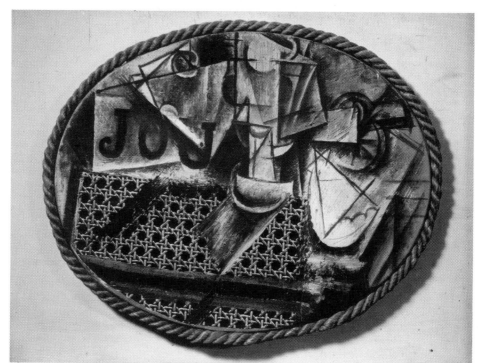

Plate 4 Pablo Picasso, *Still Life with Chair Caning*, May 1912, oil and pasted oil-cloth on canvas, $11\frac{3}{4} \times 15$ ins oval (Artist's collection; photo: Giraudon © SPADEM 1975).

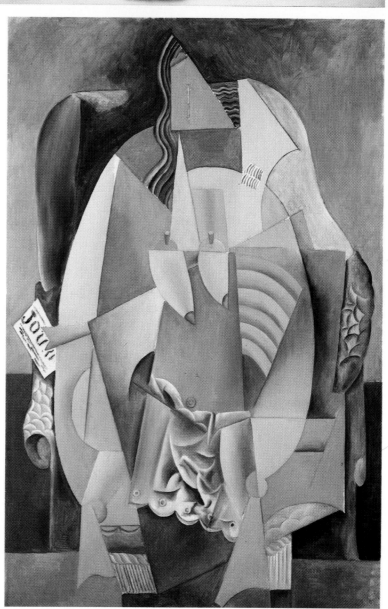

Plate 5 Pablo Picasso, *Woman in a Chemise seated in an Armchair*, 1913, oil, $59\frac{1}{2} \times 39\frac{1}{2}$ ins (Private collection, Florence; photo: Giraudon © SPADEM 1975).

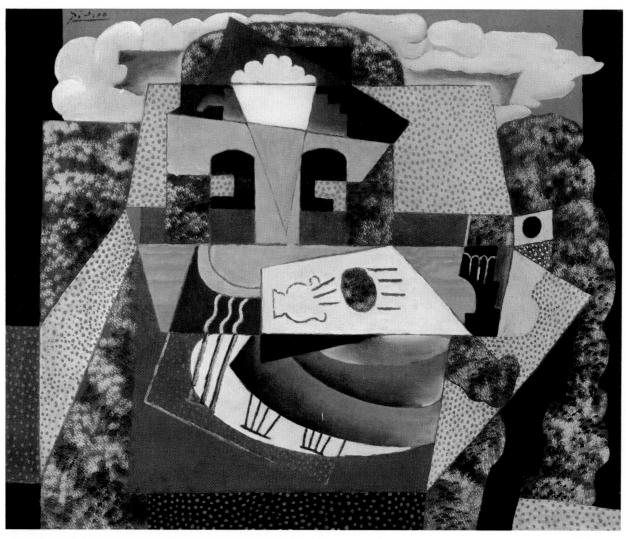

Plate 6 Pablo Picasso, *Still Life in a Landscape*, 1915, oil, 25 × 30 ins (Private collection; colorphoto: Hinz, Basel © SPADEM 1976).

Plate 7 Pablo Picasso, *Glass of Absinthe*, 1914, painted bronze with silver sugar strainer, $8\frac{1}{2} \times 6\frac{1}{2}$ ins, diameter at base $2\frac{1}{2}$ ins (Collection Museum of Modern Art, New York, gift of Mrs Bertram Smith © SPADEM 1975).

Plate 8 Henri Matisse, *Luxe, Calme et Volupté*, 1904–5, oil, 37½ × 45½ ins (Private collection, Paris; photo: Ides et Calendes S. A. Neuchatel © SPADEM 1976).

Plate 9 Henri Matisse, *Madame Matisse, the Green Line*, 1905, oil, 16 × 12¾ ins (Royal Museum of Fine Arts, J. Rump Collection, Copenhagen © SPADEM 1975).

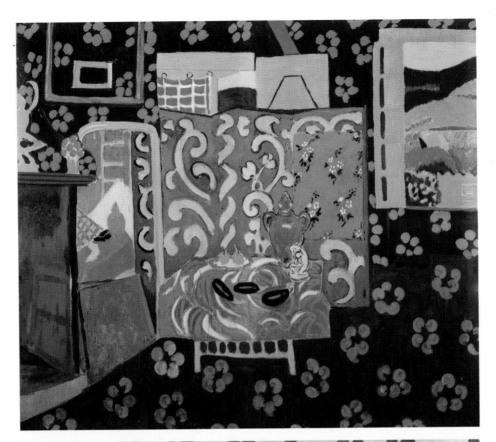

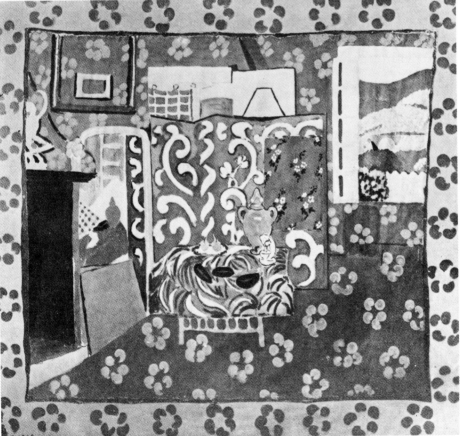

Plate 10 Henri Matisse, *Interior with Aubergines*, 1911, tempera on canvas, 72 × 97½ ins (Musée des Beaux Arts de Grenoble; photo: Maison Photopress © SPADEM 1976). Plate below shows *Interior with Aubergines* before the removal of the painted border, about 7 ins wide. Matisse removed it between November 1916, when the painting was photographed complete, and June 1922 when it was given to the museum at Grenoble. A watercolour by Matisse gives a full account of the complete painting: the border colours were golden yellow and light blue and a red line separated the border from the rest of the painting (Information from Dominique Fourcade, *Matisse au Musée Grenoble*, 1975, courtesy of Mme Marie Claude Beaud, Conservateur au Musée des Beaux Arts, de Grenoble; photo taken from Barr, 1951, by permission of Museum of Modern Art, New York).

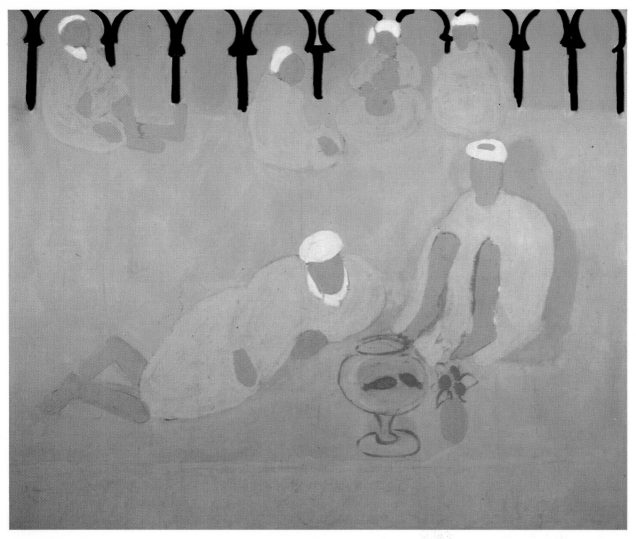

Plate *11* Henri Matisse, *Moorish Cafe*, winter 1912–13, oil, 69¼ × 82¾ ins (State Pushkin Museum of Fine Arts, Moscow; photo: Novosti (APN) © SPADEM 1976): This plate omits the painted border (an orange line surrounds the main field; to it are attached freely painted discs, about the size of the heads of the background figures and the same colour, on a pink background). It may be that Matisse wanted to suppress this element, as in the case of Plate 10, but the inclusion of a colour illustration of the complete painting, with the border, in a catalogue of Matisse's works in the Pushkin and Hermitage Museums (Leningrad, 1969) suggests that it still exists. A black-and-white reproduction of the complete painting can be found in Barr, 1951, p. 388.

Plate *12* Adolf Hölzel, *Gebet der Kinder*, 1916, collage on canvas, 20 × 16 ins (Pelikan Collection, Hanover, courtesy Doris Dieckmann-Hoelzel).

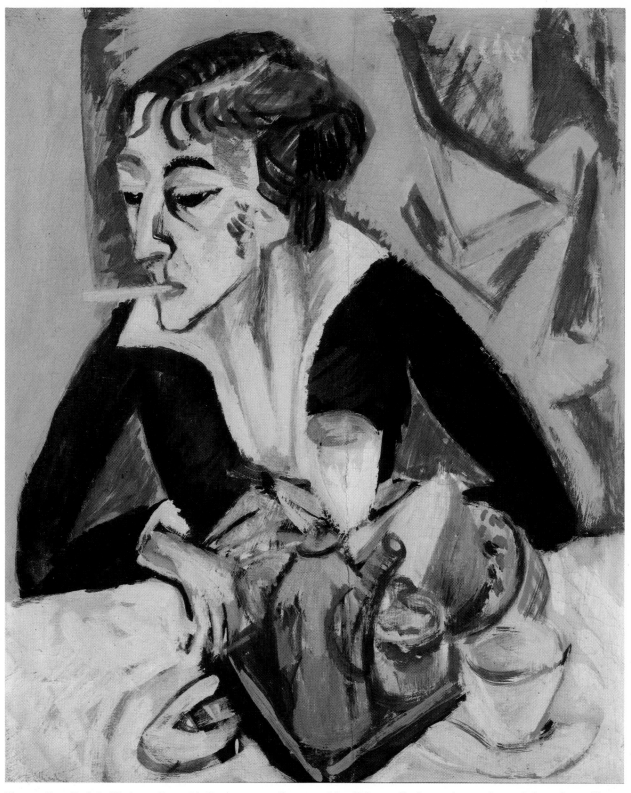

Plate 13 Ernst Ludwig Kirchner, *Erna with Cigarette*, 1915, oil, 29 × 24½ ins (Private collection, on loan to Staatsgalerie moderner Kunst, Munich; photo: Blauel, courtesy Roman Norbert Ketterer).

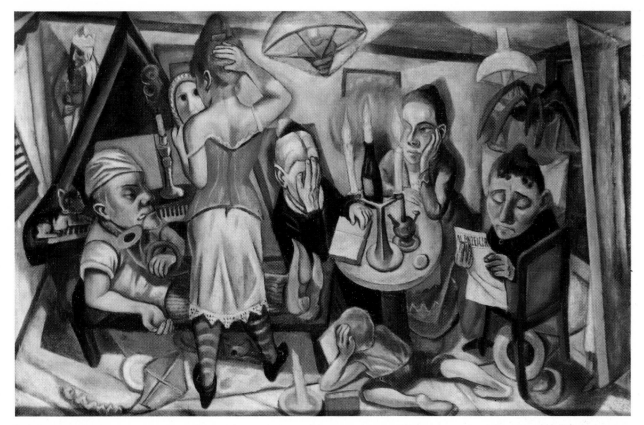

Plate 14 Max Beckmann, *Family Picture*, 1920, oil, 25⅝ × 39¾ ins (Collection Museum of Modern Art, New York, gift of Abby Aldrich Rockefeller).

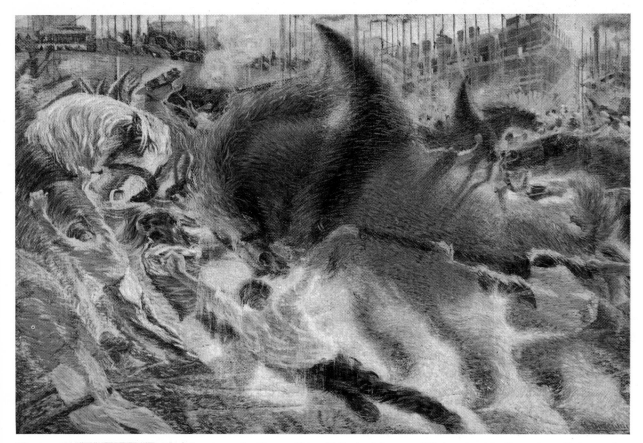

Plate 15 Umberto Boccioni, *The City rises*, 1910, oil, 78½ × 118½ ins (Collection Museum of Modern Art, Mrs Simon Guggenheim Fund).

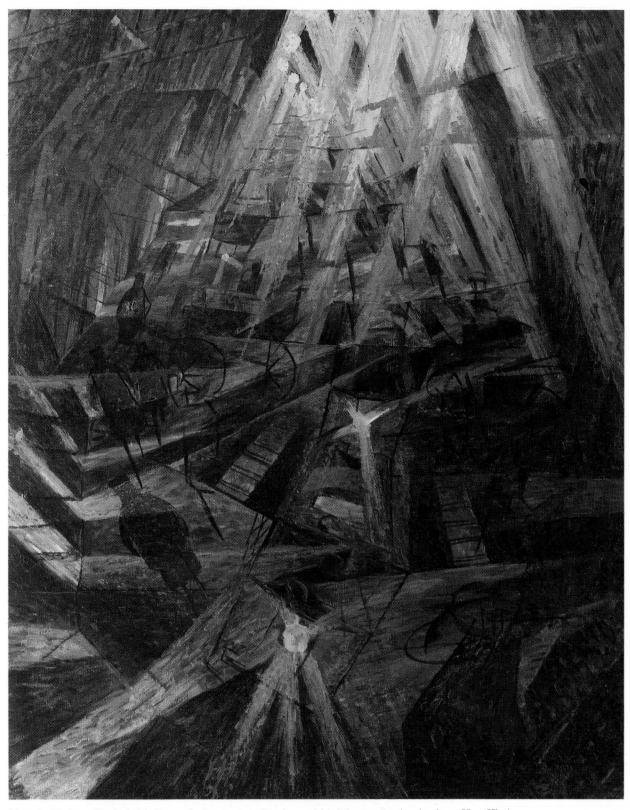

Plate 16 Umberto Boccioni, *The Forces of a Street*, 1911, oil, $39\frac{1}{2} \times 31\frac{7}{8}$ ins (Museum Basel; colorphoto: Hans Hinz).

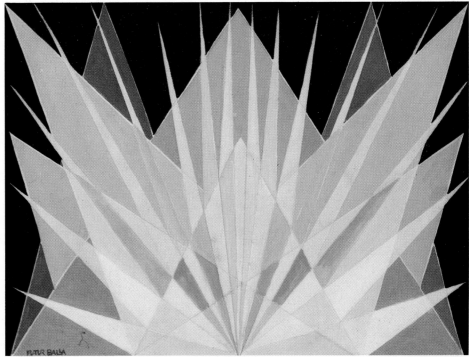

Plate 17 Giacomo Balla, *Prismatic Vibrations (Vibrazioni prismatiche)*, 1912?, tempera on card, 16 × 21 ins (Civica Galleria d'Arte Moderna, Turin; photo: courtesy Hamlyn Group Picture Library).

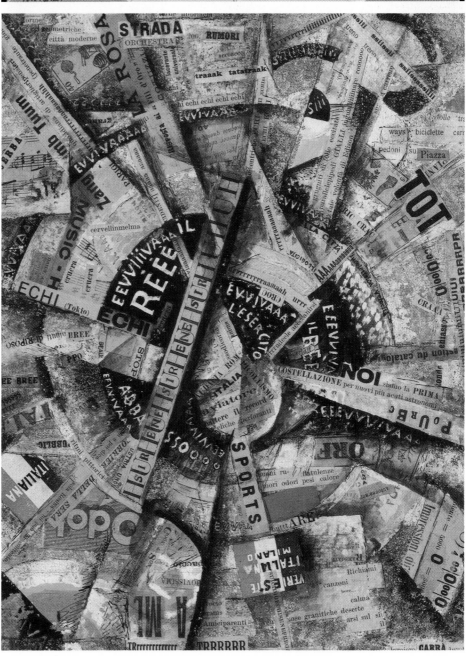

Plate 18 Carlo Carrà, *Free-Word Painting – Patriotic Celebration (Manifestazione interventista)*, 1914, *papier collé*, $15\frac{1}{2}$ × 12 ins (Collection Dr Gianni Mattioli, Milan; photo: Scala © SPADEM 1976).

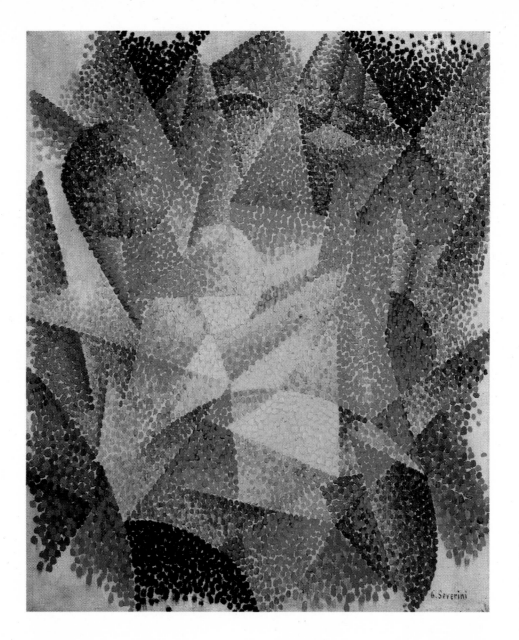

Plate 19 Gino Severini, *Spherical Expansion of Light (Centrifugal)*, 1914, oil, $24\frac{3}{8} \times 19\frac{5}{8}$ ins (Collection Dr Riccardo Jucker, Milan; photo: courtesy Hamlyn Group Picture Library).

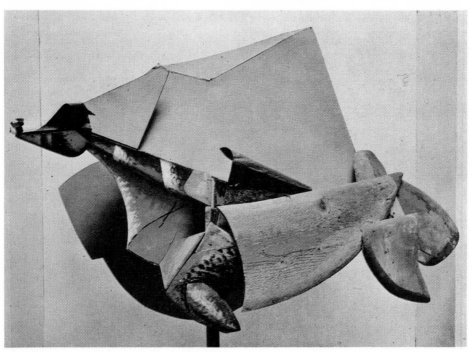

Plate 20 Umberto Boccioni, *Dynamic Construction of a Gallop: Horse + House*, 1914, wood and cardboard, $26 \times 47\frac{3}{4}$ ins (Collection Peggy Guggenheim, Venice).